Collage and Architecture

Collage and Architecture

Jennifer A. E. Shields

Routledge
Taylor & Francis Group

NEW YORK AND LONDON

First published 2014
by Routledge
711 Third Avenue, New York, NY 10017

and by Routledge
2 Park Square, Milton Park, Abingdon, Oxon OX14 4RN

Routledge is an imprint of the Taylor & Francis Group, an informa business

Library of Congress Cataloging in Publication Data
Shields, Jennifer A. E.
Collage and architecture / Jennifer A.E. Shields.
pages cm
Includes bibliographical references and index.
1. Architectural design--Methodology. 2. Collage. I. Title.
NA2750.S545 2013
729--dc23
2013016495

ISBN: 978-0-415-53326-3 (hbk)
ISBN: 978-0-415-53327-0 (pbk)
ISBN: 978-1-315-88319-9 (ebk)

Typeset in Franklin Gothic and Garamond by
Servis Filmsetting Ltd, Stockport, Cheshire
Printed in Great Britain by Bell & Bain Ltd, Glasgow

Acquisition Editor: Wendy Fuller
Editorial Assistants: Laura Williamson and Emma Gadsden
Production Editor: Ben Woolhead

For Bryan

Contents

Foreword

Juhani Pallasmaa, Architect, Professor

The World is a Collage

Collage and montage are quintessential techniques in modern and contemporary art and filmmaking. Collage combines pictorial motifs and fragments from disconnected origins into a new synthetic entity which casts new roles and meanings to the parts. It suggests new narratives, dialogues, juxtapositions and temporal durations. Its elements lead double-lives; the collaged ingredients are suspended between their originary essences and the new roles assigned to them by the poetic ensemble.

The techniques of collage and assemblage are conventionally related to visual arts and cinema, but Joseph Brodsky, the poet, makes the remark: "[I]t was poetry that invented the technique of montage, not Eisenstein".[1] However, every artistic work, be it literary, musical or visual, is bound to be a juxtaposition of images, emotions and ambiences in order to construct an articulated and engaging spatio-temporal experience. Whether the work qualifies as a collage depends on the degree of the apparent "givenness" of its ingredients. We tend to think that our awareness is a coherent and continuous mental state. In fact, human consciousness keeps shifting from one percept and thought to the next, from actuality to dream, association to deduction, and from recollection to imagination. Our very consciousness is an ever-changing collage of mental fragments held together by one's sense of self.

In its inherent permanence and penetrating, preconceived order, the art form of architecture is conventionally not associated with the notion of collage. Yet, the very role of architecture as frames and settings for human activities turns it into a varying and variously completed entity, an ever-changing collage of activities, furnishings and objects. Because of their longevity, buildings tend to change their functions and be altered as material entities. Most of our historical buildings are assemblies of alterations, materials, textures and colours layered through decades or centuries of use. Often it is this very temporal layering that gives a building its unique atmosphere and charm; the geometric spatial and material configuration of architecture is embraced

and enhanced by use, erosion and time; architecture turns from a spatial abstraction into a lived situation, ambience and metaphor.

The idea of collage has also been a conscious and deliberate artistic method in architecture from Giulio Romano's Palazzo Te in Mantua to Le Corbusier's and Alvar Aalto's fusions of modernist and vernacular images in their architectural assemblages, all the way to Jean Nouvel's collaged walls of the Belfort Theatre and David Chipperfield's renovation of Neues Museum in Berlin. Also many of Frank Gehry's works are collages although even the parts are deliberately designed by the architect; nevertheless, his buildings appear as assemblages of pre-existing units suggestive of differing origins.

Contemporary buildings, such as art museums, often appear strained and severe in their relentless formal logic, whereas the same activities located in recycled buildings – frequently of former industrial use – project a more relaxed and welcoming atmosphere due to their more complex logic, conflicting architectural themes and richer materiality; indeed, their collage-character. Peter Brook, the radical theatre director, deliberately demolished his avant-garde theatre building Bouffes du Nord in Paris in order to create an associative and emotionally responsive space for theatrical performances. "A good space can't be neutral, for an impersonal sterility gives no food to the imagination. The Bouffes has the magic and poetry of a ruin, and anyone who allowed themselves to be invaded by the atmosphere of a ruin knows strongly how the imagination is let loose", Brook argues.[2]

All collages tend to have a similar capacity to stimulate our imagination, as if the various fragments, torn from their initial settings, would beg the viewer to give them back their lost identity. The superbly executed collages by the Czech poet and artist Jiří Kolář are suspended between a literary and visual expression, and one can almost hear words being whispered by the visual imagery. Leonardo advised artists to stare at a crumbling wall in order to enter the mental state of inspiration,[3] and the collage takes similar advantage of the intricacies of our perceptual, imaginative and empathetic processes.

Notes

1 Joseph Brodsky, "Wooing the Inanimate", *On Grief and Reason*, Farrar, Straus and Giroux, New York, 1995, 343.
2 Andrew Todd and Jean-Guy Lecat, *The Open Circle: Peter Brook's Theatre Environments*, Palgrave MacMillan, New York, 2003, 25.
3 "When you look at a wall spotted with stains, or with a mixture of stones, if you have to devise some scene you may discover a resemblance to various landscapes . . . or, again, you may see battles and figures in action, or strange faces and costumes, or an endless variety of objects, which you could reduce to complete and well-drawn forms. And these appear on such walls promiscuously, like the sound of bells in whose jangle you may find any name or word you choose to imagine."
 As quoted in Robert Hughes, *The Shock of the New – Art and the Century of Change*, Thames and Hudson, London, 1980, 225.

Acknowledgments

First and foremost, I am incredibly thankful for Bryan Shields and his encouragement, continuing dialogue on the topic, and photographic contributions – this book would not have come to fruition without his efforts as both a husband and a colleague. Thanks also to my parents (and sister) for sparking and fostering a passion for art and architecture and their continued support of these pursuits.

In the development of this book, conversations with Greg Snyder and Andrew McLellan were invaluable in giving form and structure to a broad and diverse subject. My research assistants Nicole Rivera and Niki DeSimini were instrumental in the execution of this project, as were my editors at Routledge: Wendy Fuller, Laura Williamson, and Ben Woolhead. I am grateful for the financial support provided by the School of Architecture at the University of North Carolina – Charlotte, as well as Chris Beorkrem and my other colleagues and students at UNCC for discussing and testing these methods while furthering the discourse on the subject of collage and architecture.

Introduction

Collage and assemblage are favoured techniques of artistic representation in our time; these media enable an archaeological density and a non-linear narrative through the juxtaposition of fragmented images deriving from irreconcilable origins. Collage invigorates the experience of tactility and time.[1]

 Juhani Pallasmaa, "Hapticity and Time: Notes on Fragile Architecture"

One century ago, collage entered the lexicon of the contemporary art world. Pablo Picasso, in May of 1912, first appropriated a found material into a work of art. In his

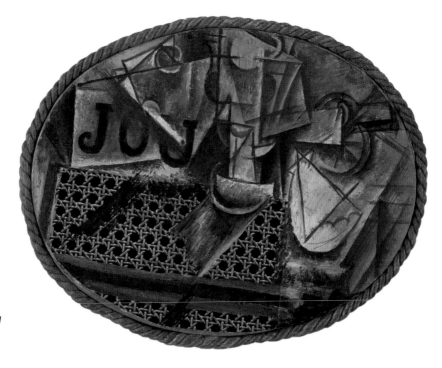

Pablo Picasso, *Still Life With Chair Caning* (1912)

1

Still Life with Chair Caning, Picasso affixed a piece of oil cloth printed with the design of chair-caning to an oil painting. This was the "first deliberately executed collage – the first work of fine art . . . in which material appropriated from everyday life, relatively untransformed by the artist, intruded upon the traditionally privileged domain of painting," according to Christine Poggi in her book *In Defiance of Painting: Cubism, Futurism, and the Invention of Collage.*[2] The founders of Cubism – Pablo Picasso, Georges Braque, and Juan Gris – valued collage as a hybridization of painting and sculpture existing at the threshold of two and three dimensions. As a means of investigating the potentialities of three-dimensional space in a two-dimensional medium, collage facilitated a new conception of space. These first acts of collage-making in the Modernist canon, in their conceptual, material, and technical originality, have profoundly influenced numerous artists and architects throughout the twentieth century and into the twenty-first.

Collage, as an art form unique to the modern era, emphasizes process over product. A collage as a work of art consists of the assembly of various fragments of materials, combined in such a way that the composition has a new meaning, not inherent in any of the individual fragments. According to Diane Waldman in *Collage, Assemblage, and the Found Object*, a collage has several levels of meaning: "the original identity of the fragment or object and all of the history it brings with it; the new meaning it gains in association with other objects or elements; and the meaning it acquires as the result of its metamorphosis into a new entity."[3] Simultaneity of spatial, material, and intellectual content is inherent in collage through a synthesis of unrelated fragments, as the process of construction remains evident in the resulting work.

We might understand architectural experience in a similar way. In *Questions of Perception,* Steven Holl illuminates the nature of our perception of the built environment, saying:

> A city is never seen as a totality, but as an aggregate of experiences, animated by use, by overlapping perspectives, changing light, sounds, and smells. Similarly, a single work of architecture is rarely experienced in its totality (except in graphic or model form) but as a series of partial views and synthesized experiences. Questions of meaning and understanding lie between the generating ideas, forms, and the nature and quality of perception.[4]

Holl proposes that we perceive human artifacts as an amalgam of sensory phenomena understood through personal experience and memory, rather than completely and objectively through a formal analysis. Like a collage, revealing evidence of time and its methods of construction, a work of architecture contains accumulated history as it is lived and engaged rather than observed. Just as a work of architecture is only fully created and comprehended through bodily, sensory engagement, collage can serve as a representational analogue, providing the medium to interrogate spatial and material possibilities. The practice of collage has the capacity to capture spatial and material characteristics of the built environment, acting as an analytical and interpretive

Bernhard Hoesli,
Plastik-Mond
(1967–76)

mechanism. Through this understanding, we can build a conscious and intentional response to the multivalence extant in sites and cities.

We consider collage in the following ways throughout this book:

1. collage as artifact
2. collage as a tool for analysis and design
3. architecture as collage.

This framework will offer a survey of collage methodologies in art and architecture beginning in 1912 and spanning a century of collage-making. This introduction offers a brief overview of collage as artifact through a chronological history of its artistic evolution – fragments of this history are revealed throughout the book. *Part 1: Collage Methodologies in Architectural Analysis + Design* investigates collage as an analytical and generative tool in the practice of architecture, organized by collage method. In *Part 2: Architecture as Collage*, specific works of architecture are analyzed through the lens of collage, as case studies representative of a collage mentality in architecture.

To provide a methodological framework for an understanding of collage, we begin a century ago with Cubism. For the first time in 450 years, the Renaissance

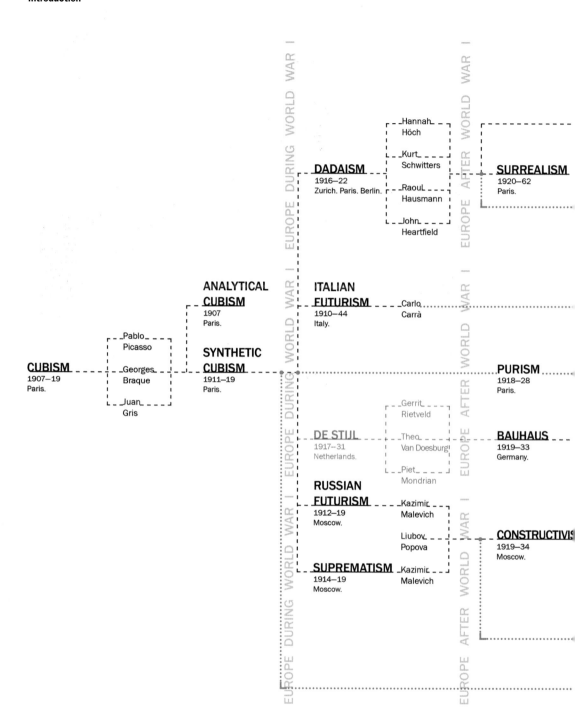

CUBISM
1907—19
Paris.

Pablo Picasso
Georges Braque
Juan Gris

ANALYTICAL CUBISM
1907
Paris.

SYNTHETIC CUBISM
1911—19
Paris.

EUROPE DURING WORLD WAR I

DADAISM
1916—22
Zurich. Paris. Berlin.

Hannah Höch
Kurt Schwitters
Raoul Hausmann
John Heartfield

ITALIAN FUTURISM
1910—44
Italy.

Carlo Carrà

DE STIJL
1917—31
Netherlands.

Gerrit Rietveld
Theo Van Doesburg
Piet Mondrian

RUSSIAN FUTURISM
1912—19
Moscow.

Kazimir Malevich

Liubov Popova

SUPREMATISM
1914—19
Moscow.

Kazimir Malevich

EUROPE AFTER WORLD WAR I

SURREALISM
1920—62
Paris.

PURISM
1918—28
Paris.

BAUHAUS
1919—33
Germany.

CONSTRUCTIVISM
1919—34
Moscow.

4

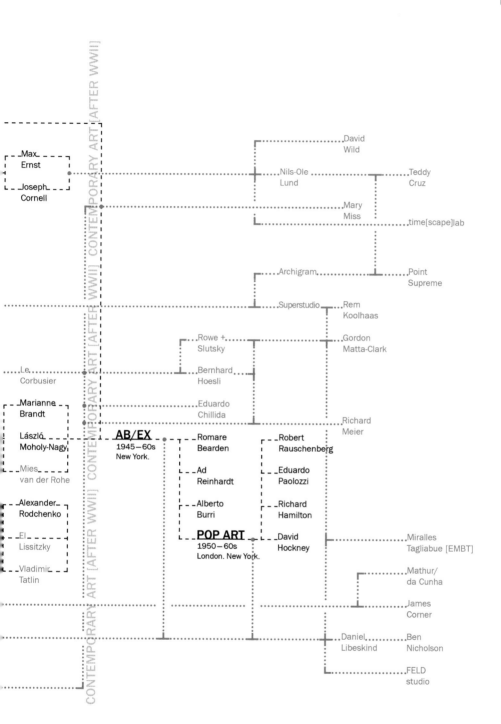

approach to representation – privileging visual experience – was rejected. The Cubists instead represented aspects of daily life through abstraction, material juxtapositions, and fragmentation and synthesis of form, cataloguing spatial and material qualities of commonplace subjects. The genealogy of collage and the influences of Cubism on art and architecture as articulated in this book are illustrated in the *Collage Genealogy*, demonstrating the conceptual or technical affiliations between various artists and architects throughout the past century.

The legacy of Cubism as demonstrated in this genealogy has its foundation in Alfred Barr, Jr.'s chart for *Cubism and Abstract Art*, the Museum of Modern Art exhibition in 1936, in which he illustrated the movements that influenced Cubism and the movements that were subsequently informed by Cubism. The bold

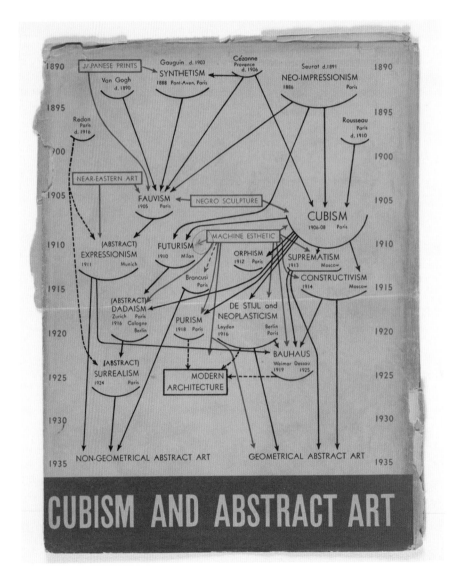

Alfred Barr, Jr. (1902–81). Cover of the exhibition catalogue "Cubism and Abstract Art," New York, The Museum of Modern Art, 1936.

Offset, printed in color, 7¾ × 10¼". Alfred H. Barr, Jr. Papers, 3.C.4. The Museum of Modern Art Archives, New York.

May have restrictions.

Digital Image © The Museum of Modern Art / Licensed by SCALA / Art Resource, NY

The Museum of Modern Art, New York, NY, U.S.A.

geometric forms of the Cubist collage were quickly adopted by artists outside France, while political unrest in Europe leading up to World War I saw the appropriation of collage for political and cultural purposes. The Italian Futurists were the first group of artists to respond to the radical shift in representation initiated by the Cubists. They embraced modern technology, fascinated by the speed, industrialization, and dynamism of modern life. The work of the Russian Avant-Garde (beginning with Futurism and Suprematism and evolving into Constructivism) was also highly politicized, the goal being to direct art towards a social purpose and demonstrate the ideals of a new society. Formally, they emphasized materiality and the dynamic composition of line, surface, and volume. According to Waldman, "From Cubism the Russians evolved an art that emphasized the surface plane and the faceting and fragmentation of forms. From the Futurists the Russians adopted the notion of speed and intersecting lines of force."[5] Artists of the Russian Avant-Garde were often architects as well, using collage, a two-dimensional medium, as a means of generating concepts for three-dimensional architectural forms.

Dadaism was founded at the outbreak of World War I in Zürich in protest and considered itself 'anti-art.' Dadaists conceived of their work as a rejection of

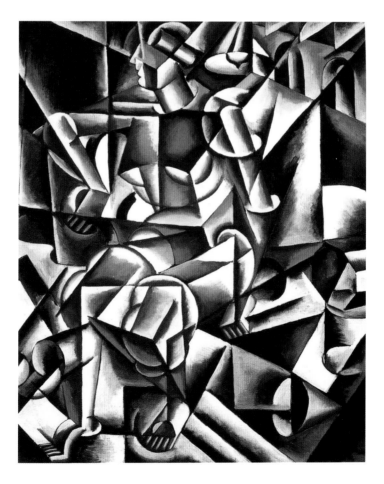

Lyubov Popova,
Air+Man+Space
(1912)

existing cultural and aesthetic values through their adoption of collage. Like the Russian Avant-Garde, their art was highly politicized, protesting the war and the political and social structures that led to it. Most Dada artists eliminated painting and drawing in their collages, and instead used photos and catalogues almost exclusively. The use of photomontage stemmed from their desire to be seen as engineers or mechanics rather than artists. There is debate over the birth of photomontage, as both the Russian Constructivists and the Dadaist Raoul Hausmann claim to have invented it.[6] The social commentary of the Dadaists was represented formally through changing perspectives, sharp diagonals, and contrasting materials and images, using rich textures and representations of the human body.

Surrealism developed in the period of peace following World War I, an outgrowth of Dadaism in Paris that become more internally focused. The Surrealists opposed the formal and rational order of Cubism, advocating for automatic or intuitive drawings to channel the subconscious. They sought to unify the inner world of the imagination with the outer world of reality, a synthesis termed 'surreality' by Surrealism's founder, André Breton. This dreamlike quality was often achieved through photomontage and the juxtaposition of unrelated objects. The often fluid and indistinguishable boundaries between layers magnifies this effect. At the same time in Germany the Bauhaus design school was founded with the intent of integrating all of the design disciplines, greatly influenced by De Stijl and Constructivism. László Moholy-Nagy, a Bauhaus professor, was in dialogue with Dada and Constructivist artists at the time, and evidence of their influence is found in his use of photomontage.[7] Like the Russian Avant-Garde, the Bauhaus artists often used minimal collage elements, creating and exploiting the deep space of the canvas.

Contemporary art, referring to art movements after World War II, has witnessed the use of collage by numerous artists including the Abstract Expressionists originating in New York and Pop Artists in New York and London. Abstract Expressionism derived directly from Synthetic Cubism as well as Futurism, the Bauhaus, and Surrealism. This movement began in the 1930s in the US, drawing from Surrealism's concept of automatism, or the power of the subconscious. Artists were motivated by a desire to investigate the role of chance in the creation of a work of art. These artists intended to merge the real and the imaginary by combining the familiar with the unknown, the personal with the universal. The process of collage-making in the manual engagement with the media "reflected both process and product, the same way the Abstract Expressionist paintings simultaneously represented the creative act and the final image," according to Diane Waldman.[8]

Pop Art was born in the 1950s as a response to Abstract Expressionism, employing found objects ('ready-mades') and photographic images like the Dadaists, with a desire to capture the complexities of contemporary culture. A leading figure in the Pop Art movement, British collage artist Richard Hamilton specified Imagery (including cinema, advertising, television, photographic image, and multiple image) and Perception (including color, tactility, light, sound, and memory) as critical issues in the movement.[9] Reflecting on the genealogy of collage, the value and meaning of

collage has transformed throughout the past century as the conception of space has evolved. Materially, the choice of fragments is also distinctive, revealing evidence of the time and place in which the collages were constructed as the artists incorporated readily available materials from everyday life into their collage compositions. The interconnectivity and overlap of collage methodologies in art movements of the twentieth century provide a diversity of ideologies, techniques, and materials from which architects have drawn, and will continue to draw, inspiration.

Part 1 considers the influence of these collage artists on the analytical and generative processes of architects over the past century. *Collage Methodologies in Architectural Analysis + Design* looks at the range of conceptual and technical collage methodologies in the field of architecture. Though Le Corbusier and other early twentieth century architects made use of collage in their design process to experiment with spatial and material juxtapositions, collage as a theoretical concept only became widely discussed after the publication of *Collage City* by Colin Rowe and Fred Koetter in 1987. In this publication, the authors were interested in collage for its metaphorical value, serving as a means of understanding the potentialities in the rich layering and complexity of the built environment. Architects have since exploited collage for both its conceptual possibilities and its material, formal, and representational potential.

Richard Meier,
*Russian/White
Paint* (1987)

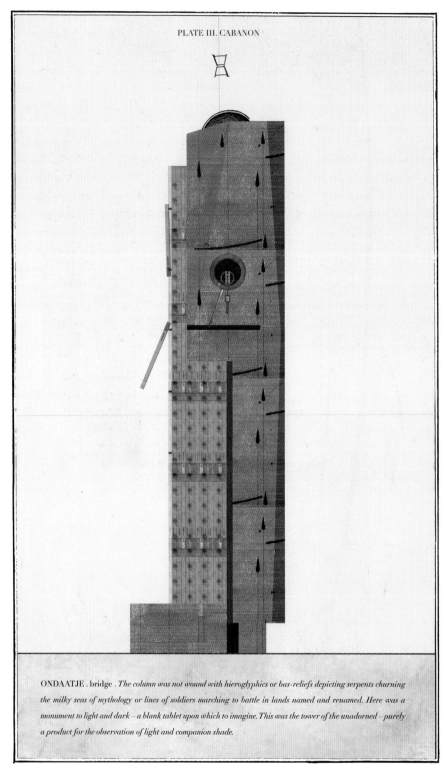

PLATE III. CABANON

ONDAATJE . bridge . *The column was not wound with hieroglyphics or bas-reliefs depicting serpents churning the milky seas of mythology or lines of soldiers marching to battle in lands named and renamed. Here was a monument to light and dark – a blank tablet upon which to imagine. This was the tower of the unadorned – purely a product for the observation of light and companion shade.*

time[scape]lab,
*Cabanon
[Ondaatje]* (2011)

Structured by collage-making technique, *Part 1* begins with the Cubist influence of *papier collé* and found materials in collage. Architects including Le Corbusier, Bernhard Hoesli, Eduardo Chillida, and more recently Richard Meier have utilized the collage techniques of the Cubists in their architectural work conceptually tied to the fragmented forms, figure/ground reversal, phenomenal transparency, and multiple perspectives found in Cubist collage and the abstract compositions of Kurt Schwitters.

Collage-drawings, employing line and photographic fragments while exploiting the negative space of the canvas, range from the geometric order, minimalism, and precision of Mies van der Rohe, Daniel Libeskind, Ben Nicholson, and James Corner, to the utopic/dystopic narratives of Superstudio, Archigram, Rem Koolhaas, and time[scape]lab. Collage-drawings often address the relationship of the body to space and materiality, with clear references to the haptic collages of the Dada and Surrealist artists and the spatial dynamism of the Bauhaus and Constructivism.

Photomontages by a variety of designers show correlations to the Constructivist, Bauhaus, and Dada use of photomontage as a means of juxtaposing unrelated fragments and meanings in the larger context of the city. These designers may use found images, like David Wild and Nils-Ole Lund, or they may construct

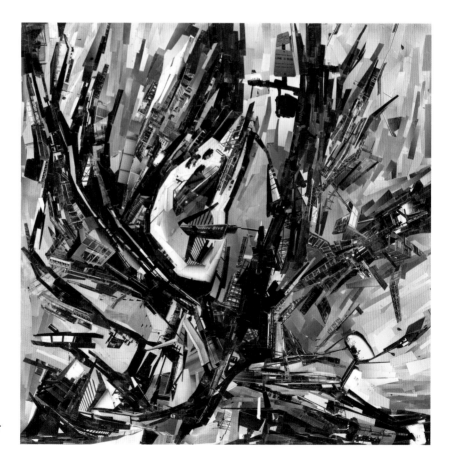

Teddy Cruz, *Border Postcard* (2002)

FELD studio,
*Extracts of Local
Distance* (2010)

their own image fragments, like Gordon Matta-Clark, Mary Miss, Miralles Tagliabue [EMBT], and Teddy Cruz. In response to the legacy of influential artists and architects working in collage through analogue means, this book emphasizes the value of the hand in the act of collage-making to offer a multitude of potential interpretations.

This book does, however, recognize the value in digital methods, documenting the work of contemporary artists and architects including Point Supreme, Mathur/da Cunha, and FELD studio. Each of these has demonstrated the potential for digital collages, and hybridizations of analogue and digital collage techniques, to investigate spatial and material futures. These methods utilize collage as a medium to captivate sensory, spatial perception. Collage serves as a tool for analysis, encouraging the evaluation of a built artifact from the perspective of the inhabitant, as well as a tool within a design methodology that pursues a multi-sensory experience in a work of architecture.

Part 2 considers *Architecture as Collage*, documenting a series of case studies investigating the qualities of collage inherent in built works of architecture and landscape architecture. Six case studies serve to evaluate elements of embodied collage. Luis Barragán's House and Studio (Mexico City, Mexico, 1948), Le Corbusier's Casa Curutchet (La Plata, Argentina, 1949–53), and Sigurd Lewerentz's Markuskyrkan (Stockholm, Sweden, 1956–63), though aesthetically dissimilar, contain an underlying order that has been disrupted and manipulated by conditions of site and perception, a fragmented and synthesized composition illustrating a three-dimensional ambiguity between figure and field. The following projects address similar themes through their interaction with a complex ground condition. Hamar Bispegaard Museum in Hamar, Norway (1973) by Sverre Fehn is a three-dimensional palimpsest, revealing distinctive yet overlapping layers of history and construction. Roberto Ercilla Arquitectura's Fundación Sancho el Sabio (Vitoria-Gasteiz, Spain, 2008) is a reappropriated landscape that has been reactivated by the processes of disassembly, fragmentation, and synthesis for the creation of a dynamic cultural space. The Olympic Sculpture Park in Seattle, WA (2007) by WEISS/MANFREDI takes the complex infrastructure of Seattle's waterfront and, through similar processes, constructs a diverse landscape. These six projects address a range of scales of architectural intervention, and are documented and analyzed through the lens of collage, revealing their distinct identities as embodiments of the collage mentality.

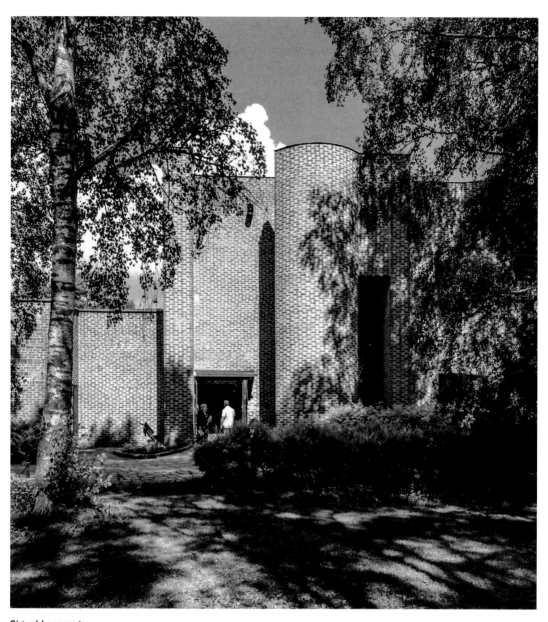

Sigurd Lewerentz,
Markuskyrkan,
Stockholm, Sweden
(1956–63)

Considering collage as an instrument for analysis and design, drawing on decades of relevance in art and architecture, offers a diverse set of material, technical, and conceptual precedents from which to draw inspiration. Diane Waldman claims: "Throughout this century, collage has come to symbolize a revolution in the nature of making art . . . The technique of collage was ideally suited to capture the noise, speed, time, and duration of the twentieth-century urban industrial experience. Collage became the medium of materiality."[10] Collage, as it has evolved, brings with it a number of dualities including representational/abstract, gestural/precise, field/

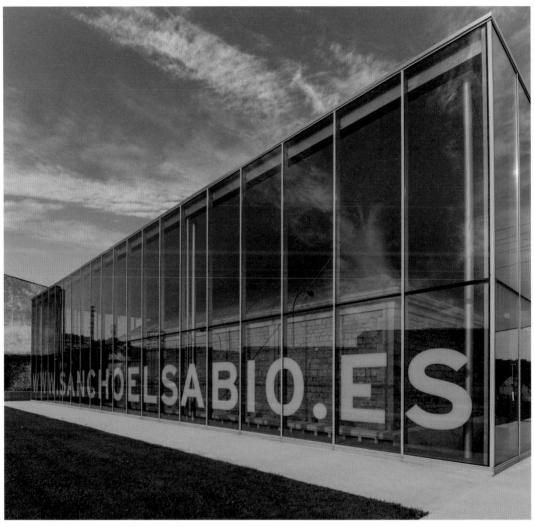

Roberto Ercilla Arquitectura, Fundación Sancho el Sabio, Vitoria-Gasteiz, Spain (2008)

figure, surface/depth, and literal/metaphorical, all of which are considered within the methodologies of art and architecture. The variety of methods can be hybridized and tailored to suit the conceptual framework within which a work of architecture (existing or proposed) resides. The multivalence and synthesis of spatial and material conditions inherent in collage-making creates the potential for a multiplicity of interpretations and experiences in the design process and the resultant work of architecture.

Notes

1 Juhani Pallasmaa, "Hapticity and Time: Notes on Fragile Architecture." *The Architectural Review* (May, 2000): 80.

2 Christine Poggi, *In Defiance of Painting: Cubism, Futurism, and the Invention of Collage* (New Haven: Yale University, 1992), 1.

3 Diane Waldman, *Collage, Assemblage, and the Found Object* (New York: Harry N. Abrams, 1992), 11.

4 Steven Holl, Juhani Pallasmaa, and Alberto Perez-Gomez. *Questions of Perception: Phenomenology of Architecture* (San Francisco: William Stout Publishers, 2006), 130.

5 Waldman, *Collage*, 71.

6 Waldman, *Collage*, 90.

7 Waldman, *Collage*, 114.

8 Waldman, *Collage*, 231.

9 Waldman, *Collage*, 272.

10 Waldman, *Collage*, 11.

Part 1

Collage Methodologies in Architectural Analysis + Design

1.1 *Papier Collé* and Found Materials

The birth of Cubism in 1907 marked a fundamental shift in the way artists thought to represent the world around them as well as the way they understood space, marking a break with the long-standing traditions of perspectival representation. "Between 1425 and 1450 artists throughout Europe . . . abandoned the medieval way of representing reality, by means of experiential conceptions, and began to rely instead on visual perception, one-point perspective and natural light," according to Douglas Cooper.[1] This conceptual framework persisted for over 450 years until the pioneers of Cubism, Pablo Picasso and Georges Braque, proposed a shift in representational thinking.

Analytic Cubism began in 1907 as Picasso and Braque collaborated in Paris to develop representative forms, or signs, for everyday objects, through an analysis of the spatial and material characteristics of these objects. Analytic Cubism quickly evolved into Synthetic Cubism in 1911 as the forms became further simplified and flattened. Although the Cubists rejected the Renaissance system of representation, their work might still be considered realism as their paintings and collages presented recognizable objects, albeit through multiple viewpoints. Despite the fragmentation

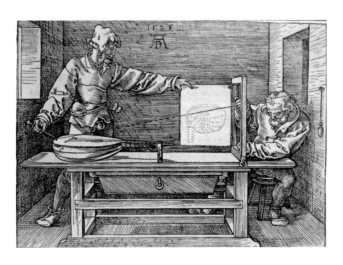

Albrecht Dürer,
*Man Drawing a
Lute* (1525)

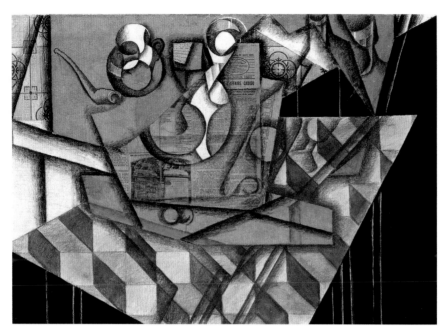

Juan Gris, *Tea Cups*
(1914)

and abstraction of these objects, they retain coherence and legibility. The intent was to capture deeper, qualitative characteristics of the subject matter, a single image revealing a simultaneity of perceptual phenomena as if the subjects of representation are static and the viewer is in motion.

Cubist collage, like architecture, is illustrative of both the labor of making and the process of fragmentation, aggregation, and synthesis. The Cubist collagists achieved a deconstruction of form through an additive process. According to Robin Dripps, in Cubist collages, "Figures of all kinds were carefully taken apart just to the point at which the resulting fragments were the most open to external relationships but not so far that reference to the original whole was lost."[2] Modern architecture can be characterized by a formal strategy in which figures are fragmented and layered to accommodate new relationships between figure and field, revealing dynamic and ambiguous spatial conditions.

The Cubists viewed collage as an intersection between painting and sculpture, initiating the investigation of three-dimensional potentialities in a two-dimensional medium. Although the collage fragments were originally used as literal representations of still life elements, eventually, to Picasso and Braque, these materials took on multiple or variable identities. They worked off a shallow, frontal space, creating multiple, fragmented objects and perspectives.

The innovative materials and techniques of the Cubists are demonstrated in their pasted paper works called *papiers collés*.[3] *Papier collé* is defined as a type of collage in which fragments of paper are used for their form, color, pattern, and/or meaning – typically newspaper, wallpaper, or solid color paper – in conjunction with other media such as oils or charcoals. These fragments can be painted with a texture before

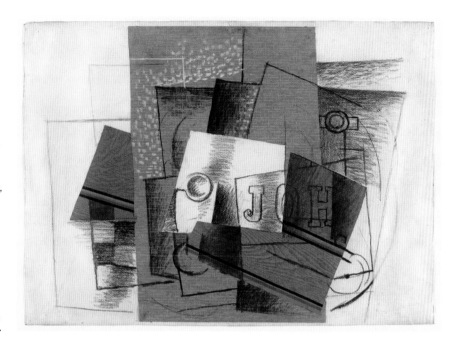

Georges Braque
(1882–1963)
© ARS, NY. *Still
Life with Glass and
Letters* (1914).

Cut-and-pasted printed
papers, charcoal, pastel,
and pencil on paper,
20⅛ × 28⅛".

The Joan and Lester
Avnet Collection.
(20.1978) May have
restrictions.

Digital Image © The
Museum of Modern Art
/ Licensed by SCALA /
Art Resource, NY

The Museum of Modern
Art, New York, NY, U.S.A.

being applied to the collage so that they might signify another material or object. Picasso's *Still Life with Chair Caning* marks the birth of collage in the spring of 1912 (see p. 1). In this first use of collage, the pattern on the paper fragment simulated the pattern of the subject, abstracting three-dimensional material properties into a two-dimensional composition. Soon after Picasso's first collage, Braque began using faux wood grain wallpaper (*faux bois* paper) in his still life compositions, using the wallpaper to represent café walls and tables. Both Picasso and Braque began to incorporate authentic fragments of everyday items (i.e. a newspaper or music score) into still life compositions of oil or charcoal[4] and tended to represent everyday activities centered around Parisian café life. The duality of gestural and precise qualities within the canon of collage-making is demonstrated in the contrast between the methods of Picasso and Braque. Picasso's collages were less precisely constructed, often tearing the paper and leaving the pins in place that he had used to work out the composition, revealing the methods of construction. In contrast, Braque's collages show evidence of pencil markings and pin-holes in an attention to craft.[5] Braque's shift to textured papers is an evolution from his earlier experiments in simulating faux wood grain with oil paints and a comb as an investigation into the creation of haptic surfaces.

Juan Gris, who like Picasso was a Spanish émigré to Paris in the early twentieth century, also began creating *papiers collés* in 1912. His collage techniques can be differentiated from those of his colleagues Picasso and Braque in a number of ways. His collage compositions completely cover the canvas, unlike the minimal use of oils and collage fragments in the early collages of Picasso and Braque that retain significant white space, interrogating the value of negative space. Gris worked primarily with oil on canvas, using minimal collage elements. The collage fragments serve a supporting role.

Like Braque, Gris created tactile surfaces in the *trompe l'oeil* tradition, using sand, brushes, and palette knives to produce surfaces resembling wood or marble. Gris studied mechanical drawing in Madrid before moving to Paris, evidenced in the geometrical framework established in his *papier collés*. Gris used the grid as a compositional device. The regulating grid organized and fragmented figures and fields within the composition. As his work evolved, he employed more textural fragments while the grid and the integrity of the objects began to dissolve.[6] Diane Waldman points out: "Where Picasso and Braque were involved in the interplay between the bare paper and the fragments of collage that punctuated its surface, Gris locked together the pieces of his collage into one intricate ensemble."[7] Despite these distinctions, all three artists utilized paper fragments in conjunction with line and tone in oil or charcoal in the construction of their collages. The intentionality with which the Cubists selected materials and constructed each *papier collé* underpins the identification of collage as a pseudo-three-dimensional medium.

The fragmentation of objects unique to Cubism at this point in history serves to imply three-dimensional space from multiple viewpoints. This technique is manifested in three different ways in the works of Picasso, Braque, and Gris:

1. In Picasso's collages, the objects are restructured through the juxtaposition or transposition of form and material, rather than displacement.

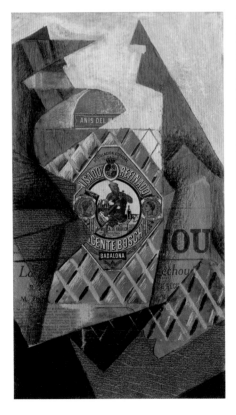

Juan Gris, *The Bottle of Anis del Moro* (1914)

2. The second method, evidenced in Braque's restructuring, occurs in the dissociation of the contours from the materiality of the object.[8]

3. In contrast, Gris's collages maintain the legibility of the original form, with the fragmentation and displacement resulting from the object's components or as a result of the superimposed grid, allowing the abstract geometry to inform shifts and disjunctures within the composition.

The fragmentation and ambiguity of form common to the Cubists creates a sense of three-dimensional space through layering and transparency. This concept is evident in Gris's *The Bottle of Anis del Moro*, most notably in the overlap between the bottle and the table. The fragment can be read simultaneously as both figure and field, belonging to both the figure of the bottle and the field of the table. The shifting impression of foreground, middleground, and background demonstrates the capacity for collage, as initiated by the Cubists, to reveal multiple spatial and material conditions concurrently and offers the potential to understand dynamic temporal and spatial conditions.

Fragmentation, or dislocation, of form is the method by which the Cubists were able to present simultaneous views. It is important to recognize the various ways we might understand fragmentation, which according to Dalibor Vesely, can have both positive and negative connotations. We might view fragmentation as a negative, in the sense of isolation or disconnection in the modern world prompted by rapid industrial and technological advancement, or, at a smaller scale, perhaps a disconnection between a building and its context. Fragmentation can be viewed positively in the possibility of multiple meanings and relationships, as evidenced in Cubist collage particularly as the Cubists have acknowledged the need for synthesis. In Synthetic Cubism, according to Vesely, "Traditional perspective was indeed replaced by a notion of space that was, as a rule, more complex and abstract . . . [geometry and fragments were a transition] . . . to the world slowly revealed in the process of construction, after which the resulting configuration remained only a mediating, symbolic representation."[9] The evidence of making in analogue collages reveals this process of construction and the temporal aspect of the collage-making process. As objects are fragmented and aggregated, the strength of the original form is lost, manifesting the surrounding context.

Georges Braque once said:

> It seems to me just as difficult to paint the spaces "*between*" as the things themselves. The space "*between*" seems to me to be as essential an element as what they call the object. The subject matter consists precisely of the relationship between these objects and between the object and the intervening spaces. How can I say what the picture is *of* when relationships are always things that change? What counts is the transformation.[10]

The Cubists used the breakdown of boundaries between figure and field to integrate the two. The relationship between object and background is not formal, but based on relation to context. The meaning then varies based on these relationships that

transform over time, giving the ground value equal to that of the figure.[11] Picasso's juxtaposition of multiple viewpoints in his *papiers collés* creates this engagement between the foreground and background. Acknowledgment of the pictorial surface and its reading against the depth implied in the collage heightens a sense of ambiguity between the represented objects and their context.

Significantly, the first recorded account of Cubism – two years prior to Picasso's first collage – was published in *The Architectural Record* in May of 1910, in an article entitled "The Wild Men of Paris" by Gelett Burgess. This article recounts his interviews with Picasso, Braque, and Matisse, among other Parisian artists. In an interview with Georges Braque, referring to his painting entitled *Woman*, Braque stated:

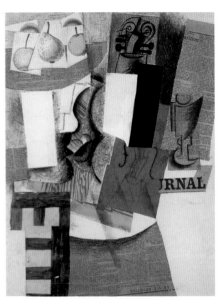

Pablo Picasso, *Bowl with Fruit, Violin, and Wineglass* (1913)

> To portray every physical aspect of such a subject . . . require[s] three figures, much as the representation of a house requires a plan, an elevation and a section . . . I couldn't portray a woman in all her natural loveliness, I haven't the skill. Noone has. I must, therefore, create a new sort of beauty, the beauty that appears to me in terms of volume, of line, of mass, of weight, and through that beauty interpret my subjective impression.[12]

Braque's statement elucidates the Cubist intent to convey simultaneity through a layering of multiple perspectives while balancing the phenomenal experience of the subject with a visual analysis. Clearly issues of materiality are foregrounded as well. Poggi describes the haptic nature of Braque's collages as going beyond the material representation of objects to the physical engagement of the viewer with the collage "through a materialized experience of space."[13] The synthesis of figure and ground in the work of the Cubists was further articulated by Juan Gris in a lecture he presented at the Sorbonne in 1924 entitled "On the Possibilities of Painting," in which he claimed, "True architecture cannot be broken up into different pieces, each of which is autonomous and exists alone. A fragment of architecture will be no more than an odd, mutilated object which ceases to exist when it is removed from the one place where it belongs."[14] As artists were contemplating architecture in the representation of spaces and forms, architects were reflecting on the Cubists' unique and innovative interpretations of architectural space.

Alfred Barr, Jr., founding director of the Museum of Modern Art in New York, curated the exhibition *Cubism and Abstract Art* in 1936 (see p. 6). He created a chart in which he proposed a causal link between the work of the Cubists, their subsequent influences on abstract art movements, and the advent of Modern Architecture. The characteristics of fragmentation, simultaneity, and phenomenal transparency, as common threads, are demonstrable in architectural works in the Modernist canon.

Kurt Schwitters
(1887–1948)
© ARS, NY. *Picture
with Light Center*
(1919)

Cut-and-pasted colored
paper and printed
paper, watercolor, oil,
and pencil on board,
33¼ × 25⅞".

Purchase. (18.1950)
May have restrictions.

Digital Image © The
Museum of Modern Art
/ Licensed by SCALA /
Art Resource, NY

The Museum of Modern
Art, New York, NY, U.S.A.

Another artist of the early twentieth century identified by Barr and integral to an understanding of *papier collé* as a collage-making method – and the genealogy of collage in general – is German artist Kurt Schwitters. The translation from two- to three-dimensional form as instigated by the Cubists is evident in the work of Schwitters, one of the most famous collage artists of the twentieth century. He began his paintings, collages, and sculptures in art school under the influence of Dada. In 1918, he began working on "Merz-a Total Vision of the World." He employed found materials in his collages, called Merz drawings, selecting fragments for form and color to appropriate in dialogue with painting. Paint served as a means of synthesizing the unrelated found fragments. Schwitters directly references Picasso's first *papier collé* in his use of a fragment of paper with a chair caning texture in his 1944 collage *The Hitler Gang*. His collages led him to create three-dimensional forms in his own home, which

he called Merzbau. The first Merzbau, created in his home in Hanover and ultimately destroyed in the war in 1943, was an inhabitable sculpture constructed over decades. In 1935, Alfred Barr, Jr. visited Schwitters and the Merzbau, and the following year included some of Schwitters's collage work in his exhibition *Cubism and Abstract Art*. The art critic Clement Greenberg considered only Picasso, Braque, Jean Arp, and Kurt Schwitters as the "few great masters of collage."[15] Schwitters clarified the intent of the Merzbau, telling Barr: "I am building an abstract (cubist) sculpture into which people can go . . . I am building a composition without boundaries; each individual part is at the same time a frame for the neighboring parts, [and] all parts are mutually interdependent."[16] The space defined by the sculptural elements was at least as important to Schwitters as the elements themselves. He said: "From the directions and movements of the constructed surfaces, there emanate imaginary planes which act as directions and movements in space and which intersect each other in empty space."[17] The interaction between the occupant and the space of the Merzbau was primary, speaking to the active role of the observer identified by the earlier work of the Cubists. We will see that the work of Schwitters's contemporaries and living architects including Richard Meier reveal evidence of the technical and spatial strategies initiated by the Cubists and advanced by Schwitters.

In Sigfried Giedeon's seminal book *Space, Time and Architecture* published in 1941, Giedeon recognized that Synthetic Cubism, particularly as evidenced in collage and montage, marked a turning point in the way artists and architects conceived of space – rooted in physical reality yet in flux, subject to multiple interpretations. These qualities of simultaneity and transparency were, in his words, "central to the architectural project of the modern movement in Europe in the 1920s."[18] In Colin Rowe and Robert Slutzky's *Transparency*,[19] they identify simultaneity of meaning as a type of transparency, designated as "phenomenal" transparency. Rowe and Slutzky drew this from György Kepes in *Language of Vision* (1944) in which he states, "Transparency mean a simultaneous perception of different spatial locations. Space not only recedes but fluctuates in a continuous activity."[20] Phenomenal transparency describes not only a multiplicity of viewpoints but also an ambiguity of figure and field, a condition in which a figure could be read as field and vice versa. This condition is not static, but temporal: in the perception of conditions of phenomenal transparency, the viewer plays an active role. A momentary impression of a Cubist collage or work of Modern architecture may yield one reading, while continued contemplation yields additional readings. The role of time in the interpretation of spatial and formal conditions is but one corollary to architectural design.

While the Cubists inserted conditions of order into their collaged analyses as a means of organizing, fragmenting, and layering figures and fields, these foreign conditions were manipulated by the physical characteristics subject to the analysis, much like the architects who have employed collage in their design work. Collage as a tool for architectural analysis and design, born of the Cubist material and conceptual innovation in representation, is interwoven throughout twentieth- and twenty-first-century design. As Steven Holl says in his book *Intertwining*:

The merging of object and field yields an enmeshed experience, an interaction that is particular to architecture. Unlike painting or sculpture from which one can turn away, unlike music or film that one can turn off, architecture surrounds us. It promises intimate contact with shifting, changing, merging materials, textures, colors, and light in an intertwining of flat and deep three-dimensional parallactical space and time.[21]

The writings of German philosopher Martin Heidegger (a contemporary and occasional collaborator of twentieth century European artists and architects) posit theories on the perception of space, relevant to the discussion of fragmentation and the interrelationship of space and time. Heidegger asserts that we understand things in the context of other things, not as separate self-contained objects. Conscious of these interrelationships, weak Gestalt[22] in a work of architecture allows for multiple readings and manipulations which reveal new relationships, much like the collages of the Cubists.[23] Space, according to Heidegger, is parceled into places by human activity and experience. It is critical to understand the architectural 'ground' as more than space enclosed by politically imposed boundaries. Instead we must read the ground as a richly layered physical and cultural construct. Heidegger postulates that the identification of place is not logical or systematic, but rather subjective and personal. Edges and boundaries are critical to an understanding of space: "the boundary is that from which something begins its presencing."[24] Boundaries are created in our minds – they can be physical and defined, such as by a wall or a row of trees, or vague and imprecise, like a horizon – although a threshold, it cannot be marked or precisely located. These imprecise boundaries are evidence of the ambiguous relationship between site and dwelling.

The following work by designers in research and practice considers the fragmentation and synthesis over time as a physical manifestation of place, intertwining building and context, while utilizing themes and methods of the Cubists. Le Corbusier, as a contemporary of the Cubist artists in Paris, was significantly influenced by their work both conceptually and technically. A protégé of Corb, Bernhard Hoesli, further abstracted and geometricized his collage compositions and contributed to the articulation of phenomenal transparency as a condition of overlap in his work with Colin Rowe and Robert Slutzky at the University of Texas at Austin in the 1950s. The Cubist abstraction of space is also powerfully evident in the collages, sculptures, and architectural proposals of Eduardo Chillida and the collages and built work of Richard Meier. The following interpretation of work by Le Corbusier, Hoesli, Chillida, and Meier considers the fragmentation and synthesis of spatio-temporal conditions as a physical manifestation of place, intertwining built form and context. These designers acknowledge an underlying order that is manipulated or disrupted by conditions of site, program, or perceptual intent, creating an ambiguity between figure and field. In the words of Steven Holl, "When a work of architecture successfully fuses a building and situation, a third condition emerges."[25] These considerations have been captured through a design methodology motivated by a collage-making process, drawing on themes and techniques of the Cubists and related artists.

Le Corbusier, *Le
Taureau Trivalent*
(1958)

LE CORBUSIER

Observe with what tools man experiences architecture – thousands of successive per-
ceptions creating his architectural sensation. His stroll, his moving around is what
counts, the driving force behind the architectural happenings. The die is therefore not
cast on a fixed point, one that is central, ideal, rotary and with circular vision all at the
same time.[26]

Le Corbusier describing the experience of Ronchamp,
in *Textes et dessins pour Ronchamp*, 1965

Le Corbusier was greatly influenced by the Cubists' re-conception of space and form through simultaneous perspective. When the Swiss architect settled in Paris in 1917, Cubism was in its seventh year following the first written account in *The Architectural Record*. As an artist working in painting, sculpture, and collage in conjunction with his architectural practice, Le Corbusier formed a response to Cubism in his exhibition with Amédée Ozenfant entitled *After Cubism*. Though they investigated the connection between Cubism and architecture, they sought a more rigorous geometric analysis in the deconstruction of form and a respect for the inherent properties of the objects (specifically weight), and opposed decorative elements found in Cubist works. Le Corbusier and Ozenfant developed Purism as a variant of Cubism, further refining these theories in their magazine *L'Esprit Nouveau* in which they called for a "new spirit of construction and of synthesis"[27] after the disorder of war. The desire to reestablish order is evident in Le Corbusier's system, *Le Modulor*. He was clearly influenced by the work of Juan Gris in the superimposition of regulating lines and grids, reducing objects to simple geometric forms mediated by the established order. Le Corbusier recognized the disconnect between the objectified system of spatial measure and the human experience,

and proposed *Le Modulor* as a system of proportion derived from the dimensions and proportions of the human body. He incorporated this system into a number of built projects in which he employed it to define measurements of the overall massing as well as at the scale of the detail.[28] The proportioning system of *Le Modulor* reappears throughout the two-dimensional artistic work of Le Corbusier, including his collage compositions.

As we consider the role of collage as both a method and a mentality in the work of Le Corbusier, we must consider the legacy of the Cubists and proximate movements in modern art and their adoption of collage as a means of synthesizing unrelated fragments. These collages were often *papiers collés*, constructed in the design process as a prelude to the final fabrication of his

tapestries. He primarily worked in painted newspaper, gouache, and ink, media found in the *papiers collés* of Picasso as well. Le Corbusier utilized collage at two scales: first, in the initial maquettes, and second, in the full-scale cartoons.[29] While documentation primarily points to Le Corbusier's use of collage in the design process for two-dimensional media, the formal content of his collages has clear ties to his architectural work. His collages include an underlying order juxtaposed against fluid lines and forms, employing phenomenal transparency as a means of implying depth in the composition.

Le Corbusier,
Taureau III (1953)

Tate, London / Art
Resource, NY

© 2012 Artists Rights
Society (ARS), New York
/ ADAGP, Paris / F.L.C.

Themes of phenomenal transparency, figure/ground reversal, and simultaneity are significant in architectural works in the Modernist canon, beginning with the work of Le Corbusier. In conjunction with issues of space and measure, Le Corbusier's interest in temporal conditions of simultaneity as investigated by the Cubists[30] is revealed in his artistic and architectural work. Despite the strong Gestalt of Le Corbusier's architecture, simultaneity and transparency are explored in figure/ground dialogues within the architecture itself. There is concurrently a frontality and collapse

of space in his work (like the Cubist compositions) while movement of the viewer is suggested. According to Colin Rowe, "The figure is simultaneously static and set in motion. There is the primary surface of attack, the frontal picture plane, and then, there is the convoluted and serpentine territory which lies behind."[31] The dynamic spatial conditions captured in two-dimensional collage compositions are evident in Le Corbusier's built works of architecture, including Casa Curutchet (discussed in Part 2), Villa Stein, and the Unité d'Habitation.

Robert Slutzky described the "exploration of metaphor and collage in Le Corbusier's urban projects and buildings of the late twenties and after."[32] Both Villa Stein in Garches, France (1927) and the Unité d'Habitation in Marseilles, France (1952), though completed decades apart and at vastly different scales, reveal themes of phenomenal transparency. They both exemplify a spatial compression through frontal perception, and require the active engagement of the occupant in interpreting the spatial complexities. In *Transparency*, Rowe and Slutzky compare Villa Stein with Walter Gropius's Bauhaus, which makes use of literal, rather than phenomenal, transparency. Their analysis of Villa Stein identifies a juxtaposition between the perceived layering of spaces implied from the exterior, the frontal view of the house and the planimetric stratification of spaces, which seems to run perpendicular to what is expected. An understanding of the interlocking spaces requires movement of the observer – a corollary to the observation of a Cubist collage in which the motion of the observer is implied through simultaneous viewpoints. An ambiguity of spatial hierarchy through a subtle "gridding of space," placing the background, middleground, and foreground in flux, "will then result in continuous fluctuations of interpretation."[33]

Like Villa Stein but on a much larger scale, the Unité d'Habitation shows the influence of Le Corbusier's artistic investigations in testing systems of proportion juxtaposed against sculptural forms. Bernhard Hoesli, who was Le Corbusier's project architect for Casa Curutchet in Argentina, was then appointed project architect for the Unité d'Habitation. The modularity and repetition necessitated by a large-scale multi-family structure is disrupted through the integration of public spaces and other programmatic elements. The "vertical garden city" concept permits a manipulation of space and form through the fragmentation and overlap of program. Parallels can again be drawn with the collages of Juan Gris, as figures are fragmented and integrated into the field condition within a system of geometrically inscribed order. The multivalence of space and form through the integration of idiosyncratic elements is perhaps most evident in the roof terrace, a surface populated with and interpenetrated by numerous sculptural figures. The connection between the work of Le Corbusier and the Cubists is captured in a photograph of Picasso's visit to the Unité d'Habitation with Le Corbusier and Bernhard Hoesli upon its completion in 1952, evidence of their personal and professional relationship, published in Le Corbusier's *Oeuvre Complete*.

The Cubists recognized and tested the value of relational qualities over those of individual objects in their collage-making, followed shortly thereafter by Le Corbusier. His artistic and architectural work, like that of the Cubists, experimented with themes of phenomenal transparency, ambiguity of figure and field, distillation, and synthesis which subsequently impacted the collage-making, design, and pedagogy of Bernhard Hoesli and many others.

Bernhard Hoesli,
XLVII: Untitled
(1976–81)

BERNHARD HOESLI

So a collage is not only meant as an object, something made, a result, but what is perhaps far more interesting: a process. Moreover, that behind this way of doing something which as a result then leads to a collage, the collage could be meant as an attitude of mind.[34]

<div align="right">Bernhard Hoesli, Lecture, May 2, 1983, Bern</div>

Bernhard Hoesli was a Swiss architect and educator for whom collage played a central role. He is best known for his pedagogical innovations at the University of Texas at Austin in the 1950s. His experiences leading up to this dynamic period in architectural education profoundly influenced his pedagogical intent. After receiving his degree in architecture from ETH Zürich in 1944, Hoesli studied painting in Fernand Léger's studio in Paris. Léger, originally trained as an architect, joined a number of other artists in Paris to create a version of Cubism (concurrent with the development of Cubism by Picasso, Braque, and Gris) called the *Section d'Or*, or Golden Section. Léger's paintings became increasingly abstract, referencing mechanisms through discrete geometric forms.[35] Evidence of this geometric abstraction is found in Hoesli's collages. Hoesli was soon accepted as an assistant at Le Corbusier's studio, eventually supervising the design and construction of Casa Curutchet in La Plata, Argentina, and Unité d'Habitation in Marseilles. In 1951, Hoesli moved to the United States where he joined the faculty of the University of Texas at Austin. He and colleagues Colin Rowe, Robert Slutzky, John Hejduk, John Shaw, and Werner Seligmann (among others) came to be known as the Texas Rangers. Hoesli aided in the development of Rowe and Slutzky's concept of phenomenal transparency in the essay *Transparency* (1955). UT Austin incorporated this concept into the architectural curriculum. Students completed exercises in which Cubist paintings were diagrammed in order to apply underlying formal properties to design problems. Rowe's equally influential book *Collage City* (with Fred Koetter) built upon this theoretical framework, proposing collage as a metaphor to critique a unified vision for city planning and instead advocating a multivalent approach.

According to Alexander Caragonne, a student of Hoesli, "Hoesli's interest in the relationship between analytical cubism and modern architecture led him to propose that space – architectural space – was the basic, irreducible phenomenon that united the apparently disparate work of Wright, Mies, and Le Corbusier."[36] For Hoesli, transparency was a requisite characteristic of modern architecture – the ambiguity of figure and field initiated by the Cubists and further interrogated by subsequent art movements served, not as a means of fracturing, but a means of synthesizing.[37] Hoesli noted the importance of an acknowledgment of temporal conditions and transformation, as, like Rowe in *Collage City*, "collage was a metaphor for the palimpsest of time."[38] Hoesli was invested in the concept of phenomenal transparency and its place as a defining characteristic of modern architecture and wrote a substantial commentary in the 1964 edition of Rowe and Slutzky's *Transparency*.[39] In this commentary, Hoesli points out that the value in abstract painting and sculpture as scaleless (or 1:1 scale) objects is that it serves as an immediately tangible way to investigate architectural space.[40] Hoesli saw phenomenal transparency as a tool for formal and spatial ordering and the graphic representation of this ordering – evident in his untitled collage from 1966. This collage reveals a constantly shifting figure and field in the black rectangles delimiting the circular central figure. Hoesli understood form as "an instrument for design,"[41] rather than an end in and of itself or the mere outcome of a design process – as such, phenomenal transparency became the operative mechanism for this method. Collage became the medium by which to interrogate form as process.

Bernhard Hoesli,
XXVI: Untitled
(1966)

For Hoesli, collage served as a means by which to test these themes, informing both his professional practice and his pedagogical approach.[42]

The interest in process over product is evident from Hoesli's earliest collage-making in the 1960s, in which he utilized found materials with a focus on their haptic qualities. These collages resembled Art Informel, which describes a form of art utilizing improvised or informal and gestural methods for the creation of abstract art. Precisely cut orthogonal fragments are often juxtaposed against torn, irregular fragments. As we will see, the collages of Richard Meier follow similar methods and result in a similar aesthetic. The use of highly tactile, weathered materials speaks to Hoesli's interest in the role of time and chance in the design process.[43] A number of his collages reveal time in their creation – constructed and reworked over a period of years. Hoesli commenced the collage *As Tuerli* in October of 1976 in Paris, working on it over a number of days in October – the notations on the back of the collage state that Hoesli viewed

the collage as finished on two different dates in October, only to recommence work on it in November. Six years later he gave the collage to his daughter, reworking it for a final time in 1982, at which point Regina declared it complete.[44]

Hoesli's collage-making throughout his career demonstrates an evolution towards more gestural execution, revealing evidence of process. Drawn lines and sketches in the collages were a response to his renewed interest in Cubism after a visit to the 1966 Picasso Exhibition in Paris.[45] Hoesli's early collages, while abstract, begin to suggest landscapes embedded with architectural form, implying a sense of scale. John Shaw, a member of the Texas Rangers, observes: "The intricacies of Hoesli's surfaces involve diverse assemblies and organizing structures, and bring to mind the characteristics of extended, partially man-made landscapes."[46] In these compositions suggestive of site, there

Bernhard Hoesli, *Amsterdam* (1965–72)

is an ambiguity and multivalence in the reading of both compressed frontality and three-dimensional space. Shaw also points out that: "Many [compositions] read as perspectival landscapes with insistent horizons, yet a tendency to flatten challenges the perception of deep space."[47] The collapse of space within the compositions suggests a response to the spatial investigations of Cubist collages and the paintings, collages, and architecture of Le Corbusier.

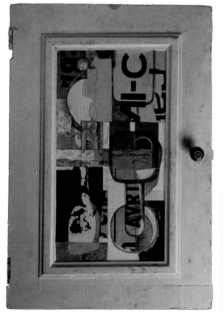

Bernhard Hoesli, *As Tuerli* (1976–82)

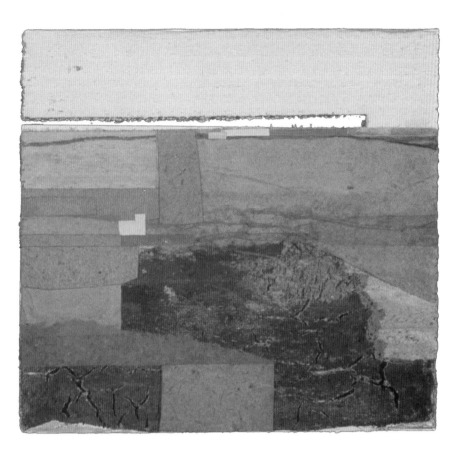

Bernhard Hoesli,
Santa Eulalia, Ibiza
(1963)

Despite the influences of Cubism, the majority of Hoesli's collages remained abstract. In contrast with the collages of the Cubists and Le Corbusier, there are no recognizable forms – rather the compositions were used to investigate formal and spatial relationships divorced from scale. Spatial conditions investigated through the use of phenomenal transparency are evident in the figure/ground ambiguity in collages such as *Menorca No. 2*, in which the composition and layering of materials imply various scales and depths of overlapping planes. The substrate for Hoesli's collages will, according to Shaw, "frequently be exposed as defined shapes trapped between other materials in the composition, creating a reversal of figure and ground."[48] The central figure of collaged newsprint appears simultaneously as a foregrounded figure on a blue and white field, and a fragment of a newsprint background visible through apertures in the blue and white foreground. In this composition, it is impossible to identify and define space as negative or positive.

At a much larger scale, Hoesli constructed a collage on the retaining wall of his Zürich residence. He worked on this composition from the 1970s until his death in 1984, conscious of the effects of time and chance that differentiate such a project from a small-scale paper collage: weathering and vandalism. Mark Jarzombek, a student of Hoesli at ETH Zürich, observes: "This self-conscious embedding of collage in the temporalities of its production paralleled Hoesli's idea that the broad flow of history

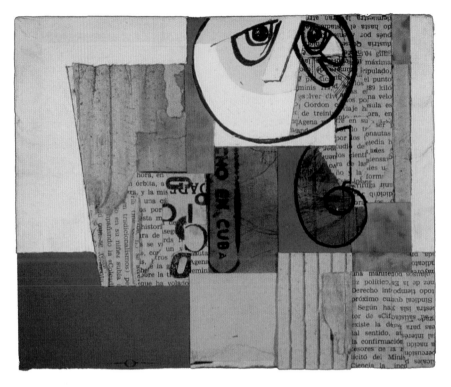

Bernhard Hoesli,
Menorca No. 2
(1966)

on the one hand and the existential dimension of human time on the other hand were always translations of one into the other."[49] Effects of time and chance were critical to Hoesli in his collage-making, architecture, and pedagogy.

Hoesli pursued investigations of spatial overlap and phenomenal transparency throughout his career, focusing on its relevance to design method.[50] He articulated his interest in the dialogue between figure and ground, stating:

> "Solid and void are similarly constituted in the overall spatial continuum. Space within a building and space between buildings are parts of the same medium, the same totality. This dualistic spatial concept of a *figure–ground continuum* [emphasis added] in which building and space are complementary manifestations of an entirety, is – as practically every planned or built example shows – the modern space concept."[51]

Bernhard Hoesli,
Retaining Wall
(1970s–84)

The architectural work of Bernhard Hoesli remains largely unpublished. He left UT Austin in 1959, returning to Zürich where he became a professor at ETH (and eventually Chair of the Architecture Department). He also shared an architectural practice in Zürich with Werner Aebli. An image of a house designed by Hoesli and Aebli for Dr. A. S. Reynolds in Switzerland was published

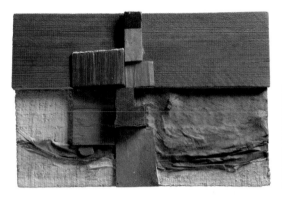

Bernhard Hoesli, *Santa Eulalia del Rio, Ibiza* (1963)　　Diagram of Bernhard Hoesli's Reynolds House (1961–64)

in a catalogue to accompany an exhibition of his collages. In an evaluation of the impact of Hoesli's collage-making on his architecture, we can compare a collage from 1963 (*Santa Eulalia del Rio, Ibiza*) with the Reynolds House designed concurrently. The collage and the façade both appear to be composed about the horizon, evoking a dialogue between earth and sky through geometric forms linking the two.[52] A richly haptic material palette and ambiguity of form captured in the collage are manifested in the built work. On a conceptual level, the architectural implications of Hoesli's collages speak to the 'givens' of geometries and materials juxtaposed against the idiosyncrasies of program and site.[53] In this, Hoesli was clearly influenced by Le Corbusier's interest in geometric order disrupted by irregular forms. And like Le Corbusier, Hoesli questioned the hegemony of homogenous, mathematical space, recognizing 'architectural space' as an interference in mathematical space that is experienced and defined.[54] The richness of representational and spatial potential in the collages of Bernhard Hoesli is ripe for further interrogation as a satellite to the canon of Le Corbusier, and as artifacts that can stand alone in an analysis of collage and architecture.

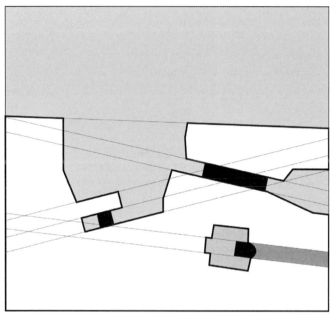

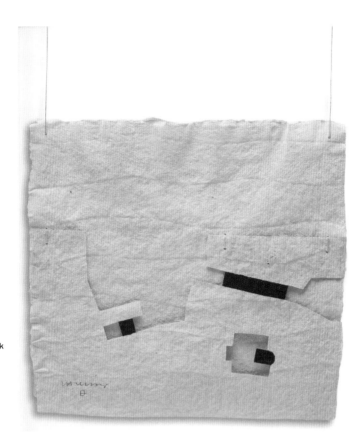

EDUARDO CHILLIDA

Nacen inesperadamente. Un día estando yo trabajando como cualquier otro día. A mí nunca me había gustado la cola. El hecho de pegar los papeles no me parecía el ideal pero nunca se me había ocurrido que se podía solucionar de muchas maneras. De repente pensé: por qué? en vez de pegar estos dos papeles con cola no los unes de alguna manera, los coses con cuerda o con lo que sea? Empecé a darle vueltas, a hacer pruebas, y claro, inmediatamente. Además, me di cuenta de las consecuencias que tenía. En el lugar donde antes estaba la cola metías el espacio. Cómo vas a comparar el espacio con la cola!

Eduardo Chillida, exhibition catalogue for the
Centro Cultural de España Juan de Salazar

They were born unexpectedly. I was working one day; it was a day like any other. I never liked glue. While the act of gluing sheets together didn't strike me as ideal, it never occurred to me that there could exist many other solutions. All of a sudden I thought: Instead of sticking these two sheets together with glue, why not join them in some other way, perhaps with cord or . . . ? I started to turn it over in my mind, of course, immediately I began to experiment. And, I realized the consequences of what I had. Where there was once glue, you had space. As if glue could compare to space![55]

The Spanish sculptor Eduardo Chillida's innovations in collage-making and the implications of three-dimensional space were likely influenced by his architectural education at Colegio Mayor Jiménez de Cisneros in Madrid in the 1940s. An interest in sculpture took him to Paris in 1948 where he began working in clay, then carving in stone and plaster. Although there is no evidence of their interaction, Chillida was working in Paris at the same time as Picasso, Le Corbusier, and the Surrealists, and he was likely influenced by their work. Chillida returned to the Basque region of Spain in 1951 to work with a blacksmith, as ironworking is a traditional trade of the region. Peter Selz observes:

> After returning to the Basque country, Chillida wanted above all to capture and penetrate space rather than occupy it, and primarily for that reason he rejected working with massive blocks of stone or plaster and turned to a ductile material, iron, which when heated sufficiently can be bent to shoot and curve into space.[56]

Chillida's architectural education and the work of the Cubists clearly influenced his conception of space, augmenting a fascination with the dialogue between solid and void. Investigations of this dialogue began to take place through collage and lithographic techniques in 1952, iterative means of testing formal relationships that might ultimately be forged in iron or carved in stone. Like Le Corbusier's Purism, materiality and weight were integral to Chillida's work. He wrote:

> From space
> with her brother time
> under insistent gravity
> with a light to see that I can't see.[57]

Martin Heidegger and Chillida met in 1968, finding a shared interest in issues of space and place. Heidegger subsequently wrote *Die Kunst und der Raum* (Art and Space) in relation to the work of Chillida in 1969. In this essay, Heidegger asserts, "In plastic embodiment the void acts like the searching and projecting establishment of place."[58] Chillida created a series of seven lithographic collages to accompany Heidegger's essay, in which the compositions play with a reversal of figure and field, creating tension between the boundaries of the collage and the figures held within. Boundaries were a significant consideration in Chillida's work as they were for Heidegger. Chillida's focus on space and boundary was further refined by his material investigations, interrogating the capabilities for plaster, alabaster, and iron to delimit space.

Tactility as a consideration in spatial perception is evident in the translation from collage to sculpture to architectural intervention. Chillida's col-

Eduardo Chillida, *Collage beige* (date unknown)

lages include lithographic collages, as seen in *Die Kunst und der Raum*, pasted paper collages, and subtractive paper collages using black and white textured papers, or in some cases, exclusively white paper. In his subtractive collages, collectively termed *Gravitations*, voids were inscribed in the top-most surface revealing layers beneath. The layers of paper are minimally attached, suspended from string. This method of attachment creates an air space between layers to articulate spatial depth through shadow. Chillida called them only *Gravitations*, not collages, since the paper is not pasted – however, these spatial investigations existing at the threshold of two and three dimensions necessitate inclusion in the canon of collage (see p. 43). The spatial implications of his reductive methods of collage-making reveal themselves in his three-dimensional work. Three of Chillida's large scale works demonstrate the value of the void: two works in Spain in collaboration with architect Luis Peña Ganchegui – one additive and one subtractive – as well as an architectural proposal for the Canary Islands. Each project reveals an evolution from collage to three-dimensional inhabitable space, all investigating tension created by boundaries and the definition of the void.

Chillida's most revered work, and the fruition of a life-long dream, is his *Peine de Viento*, ultimately realized in 1975–77. Designs for this site-specific installation in his hometown of San Sebastian began as early as 1952. The installation at the edge of the Bay of Biscay consists of three iron sculptural components in dialogue. Chillida constructed two horizontal sculptures inserted into the dynamic natural landscape. One insertion extends from the cliff towards the ocean, another reaches back from a rocky outcropping towards the cliff, and the third insertion is vertical, occupying the middle ground. The two horizontal sculptures are positioned, according to Chillida, "as if in colonization of the horizon,"[59] while the third is placed on the edge of the town boundary. Heidegger, in *Die Kunst und der Raum*, said, "Sculpture would

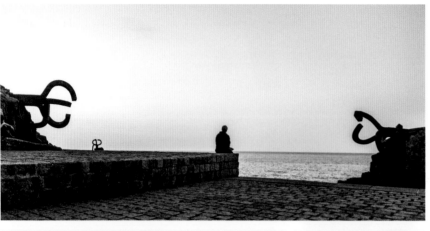

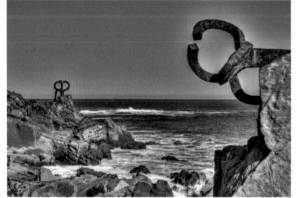
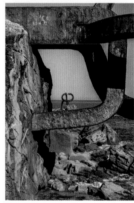

Eduardo Chillida
and Luis Peña
Ganchegui, *Peine
de Viento* (1977)

be the embodiment of places,"[60] and *Peine de Viento* defines this place through sculptural insertions which imply boundaries to the vast context of the ocean while framing the observer's experience of the void. Chillida explains: "Limit is the true protagonist of space, just as the present, another limit, is the true protagonist of time."[61]

In the Basque capital Vitoria-Gasteiz, Chillida and Ganchegui's Plaza de los Fueros (Plaza of Basque Liberties) was completed shortly after *Peine de Viento*, providing public space in a dense medieval city. Chillida's lithographic collages served as a conceptual foundation, particularly those using only two tones to interrogate the perception of solid and void. This investigation continued in his subtractive alabaster sculptures such as *Gasteiz*, a study for the spatial configuration of the plaza. According to Mexican poet Octavio Paz, "The alabaster sculptures do not try to enclose inner space; neither do they claim to delimit or define it: they are blocks of transparencies in which form becomes space, and space dissolves in luminous vibrations that are echoes and rhymes, thought."[62] The resultant form in the full-scale plaza construct embodies similar qualities, at this scale permitting the human occupation and full, bodily experience and perception of the void. Subtleties of scale, perceived boundaries, and spatial overlap offer multivalent experiences within the plaza.

Eduardo Chillida, *Gasteiz* (1975)

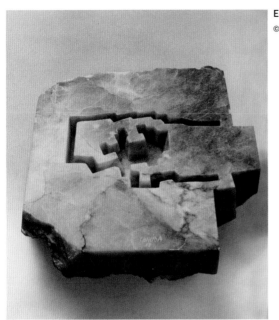

Eduardo Chillida and Luis Peña Ganchegui, Plaza de los Fueros, Vitoria-Gasteiz, Spain (1979) diagram

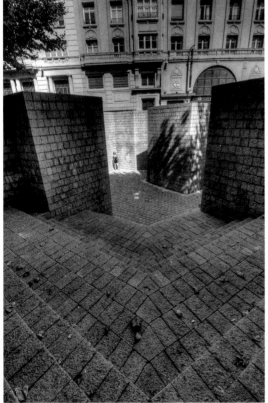

Eduardo Chillida and Luis Peña Ganchegui, Plaza de los Fueros, Vitoria-Gasteiz, Spain (1979)

The third project, a controversial work proposed by Chillida before his death in 2002 to be constructed in Tindaya, Fuerteventura, Canary Islands, has been moving forward thanks to his widow, Pilar Belzunce, and Canary Island authorities. In Chillida's *Tindaya*, he proposed to excavate a 40m cube of rock from inside Tindaya Mountain. This space would be connected to the surface via two 25m high vertical shafts for light and a 15m × 15m entrance tunnel. Although the vast scale of the proposal is unique among Chillida's built work, concepts of spatial overlap and the value of the void continue to be the conceptual motivation. Studies beginning in a subtractive collage process and extending to alabaster sculptures test the subtractive methodology. Similar to his completed large-scale sculptures, the dialogue between Chillida's intervention and its context is vital. He states: "The large space created within it would not be visible from outside, but the men who broke into his heart would see the light of the sun, the moon, inside a mountain facing the sea, and the horizon, unreachable, necessary, non-existent."[63]

In this poetic language we see a complement to the writing of colleagues

Eduardo Chillida, Proyecto Tindaya, Canary Islands (2002) diagram of voids

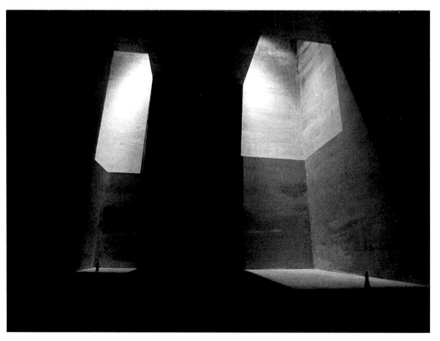

Eduardo Chillida, Proyecto Tindaya, Canary Islands (2002)

Martin Heidegger and Gaston Bachelard. Bachelard wrote an essay for Chillida's first exhibition at Maeght Gallery entitled "The Cosmos of Fire." In another publication by Bachelard, *The Poetics of Space*, he describes how: "In its countless alveoli space contains compressed time. That is what space is for."[64] Spatial and temporal conditions were inseparable and revelatory in the mind and work of Chillida. Ambiguities in the measurement and discernment of time and space point to architecture's relationship to ground as both synchronic and diachronic. In our experience of building and ground, Dalibor Vesely says, "[The fragment] cannot be grasped in a single intuition; it relies on a sequence of stages bringing together individual phenomena and the universal ground in a process that may be described as the restorative mapping and articulation of the world."[65] This simultaneity is what the Cubists were attempting to capture in their collage-making.

Chillida, like Le Corbusier and the Cubists, tested the dialogue between solid and void while inverting the normative value system and hierarchy. The continuity of concept through a spectrum of media and scales – from collage to sculpture to architectonic form – is evidence of this. Chillida has said:

> My whole Work is a journey of discovery in Space. Space is the liveliest of all, the one that surrounds us . . . I do not believe so much in experience. I think it is conservative. I believe in perception, which is something else. It is riskier and more progressive. There is something that still wants to progress and grow. Also, this is what I think makes you perceive, and perceiving directly acts upon the present, but with one foot firmly planted in the future. Experience, on the other hand, does the contrary: you are in the present, but with one foot in the past. In other words, I prefer the position of perception.[66]

In considering this question of perception, we again reference Heidegger who asserts that we understand things in the context of other things, not as separate self-contained objects. Conscious of these interrelationships, weak Gestalt in a work of architecture allows for multiple readings and manipulations, offering new relationships: much like the collages of the Cubists.[67] The ambiguity of space resulting from the dialogue between the intimacy of individual space and the immensity of the landscape (to draw on a concept articulated by Bachelard)[68] offers a wealth of potential in the fragmentary relationships. The occlusion or revelation of these spatial and temporal conditions can be understood through collage. There is an inherent ability for collage to capture qualities of time and a potential for collaged fragments to identify relationships within architecture and between architecture and site, as demonstrated by the work of Eduardo Chillida.

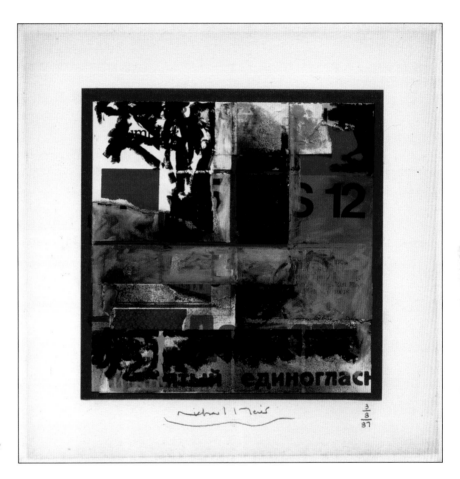

Richard Meier, *S12* (1987)

RICHARD MEIER

Architecture is a long process. The beginning through drawings, through construction, through when it is actually occupied and used. A project takes anywhere from three years to twelve years. Whereas this – [collage-making] – is immediate gratification. For the most part, but not totally, if I do this, I put it down and it's done. But occasionally I'll go back over it, change it and revisit it. And that's a good reason not to frame something. It is more about the moment than about a span of time.

Richard Meier, in an interview with the author

Richard Meier, Pritzker-Prize-winning architect, has been creating collages for over fifty years. An avid painter, Meier began making collages in 1959 after a transition to a small studio space precluded the continuation of his large-scale paintings. Collage became a method for pursuing his interest in two-dimensional compositions. His collage-making accelerated in the 1970s while he was working on the Getty Museum in Los Angeles. He spent significant amounts of time traveling, so he would bring a box of collage materials with him on cross-country flights and pass the time in collage-making. As a personal and meditative ritual, Meier constructed collages directly in books, never intending for them to be framed or even viewed by others. This daily practice is responsible for 160 books of collages and over 4000 loose collages.[69]

Having attended architecture school at Cornell in the early 1960s, Meier was likely influenced by Colin Rowe and Robert Slutzky and their articulation of phenomenal transparency as a conceptual link between modern art and architecture. In his collage work, Meier acknowledges a debt to Cubists Picasso and Braque, and Dadaists Kurt Schwitters and Hannah Höch. Methodologically, Meier draws from Schwitters's appropriation of refuse from daily life, such as bus tickets and food packaging, for use in abstract compositions. Subtler links include De Stijl, Russian Constructivism, and

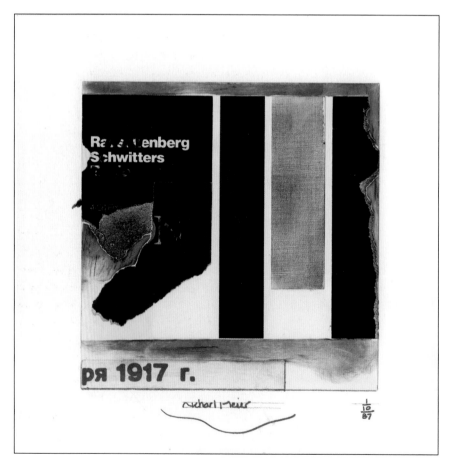

Richard Meier,
*Rauschenberg and
Schwitters* (1987)

the Bauhaus. Marcel Breuer, an instructor at the Bauhaus in the 1920s who moved to the US during the war, opened an office in New York and in the 1960s employed a young Richard Meier. According to Volker Fischer, Curator of the Museum for Applied Art in Frankfurt, Meier's collages reinterpret Constructivist themes while echoing Pop Art collages with their torn edges and advertising fragments.[70]

The material fragments used by Meier have been collected throughout his travels and include postcards, ticket stubs, photographs, and advertisements archived for future use. While incorporating fragments from his travels and experiences, the collages are not meant to document them. Meier attempts to select and compose the paper fragments in such a way as to shed their significance. The temporal displacement occurring as a result of archiving encourages the dissolution of meaning. Fragments may be archived for decades: when they are revisited and considered for use in a collage, their original geographic source and meaning has been lost to memory. Even the text in the paper fragments is divorced from its semantic value. Meier prefers text in other languages and alphabets (such as Cyrillic) for this reason. In some cases, the text becomes a ground that Meier builds off, establishing a grain for the composition. In other cases the text fragments become figural. Meier ultimately selects fragments based on color, texture, and form over meaning, valuing composition over connotation. Like Bernhard Hoesli, Meier's collages are often intuitive and gestural, rather than premeditated. More recently, by his own admission, his compositions have become more intentional. He invests more time in consciously articulating fragment relationships and placement.[71]

Meier's collage-making process is typically founded in the establishment of a few simple parameters. A common parameter in Meier's collages is the module of the substrate. When working on loose sheets, the collages are typically 10 × 10 inch

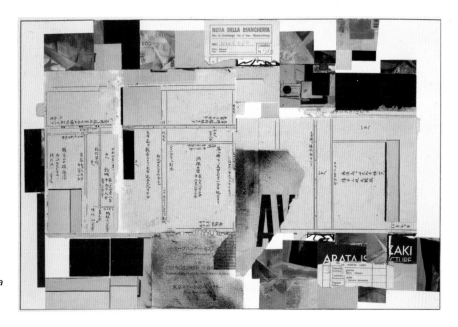

Richard Meier, *Nota della Biancheria* (1992)

or 16 × 16 inch squares. Meier's intent is to avoid a prescribed directionality for the composition based on the initial format.[72] The replicated format, a small square defined and inset within the larger physical boundaries of the paper, was a boundary rarely permeated. A number of Meier's collages recall the dynamic diagonal compositions of the Russian Constructivists, but few (like *Annano Agent* from 1987) selectively puncture the frame. Meier, in retrospect, critiqued this compositional, preferring and returning to the contained compositions.[73]

Meier will often work thematically and serially, setting up a theme to loosely govern a set of collages. For example, he created a series of collages using red to greater or lesser degrees or occasionally bringing in an additional color. In contrast with the white architecture for which Meier is famous, his collages are replete with vibrant colors. According to Lois Nesbitt in the foreword to *Richard Meier Collages*, "A student of postwar Abstract Expressionism, . . . Meier also deletes any explicit thematic strands from the collages, favouring instead juxtapositions of pure colour."[74] Meier confirms this distinction, pointing out that the variable environment in which architecture is embedded offers color to the composition, as the white panels take on contextual hues. The static nature of collage with regard to its engagement with nature requires that the collage itself embody color.

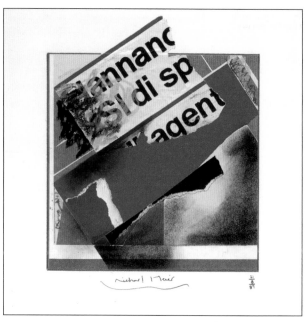

Richard Meier,
Annano Agent
(1987)

Meier often claims that a dichotomy exists between his collages and his architecture. In an interview with the author, Meier makes a distinction between his two- and three-dimensional practices, describing his collage-making as respite from the practice of architecture.[75] Although Meier views the practices as distinct, his formal strategies for composition permeate his works in both collage and architecture. He acknowledges the comparable mentality, in that:

> It has to do with an organizational sense. If one is working on a building for instance, you're organizing spaces in relation to one another. Three-dimensional spaces. In collages I'm also thinking about spaces in a two-dimensional sense . . . about the spatial configuration of the material that you're working with.[76]

Strong genealogical ties exist between Meier and Le Corbusier in their strategies for spatial and material configuration. The juxtaposition of a precise, rectilinear field against fluid figures is common to the compositions of both architects. In an interview with Lois Nesbitt, Meier said:

Richard Meier, *In Pedana* (2005)

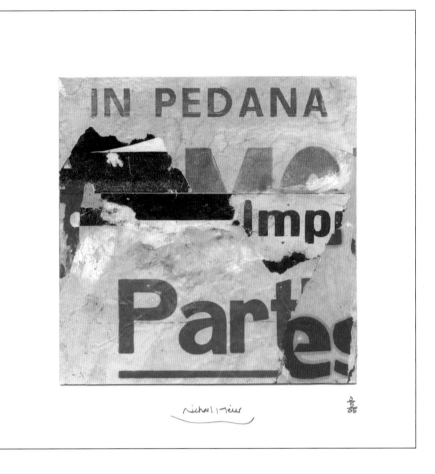

Always, within the collages, there is fragmentation and there is organisation. For the most part there is a rectilinear organization, which is then related perhaps to curvilinear elements, and there's a sense of structure. The structure in the collages is generally based on the material at hand, so although the structure of the buildings is based on perhaps a more clearly defined grid . . . within that there can be fragmentation and a shifting of grids, there are certain formal similarities.[77]

Meier's Smith House, constructed in 1965–67 on a bucolic site overlooking the Long Island Sound, demonstrates clear formal similarities to his collage compositions. Looking specifically at *O4A* from 1987, we see a pure geometric figure suspended in the infinite depth of the canvas, disrupted by irregular fragments that begin to blur the boundaries of the figure. Compared to the augmented distinction between the work of architecture and the landscape in the Smith House, we read an artificial construct – a pure geometric figure – implanted into the existing natural context. Collage-architect Nils-Ole Lund (see Chapter 1.3) constructed a photomontage highlighting Meier's conceptual approach to the dialogue between architecture and landscape in *Arcadia*

from 1985, appropriating an image of the Smith House. Meier articulates a need for the artificiality of architecture to be evident, in order for the architecture to be authentic. It seems that working with the logic of a module like the square reinforces the idea of the artificial: rather than ignoring the richness of the natural context, the pure white geometries are acting in deference to it. Meier explains:

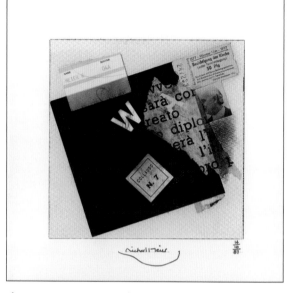

> In my work, I have come to rely more and more on the juxtaposition of that which one makes against that which one does not. This has to do with the play of architecture's inherent artificiality against an unpredictable and dynamic context. I believe that this dynamic quality of natural and urban phenomena is very much a part of man's experience of architecture.[78]

Richard Meier, *04A* (1987)

A subtle shift in compositional strategy occurred, according to Meier's archivist Laura Galvanek, in about 2008 when Meier began to create more reductive collages.[79] Rather than compositions establishing field conditions or objects floating within the field of the canvas, a dialogue between negative and positive space – between field and figure – began to emerge. This dialogue is evident in the collage entitled *Obama* from 2008. The majority of image fragments conform to established grid lines,

Nils-Ole Lund, *Arcadia* (1985)

while voids and irregular forms work in contrast, creating the illusion of depth. Meier strategically employs curvilinear elements as counterpoints to the rectilinear logic, establishing hierarchy in the composition.[80] On one hand, Meier describes the disruption of order as a formal decision within the artifact of the collage or the object of the building. However, he also acknowledges that the site plays an important role in some of these manipulations of order. The Arp Museum in Rolandseck, Germany – exhibiting the work of Dada artist and collagist Jean Arp, completed in 2007 – demonstrates the significant influence that the geometry and other intangible factors of the site had on the resultant architecture. Rather than a self-contained object, Meier created a fragmented composition that interlocks the architectural elements with the escarpment overlooking the Rhine River. In response to this observation, Meier confirmed: "The site is very, very important. Both in terms of its physicality but also its history. So it's not just the nature of the site as you find it, but what it is in terms of its relation to its context is very important. You are making your own context."[81] Comparing his composition strategies for the Arp Museum with his more recent collage work like *Obama*, Meier points out the intentionality of the negative space in some of his more recent collages as compared to the dialogue of solid and void, or openness and closure,

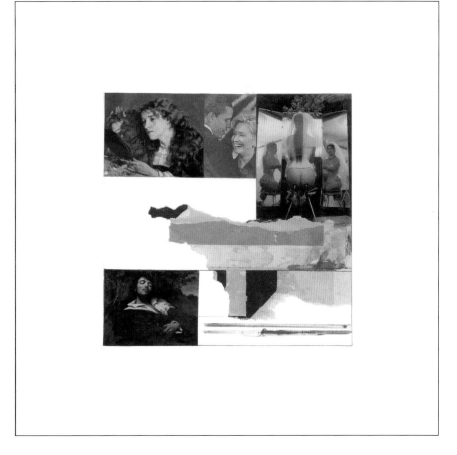

Richard Meier,
Obama (2008)

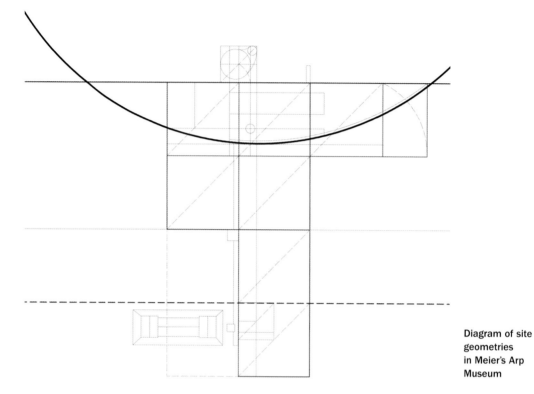

Diagram of site
geometries
in Meier's Arp
Museum

in his architectural work. While there is a cohesiveness and a consistency to the body of work that Meier has created both in collage and in architecture, his tactics for abstraction and composition have slowly evolved. The discreet practices of collage-making and architectural design have witnessed mutual transformation: it is apparent that Meier's architectural design work stimulates his collage-making, while experiments in gestural collage-making inspire his architecture.

Synthesis

There is a thematic consistency across the work of the four designers discussed in this chapter. Each designer explores conditions articulated by Rowe, Slutzky, and Hoesli in their writing on phenomenal transparency. These themes include simultaneity, spatial and material overlap/interpenetration, and juxtaposition of figure/field, background/foreground, and order/disorder found in both their collage-making and built work. These designers acknowledge value in the thickened thresholds and liminal spaces that offer the potential for dialogue between the existing and proposed. Robin Dripps proclaimed: "As the junctures, seams, fissures, and gaps in the figure are revealed, these become significant moments of discontinuity, small hooks grabbing onto the world beyond."[82] Fragmentation and synthesis imbue meaning as a result of context, as the relationships between elements become more important than the objects themselves. Le Corbusier's responses to Cubism demonstrate a development in the composition of shallow space through ambiguity and overlap. A step further towards abstraction and scaleless spatial compositions is demonstrated in the collages of Bernhard Hoesli, anticipating the geometric explorations in the work of Richard Meier. Although Eduardo Chillida was not associated with a particular art movement, his biographer Peter Selz proclaims that the work of Chillida was only possible due to the Cubist reconception of space.[83]

Collage is valued by these designers, as tangible qualities of space and form are heightened and revealed through collage-making. The partial transference, transparency, and layering of materials serves to incite a haptic engagement with the work, provoking a visceral response and a multiplicity of ways in which to interpret this response. The works of architecture resulting from the implication of collage in the design process offer the rich and varied ways the inhabitant might perceive the spatial and material experience of the architecture and landscape.

Notes

1 Douglas Cooper, *The Cubist Epoch* (London: Phaidon Press, 1971), 11.
2 Robin Dripps, "Groundwork," in *Site Matters*, eds. Carol J. Burns and Andrea Kahn (New York: Routledge, 2005), 79.
3 The term collage derives from the French '*coller*' meaning 'glue.'
4 Braque and Picasso were collaborators, working in the south of France; according to some sources, Picasso was the first to use the collage technique in oil paintings, while Braque applied it to charcoal drawings.
5 Christine Poggi, *In Defiance of Painting: Cubism, Futurism, and the Invention of Collage* (Yale Publications in the History of Art) (New Haven: Yale University Press, 1993), 6.
6 Poggi, *In Defiance of Painting*, 123.
7 Diane Waldman, *Collage, Assemblage, and the Found Object* (New York: Harry N. Abrams, 1992), 47.
8 Poggi, *In Defiance of Painting*, 41.
9 Dalibor Vesely, *Architecture in the Age of Divided Representation: The Question of Creativity in the Shadow of Production* (Cambridge, MA: The MIT Press, 2004), 336.

10 Vesely, *Architecture*, 338.

11 Dripps, "Groundwork," 80.

12 Gelett Burgess, "The Wild Men of Paris," *The Architectural Record* (May, 1910), 405.

13 Poggi, *In Defiance of Painting*, 98.

14 Quoted in Bruno Reichlin, "Jeanneret-Le Corbusier, Painter-Architect," in *Architecture and Cubism*, eds. Eve Blau and Nancy J. Troy (Cambridge, MA: The MIT Press, 2002), 218.

15 Isabel Schulz, *Kurt Schwitters: Color and Collage* (New Haven: Yale University Press, 2010), 8.

16 Gwendolen Webster, "Kurt Schwitters's Merzbau," in *Kurt Schwitters: Color and Collage*, ed. Isabel Schulz (New Haven: Yale University Press, 2010), 125.

17 Webster, "Kurt Schwitters's Merzbau," 125.

18 Eve Blau and Nancy J. Troy, *Architecture and Cubism* (Cambridge, MA: The MIT Press, 2002), 2.

19 Two essays by Rowe and Slutzky, "Transparency: Literal and Phenomenal" and "Transparency: Literal and Phenomenal . . . Part II" were written in 1955 and 1956, however the first essay was not published until *Perspecta*, Vol. 8 (1963), the second in *Perspecta*, Vol. 13/14 (1971).

20 Colin Rowe and Robert Slutzky, *Transparency* (Basel: Birkhäuser, 1997), 23.

21 Steven Holl, *Intertwining* (New York: Princeton Architectural Press, 1996), 12.

22 Gestalt theory addresses unity of form, clarity in organization, and relationship of parts to define a whole.

23 Juhani Pallasmaa, "Hapticity and Time: Notes on Fragile Architecture," *The Architectural Review* (May, 2000), 78–84.

24 Martin Heidegger, "Building Dwelling Thinking," *Poetry, Language, Thought*, translated by Albert Hofstadter (New York: Harper Colophon Books, 1971).

25 Steven Holl, *Anchoring* (New York: Princeton Architectural Press, 1989), 9.

26 Yves Bouvier and Christophe Cousin, *Ronchamp: Chapel of Light* (Paris: Besançon, CRDP, 2005), 12.

27 William Curtis, "Le Corbusier: nature and tradition," in *Le Corbusier Architect of the Century* (London: Arts Council of Great Britain, 1987), 16.

28 The *Modulor* proportioning system governs the spatial organization of the Unité d'Habitation, an 18-story housing complex in Marseilles, France completed in 1952 to provide housing for people displaced during the war. This proportioning system is evident at the scale of the building as a whole as well as the spatial organization of the individual apartments.

29 Cristopher Green, "The architect as artist," in *Le Corbusier Architect of the Century* (London: Arts Council of Great Britain, 1987), 130.

30 This theme was also reinterpreted in the collages of the Dada, Bauhaus, and Constructivist movements after World War I, serving as precedent for Corb's artistic pursuits.

31 Colin Rowe, "The provocative façade: frontality and contrapposto," in *Le Corbusier Architect of the Century* (London: Arts Council of Great Britain, 1987), 26.

32 Blau and Troy, *Architecture and Cubism*, 4.

33 Rowe and Slutzky, *Transparency*, 41.

34 Christina Betanzos Pint, "Introduction," in *Bernhard Hoesli: Collages*, ed. Christina Betanzos Pint (Knoxville: University of Tennessee Press, 2001), 1.

35 While Léger primarily worked in oil paint, *Untitled* from 1925 is evidence of his use of collage.

36 Alexander Caragonne, *The Texas Rangers: Notes From an Architectural Underground* (Cambridge, MA: The MIT Press, 1995), 320.

37 Mark Jarzombek, "Bernhard Hoesli: Collage/Civitas," in *Bernhard Hoesli: Collages*, ed. Christina Betanzos Pint (Knoxville: University of Tennessee, 2001), 5.

38 Jarzombek, "Bernhard Hoesli: Collage/Civitas," 8.

39 Hoesli translated *Transparency* into German for publication in the 1960s.

40 Bernhard Hoesli, "Commentary," in *Transparency*, eds. Colin Rowe and Robert Slutzky (Basel: Birkhäuser, 1964), 58.

41 Hoesli, "Commentary," 87.

42 John P. Shaw, "Hoesli Collages," in *Bernhard Hoesli: Collages*, ed. Christina Betanzos Pint (Knoxville: University of Tennessee, 2001), 13.

43 Pint, "Introduction," 1.

44 Jarzombek, "Bernhard Hoesli: Collage/Civitas," 6.

45 Jarzombek, "Bernhard Hoesli: Collage/Civitas," 4.

46 Shaw, "Hoesli Collages," 15.

47 Shaw, "Hoesli Collages," 14.

48 Shaw, "Hoesli Collages," 14.

49 Jarzombek, "Bernhard Hoesli: Collage/Civitas," 6.

50 Shaw, "Hoesli Collages," 15.

51 Caragonne, *Texas Rangers*, 383.

52 Jarzombek, "Bernhard Hoesli: Collage/Civitas," 3.

53 Shaw, "Hoesli Collages," 15.

54 Hoesli, "Commentary," 90.

55 Translation by Sheryl Bridges.

56 Peter Selz and James Johnson Sweeney, *Chillida* (New York: Harry N. Abrams, 1986), 11.

57 Museo Chillida Leku. www.eduardo-chillida.com

58 Selz, *Chillida*, 116.

59 Selz, *Chillida*, 120.

60 Martin Heidegger, "Art and Space." *Poetry, Language, Thought*, translated by Albert Hofstadter (New York: Harper Colophon Books, 1971).

61 Selz, *Chillida*, 116.

62 Selz, *Chillida*, 42.

63 Eduardo Chillida, Tindaya Project website. www.tindaya.org

64 Gaston Bachelard, *The Poetics of Space* (Boston: Beacon Press, 1969), 200.

65 Dalibor Vesely, *Architecture*, 334.

66 Eduardo Chillida, Wikipedia. http://en.wikipedia.org/wiki/Eduardo_Chillida

67 Juhani Pallasmaa, "Hapticity and Time: Notes on a Fragile Architecture," *The Architectural Review* (May, 2000): 78–84.

68 Bachelard, *The Poetics of Space*, 8.

69 Richard Meier interview with author, March 14, 2012.

70 Volker Fischer, *Richard Meier: The Architect as Designer and Artist* (New York: Rizzoli, 2003), 16.

71 Richard Meier interview with author, March 14, 2012.

72 Richard Meier interview with author, March 14, 2012.

73 Richard Meier interview with author, March 14, 2012.

74 Lois Nesbitt, *Richard Meier Collages* (London: St. Martin's Press, 1990)

75 Richard Meier interview with author, March 14, 2012.

76 Richard Meier interview with author, March 14, 2012.

77 Nesbitt, *Richard Meier Collages*, 13.

78 Richard Meier, "Essay," *Perspecta*, Vol. 24 (1988), 104–105.

79 Richard Meier interview with author, March 14, 2012.

80 Nesbitt, *Richard Meier Collages*, 10.

81 Richard Meier interview with author, March 14, 2012.

82 Dripps, "Groundwork," 78.

83 Selz, *Chillida*, 115.

1.2 Collage-drawing

Collage-drawing can be defined as a sub-set of collage in which select fragments of color, texture, or image are combined with line, exploiting the canvas as a three-dimensional (potentially infinite) space. The plasticity of space plays a primary role in collage-drawing compositions. Artists and architects working with the medium of collage-drawing share a common interest in constructing a sense of order. Construction, in contrast with composition, motivates these designers. The construction of order can be delineated in one of two ways. First, geometric order can be constructed through formal means. Second, social order can be constructed conceptually through narrative means, framing utopic or dystopic conditions. Architects employing collage-drawing are organized by this dichotomy in the following survey.

Artists and architects who construct collage-drawings employ pasted paper or photographic materials in conjunction with additional media such as charcoal or

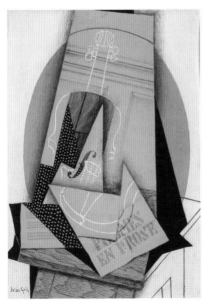

pencil. The addition of such media permits the creation of lines and/or fields as a means of synthesizing collage fragments. Line also establishes depth, a response to the collapse of space common to Cubist compositions. These methods have their genesis in the Cubist *papiers collés* of Braque and Gris, which often demonstrate sparing use of collage combined with charcoal and/or pencil line drawing. In works such as Juan Gris's *Composition with Violin*, the use of line in conjunction with collage fragments serves as a means to disassociate object profiles (line) from their materiality (collage fragments).

An attention to craft and construction is a common theme in collage-drawing, and precedent can be found in Braque's

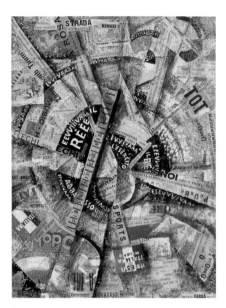

Carlo Carra, *Interventionist Manifesto, or Paintings – Words in Liberty* (1914)

© 2012 Artists Rights Society (ARS), New York / SIAE, Rome

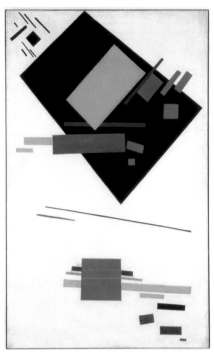

Kazimir Malevich, *Suprematist Painting (with Black Trapezium and Red Square)* (1915)

papiers collés which show evidence of pencil markings and pin-holes.[1] Artists inspired by Cubism and motivated by the political and social tensions that came to a head with the onset of World War I developed subsequent movements including the Russian Avant-Garde, Italian Futurism, and De Stijl. An overview of these developments in the abstraction of space and form through construction provides a critical framework for the work of architects discussed in this chapter.

Prioritizing construction over composition owes much to the Russian Avant-Garde, which offered an almost instantaneous response to Cubism. The period of instability leading up to the Russian Revolution of 1917 was accompanied by a remarkable period of artistic experimentation, which questioned the fundamental properties of art and challenged its role in a new society. Beginning with Russian Futurism (1912–19), artists were influenced primarily by Cubism and Italian Futurism. The use of geometric abstraction conveyed the speed and dynamism of modern life, often through radial gestures and diagonals.

Suprematism (1915–19), founded by the artist and theoretician Kazimir Malevich, looked at fundamental geometric forms, primarily the circle and the square. This interest in geometric purity and order serves as a corollary to the pursuit of the establishment of a new social order. Formally, these movements stem from the geometric abstractions of the Cubists. In Cubist work, according to Hal Foster, "value, signification, was manifestly produced, and produced out of material difference; and in the materiality signification was shown to be involved, dialectically, with other social, political, and economic domains. Constructivism developed these insights in theory

and practice."[2] Malevich began to produce collages only two years after Picasso's first collage in 1912. The work of Malevich exhibits a clear influence of Cubism, though his work tended towards further geometric abstraction. Futurism and Suprematism built the foundation for Constructivism, which developed in 1919 as a result of the social upheaval caused by the Russian Revolution. In Russian Constructivism (1919–34), artists had industrial or functional goals, desiring a social relevance for art and design. Their work was highly politicized with the intention of directing art towards a social purpose in order to demonstrate the ideals of a new society. The Constructivists compared the artist to an engineer, arranging materials scientifically and objectively and producing art works as rationally as any other manufactured object.

In *Realistic Manifesto* from 1920, a critique of Cubism and Futurism for not being avant-garde enough, the motivation of the Constructivists is identified: "The realization of our perceptions of the world in the forms of space and time is the only aim of our pictorial and plastic art . . . We affirm depth as the only pictorial and plastic form of space."[3] Constructivist collages were dominantly formal, scale-less studies, with layered and intersecting forms. Dynamic compositions were

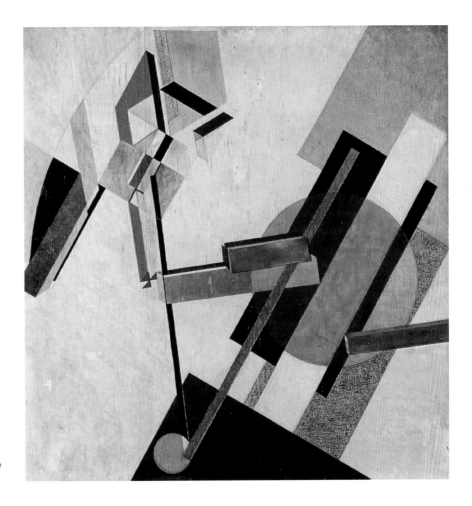

El Lissitzky, *Proun 19D* (1922)

achieved through diagonal emphasis, and through the conception of the canvas as an infinite space. Despite the formal abstractions of the Russian Avant-Garde, materiality was highly considered with an emphasis on construction over composition. El Lissitzky, who helped found Suprematism with his mentor Malevich, gave a lecture in 1921 in which he asserted: "MATERIAL ACQUIRES FORMS IN CONSTRUCTION."[4] Following this theoretical and practical interest in materiality, Constructivists working in collage

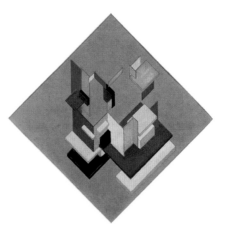

Theo van Doesburg, *Color Construction* (1924) – De Stijl artists in the Netherlands were working with similar methods at the same time as the Russian Constructivists.

often used precisely cut paper and metal in conjunction with oils and other media capable of defining precise lines and figures. Cross-fertilization occurred in the early 1920s when Dada, Constructivist, and De Stijl artists, each pursuing geometric abstractions, convened at the Dada-Constructivist Congress in 1922. De Stijl artist Theo van Doesburg, Dada artists Kurt Schwitters, Jean Arp, and Raoul Hausmann, Russian Constructivist El Lissitzky, and Bauhaus artist László Moholy-Nagy attended. Orthographic, isometric, and axonometric representations of space and form were predominant, and perspective was rarely employed.

The work of the Russian Constructivists demonstrates an emphasis on abstract geometric forms and their interaction in mathematical space. Tectonic assembly – the process of construction – was a dominant theme in the work of the Constructivists as well as De Stijl and Bauhaus artists and architects. In *The Line*, written in 1921, A. M. Rodchenko acknowledged: "Form, color, and texture become the material, and are subordinated to the line that determines the entire structure of the construction."[5] The Constructivists looked to science and mathematics in the development of their theories in art and architecture. A thematic thread in this period of artistic experimentation was the relativity of both space and time, stemming from advanced thinking in non-Euclidean geometry. In 1925, El Lissitzky described Constructivism as a "revolution in art begun by giving form to the elements of time, of space, of tempo, of rhythm, of movement."[6]

Many of the Constructivists, including El Lissitzky and father of the Constructivist movement Vladimir Tatlin, were both artists and practicing architects. Alexi Gan, in his 1922 essay "Constructivism," identified three principles of Constructivism:

> [1] tectonics [*tektonika*] – employing industrial materials and systems of assembly, which we can associate with the ready-mades appropriated in collage and assemblage concurrently.
> [2] facture [*faktura*] – revealing the process of fabrication/construction and valuing materiality and texture in the work.

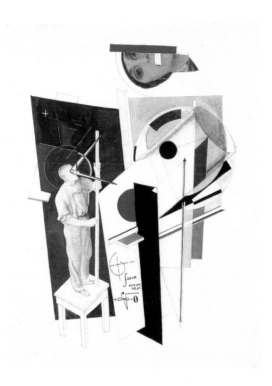

El Lissitzky, *Tatlin at Work* (1921)

[3] construction [*konstruksiia*] – equating the role of the artist/architect with that of the scientist/engineer through an empirically driven process of deriving space and form.[7]

The boundaries between art, architecture, and industrial design were intentionally ambiguous in the work of the Constructivists. Plasticity was of critical concern. At the scale of a work of architecture, this three-dimensional, sculptural consideration of space is achieved through the molding of space and light. In the words of Juhani Pallasmaa, "Architecture must again learn to speak of materiality, gravity, and the tectonic logic of its own making. Architecture has to become a plastic art again to engage our full bodily participation."[8] Plastic space is pervasive in the work of the architects discussed in this chapter, underlying an interest in constructing order whether abstract and geometric or narrative and socio-political.

Constructs: Geometric Order

The architects surveyed in this section have employed collage-drawing as a vehicle for the construction of geometric order. In sharing this conceptual intent, they demonstrate an interest in geometric order defined through precision, minimal collage fragments, and an implication of depth through substantial negative space and layered figures. Mies van der Rohe, Daniel Libeskind, Ben Nicholson, and James Corner are

indebted to the Constructivists for these techniques – specifically El Lissitzky, who created collage-drawings by combining photomontage with colored paper and line drawing. El Lissitzky developed a prolific series of paintings, collages, and assemblages under the nomenclature *Proun* or 'project for the affirmation of the new,' referencing the new society emerging after the Bolshevik Revolution. Here we see an overlap between art and architecture. El Lissitzky described his *Prouns* in an issue of *De Stijl* magazine, saying:

> Proun begins as a level surface, turns into a model of three-dimensional space, and goes on to construct all the objects of everyday life. In this way Proun goes beyond painting and the artist on the one hand and the machine and the engineer on the other, and advances to the construction of space, divides it by the elements of all dimensions, and creates a new, many-faceted unity as a formal representation of our nature.[9]

These collage-drawings represent three-dimensional architectural compositions, emphasizing materiality and depth of space by interlocking simple geometric forms. Lissitzky saw *Prouns* as a mediator between painting and architecture, as maps or designs rather than purely pictorial.

The formal compositional strategies of Constructivists like El Lissitzky inspired the collage-drawings of two Bauhaus artists: Hungarian artist László Moholy-Nagy and German artist Marianne Brandt. The Bauhaus design school in Germany operated from 1919 to 1933, with a similar agenda to that of Lissitzky – to integrate all of the design disciplines. Moholy-Nagy taught the foundations course, and both taught and practiced in a variety of media. In his collage-drawings, Moholy-Nagy used photomontage in conjunction with tonal collage and line drawing to capture the dynamic nature of the modern world. Employing minimal collage components, he typically combined photomontages with pen and ink, leaving significant white space in each composition. He intended to "reconcile art and humanity with the machines of the technological age."[10] A critique or commentary on industrialization and modernization was common to many artists and architects of this era. Moholy-Nagy advocated the engagement of the senses, and often overlooked in the rapid modernization of society which created a barrier to social reform. In *Vision and Motion* he stated: "The remedy lies in the enhancement of our spiritual education by a sensory education, a nurturing of the senses, by the readiness to articulate senses through the media of artistic expression."[11] His vision for an integration of the authentic, sensory human experience with the modern, mechanized world is evident in his collage-drawings that he termed

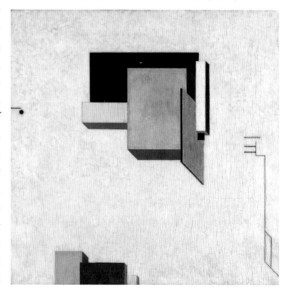

El Lissitzky, *Proun 1C* (1919)

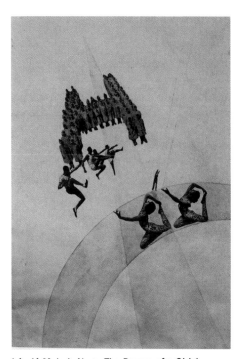

László Moholy-Nagy, *The Dream of a Girls' Boarding* (1925)

© 2012 Artists Rights Society (ARS), New York / VG Bild-Kunst, Bonn

Marianne Brandt, *Me (Metal Workshop)* (1928)

© 2012 Artists Rights Society (ARS), New York / VG Bild-Kunst, Bonn

photoplastics. Moholy-Nagy's *photoplastics*, showing clear formal associations with El Lissitzky's *Prouns*, attempt to reveal an underlying social or personal truth. Diagonal lines imply motion and depth, while tension and spatial dimensions are constructed through a juxtaposition of line and figure.

Marianne Brandt joined the Bauhaus in 1923, and by 1928 was director of the metal workshop, having succeeded Moholy-Nagy. While her designs for mass production – lamps, teapots and so on – were publicly successful, her collages were typically not intended for public viewing. Her techniques and materials were very similar to Moholy-Nagy's, developing a dynamic composition through radial organization, and employing minimal layering of figures and text with outliers. Similarities exist between her industrial design and her collage-drawing approach to composition – in both we can see a reduction to simple construction of geometric forms. The role of plasticity, investigating reductive geometries and their interrelationships in the infinite space of the canvas, was paramount to the design process of the Constructivist, Bauhaus artists and architects, as well as the architects who have incorporated collage-drawing into their design methodologies.

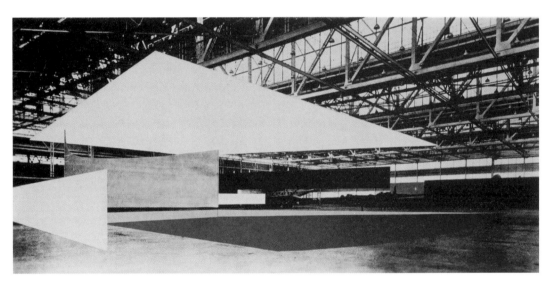

Mies van der Rohe, *Concert Hall proposal* (1942)

MIES VAN DER ROHE

The long path through function to creative work has only a single goal: to create order out of the desperate confusion of our time.

Mies van der Rohe

Mies van der Rohe, a German architect and a critical player in the birth of Modern Architecture, developed collage-drawing techniques in parallel with the aforementioned artists beginning in the 1920s. He attended the First International Dada Fair in 1920 and soon after met De Stijl founder Theo van Doesburg and Russian Constructivist El Lissitzky. In the early to mid 1920s, he was involved in the magazine *G* (short for *Gestaltung*, translated as composition or creation) that was edited by Dada artist Hans Richter and included collaborators El Lissitzky and Kurt Schwitters. (Mies and Schwitters would become life-long friends.) *G* brought together the art and theory of Dada, De Stijl, and Constructivism with a shared interest "in modern constructive form, including buildings, aeroplanes, cars and town planning, and it drew into its orbit film and photomontage."[12] Existing in this social sphere in Berlin in the 1920s also brought Mies into contact with other Dada collage artists including Raoul Hausmann and Hannah Höch. From 1930 until 1933 Mies served as the Director of the Bauhaus, inheriting the legacy of fellow collagists László Moholy-Nagy and Marianne Brandt who had recently left the school. Ultimately, Mies was forced to close the Bauhaus in 1933 due to Nazi pressure. Realizing that design opportunities were continuing to decline in Germany, Mies emigrated to the US in 1937. He spent the rest of his life in Chicago where he served as head of the architecture school at the Illinois Institute of Technology and created some of his most notable works including the Farnsworth House (1946–51) near Chicago and the Seagram Building (1958) in New York. Frequent visits to New York during the design and construction of the Seagram Building provided the opportunity for Mies to organize an exhibition of the collage work of Schwitters at Sidney Janis Gallery in New York in 1959. Mies had not previously been a collector of art, but at this time acquired a number of Schwitters collages and a Picasso painting. The ordering of unrelated fragments in collage-making is a thematic correlation between the collages in Mies's personal collection and his own design process, represented by his call for order in a chaotic world. Mies utilized collage in early compositional design studies as well as perspectival representation.

The tectonic legibility of Mies's work relates to the themes of pure form and skeletal visibility expounded in *G*. Van Doesburg once described Mies as an "anatomical architect."[13] A characteristic of De Stijl design was to allow vertical and horizontal elements, in two- or three-dimensional compositions, to literally or phenomenally bypass each other. Abstraction played a critical role by exploiting the geometric potential of points, lines, and planes. Mies used abstract spatial constructions and an ambiguity of figure and field in his proposal for the Brick Country House, and eventually realized these concepts in the German Pavilion in Barcelona. In each, materiality was prioritized. In an emphasis on construction, Mies said that: "Architecture begins when two bricks are placed carefully together." Collage provided a means of interrogating

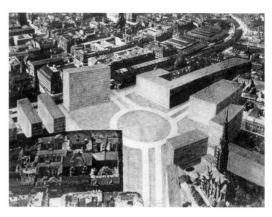

Ludwig Mies van der Rohe, *Alexanderplatz proposal* (1928) Köster, Arthur

Photocollage of a model for the competition for the urban renewal of Alexanderplatz of 1928–29, Berlin, 1928 or later

© 2012 Artists Rights Society (ARS), New York / VG Bild-Kunst, Bonn

Collection Centre Canadien d'Architecture / Canadian Centre for Architecture, Montréal

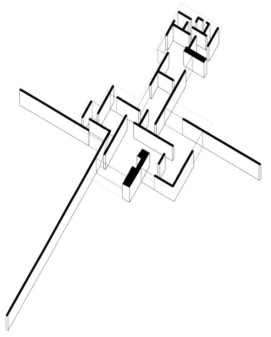

Axonometric diagram of Mies van der Rohe's Brick Country House (1924)

materiality in the design process. His interior perspective drawing for the German Pavilion in which materials were selectively rendered anticipated his ensuing collage-drawings. Like the rendering, his collage-drawings would be built from constructed perspectives which prioritized line and valued negative space, while applying minimal collage fragments.

The project that brought Mies to the US in 1937 was the Resor House, a proposal – ultimately unbuilt – for a vacation home in the mountains of Wyoming. Alfred Barr, Jr., the first director of the Museum of Modern Art in New York, recommended Mies to the Resors, who were trustees of MoMA at the time. Inhabiting a dynamic natural setting, the proposed home would straddle a creek framing views of the mountains beyond. In the collage-drawings for the proposal, there is a reductive quality to the architecture itself while the landscape being framed is articulated as a figure in the composition. The perspective maintains the spatial relationships but hierarchy is transformed: architecture and landscape are juxtaposed, and background and foreground are inverted.[14] Dan Hoffman argues: "The importance of Mies's drawing-photographs lies in the manner in which differing means of signification are used to challenge the symbolic and spatial meanings of a project relative to its context."[15] There is a tension rather than a seamlessness between architecture and landscape in the American collages. The architecture

Ludwig Mies van der Rohe, Farnsworth House (1946–51) foregrounding the landscape

Glaeser, Ludwig

View of supporting structures of Farnsworth House with trees in background, Plano, Illinois, United States, April 30, 1978

Collection Centre Canadien d'Architecture / Canadian Centre for Architecture, Montréal

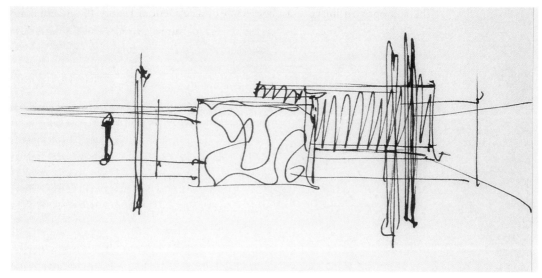

Ludwig Mies van
der Rohe, *Museum
for a Small City*
published in
*Architectural
Forum* (1943)

Mies van der Rohe,
Ludwig

Interior study with
partition, painting,
columns and sculpture
for the "Museum for a
Small City," 1941–43

© CCA, Montréal/Lohan
Associates © 2012
Artists Rights Society
(ARS), New York / VG
Bild-Kunst, Bonn

Collection Centre
Canadien d'Architecture
/ Canadian Centre for
Architecture, Montréal

itself becomes the negative space, the ground against which the figures of the interior partitions and exterior framed and encapsulated environment are read. This concept is manifested in the Farnsworth House, where the architecture of planes and columns becomes a neutral frame, foregrounding the landscape.

The dialogue between architecture and context presented in the Resor House proposal continued to be of interest to Mies, as, according to Detlef Mertins, he "gradually developed a distinctive idea about combining painting, sculpture, architecture, and landscape."[16] In 1941, Mies was asked to contribute to the design of an ideal American post-war city, to be published by *Architectural Forum* in 1943. The collage proposal places Picasso's *Guernica* against a backdrop of natural elements, implying a context in flux. The collage is constructed in greyscale images, referencing the lack of color in *Guernica*.[17] The design consists of a free plan allowing for the works of art themselves to become occupants of the space. Simplicity of form stemming from De Stijl principles allows the composition of floor slab, columns and roof plane to create a covered outdoor sculpture garden. The functional intent was to remove barriers between the community and the art, a concept conveyed through collage-drawing. The dialogue between the architectonic logic, scale figures, and the external landscape can be seen even in his earliest sketches for the project.

Mies's proposal for a Concert Hall in 1942 emphasizes structure and inhabitation over the dialogue between interior and exterior evident in the Resor House and Museum for a Small City. In the collage-drawing created for this proposal, the architecture is foregrounded. However, we can see a conceptual link: the architectural interventions are read against the existing context, in this case a building rather than a natural landscape. The vast structure of the roof establishes a rhythm and module, allowing the walls to be composed freely. Appropriating an existing building as the architectural basis for a proposal is unique among the work of Mies van der Rohe. This collage-drawing is also unique at this point in Mies's career due to its political agenda.

The appropriated image is a photograph of an American factory (by Albert Kahn, 1937) that at the time was being used to manufacture planes to bomb Germany. The first act of collage-making for Mies in this instance was subtractive – to remove the airplanes inhabiting the space of the photograph. Over this manipulated photograph, Mies collaged pieces of colored paper and an image of a sculpture by Aristide Maillol (subsequently replaced by an image of an Egyptian sculpture, for unknown reasons). According to Neil Levine, "War, in effect, is naturalized and aestheticized by the act of collage."[18] The initial excisions and subsequent additions of abstract color planes and a sculptural figure give the space a new value. The meaning and consequences of the activities occurring in the space of the photograph are redeemed through architectural intervention (see p. 71).

The collage-drawings of Mies van der Rohe consistently address an abstract ordering of space through planar configurations. The compositions tend to dematerialize the architecture and reduce the exterior environment to a planar surface, though the Concert Hall provides evidence of enclosure through photomontage rather than exclusively line and negative space. Arthur Drexler claims that Mies's collage-drawings create "a surreal juxtaposition by montage of photographs with flat charcoal or crayon surfaces; these transform ideas into hallucinatory images, beautiful and urgent."[19] Unlike the Constructivists or De Stijl artists, Mies employed perspective – but with a level of abstraction that allows for an ambiguity in the reading of the material and spatial character of the proposals. Within the context of constructing geometric order through the rhythm and repetition of tectonic components, much like the Constructivists, Mies exploited collage-drawing to reveal not only spatial and material qualities of his architectural proposals, but to illustrate a dialogue between the architecture and its natural or built context.

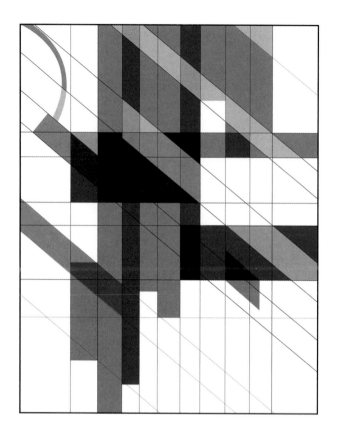

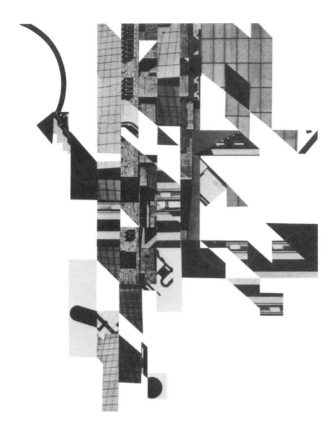

Daniel Libeskind,
*Collage
Architecture –
Structure* (1970)

DANIEL LIBESKIND

Collage challenges the notion of architecture as a synthetic construct – a mixture of various creative disciplines. The idea of achieving such a synthesis by a hollow manipulation of heterogeneous elements can result only in "synthetic flaws" . . . The analytic approach, devoid of multiple means, limited to the existing materials, determined by historical realities, can fashion a new framework for concepts and ideas by releasing us from the determinism in both syntactic and semantic domains. It is a kind of poverty that is being proposed. A poverty of matter to be compensated by the development of the conceptual ideal. The use of "garbage" reveals a possible method which can penetrate beyond the surface appearance of meaning and form, and strike at the very depth of conditioned relations; generating through a new grammar radically different ways of perceiving, thinking, and ultimately perhaps acting.[20]

> Daniel Libeskind, in John Hejduk's *Education of an Architect:*
> *The Cooper Union School of Art and Architecture, 1964–1971*

Daniel Libeskind, American architect and educator, is best known for an architecture of fragmented, angular forms. Libeskind's approach to architectural design demonstrates an experimentation with both the construction and deconstruction of geometric order, which he has tested through collage-drawing. This formal language stems from his education at Cooper Union in the 1960s. In the introduction to *Education of an Architect*, Professor Ulrich Franzen states, "it is the revolutionary work of the early Twenties, focused on Cubism, Neo-plasticism, Dada, and Constructivism – upholding the promise of new life-style options – with which the developments at Cooper Union have reestablished contact."[21] Under the direction of John Hejduk, chair of the Department of Architecture, students were given a series of highly constrained exercises based on "the visual discoveries of Cubism and Neo-plasticism, the very discoveries from which Le Corbusier and the other Paris-oriented early masters constructed their plastic and spatial language," according to Franzen.[22] Hejduk offered an assignment asking students to design a building "in the intention of Juan Gris," considering the overlap between the concepts and works of artists and architects. Themes of the Cubists such as phenomenal transparency as articulated by Colin Rowe and Robert Slutzky would have been integral to this design methodology. In fact, Slutzky was a faculty member at Cooper Union at the time, and played a significant role in the pedagogical agenda. He taught a course in two-dimensional color exercises in which students experimented with space and form through collage. The intent of these exercises was, in his words, to "demonstrate the concept of pure plastic composition."[23] Libeskind was indoctrinated into these theories and methodologies in his undergraduate education at Cooper Union. His thesis project, published in *Education of an Architect* and shown in an exhibition of the same name at MoMA in 1971, was entitled "Collage." In the project, he developed a methodology for transforming collage-drawings into three-dimensional architectural form.

Libeskind's project from Cooper Union resulted in a series of explorations called *Collage Rebus*. This shows the deconstruction and reassembly of architectural plans which then serve as the basis for a three-dimensional, axonometric exploration of space and form. This planimetric reconfiguration is reminiscent of Bernhard Hoesli's actions as a professor at the University of Texas at Austin in which he would cut apart and reconfigure the drawings of his students. (There is also a procedural identification with the collages of artist Robert Motherwell.) Libeskind's collage-drawings utilize a shallow pictorial space like the Cubists, implying depth through the fracturing and displacement of form. These compositions then inform tectonic investigations through axonometric, clearly influenced by the work of De Stijl and Constructivist architects. In *Collage Rebus*, overlayed grids provide the framework for

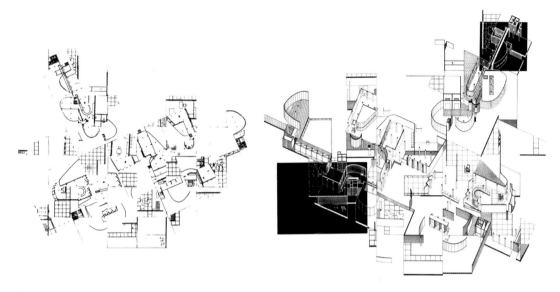

Daniel Libeskind,
Collage Rebus
(1970) – collage
and axonometric

ordering the complex geometries of the drawing fragments – one orthogonal grid, and one rotated 30 degrees counter-clockwise. These geometries are then extrapolated into three-dimensional form via axonometric drawings.

The study of geometric, formal relationships through abstraction occurs through collage-drawings that become generative, offering a multiplicity of spatial interpretations to be tested through axonometry. Libeskind toys with the apparent objectivity of the axonometric by creating drawings which themselves allow for multiple readings based on the ambiguity of spatial referents. This is particularly evident in *Collage Rebus 3*, in which the angled fragments and planimetric rotations are highly reductive. The dynamic spatial configuration is composed primarily through orthogonal displacement.

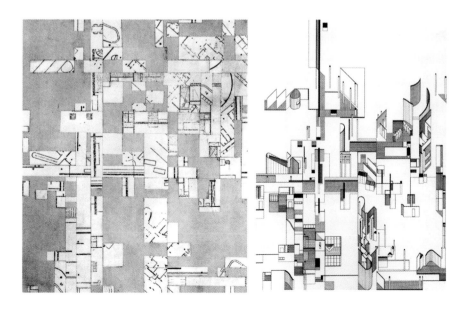

Daniel Libeskind,
Collage Rebus 3
(1970) – collage
and axonometric

Continuing the collage mentality into his post-graduate paper architecture, Libeskind produced two important series of palimpsest drawings: *Micromegas* (1978) and *Chamber Works* (1983). In *Micromegas*, Libeskind created dynamic three-dimensional spatial compositions consisting of fragments that have been reassembled and ordered to construct a synthetic whole. The *Chamber Works* series is further abstracted and more highly synthesized, using line only to imply depth and hierarchy without defining discreet formal fragments. In this series, Libeskind constructs a horizon, a dominant line to serve as an ordering device.[24] The language of line evolved from Libeskind's work at Cooper Union through his *Micromegas* and *Chamber Works* to drive his architectural proposals and built work. Libeskind's proposal for the City Edge Competition in Berlin (1987) conceptually addresses line, while collage techniques play a role in conveying this concept. The physical models constructed for the competition appropriate newspaper text, not for its meaning but rather for its pattern, grain, and capacity to convey the heterogeneous nature of the urban context. This technique is borrowed from the Czech collage artist Jiří Kolář, who coined the term 'chiasmage' to describe this technique. For Libeskind, the text also serves a metaphorical purpose – he understands language as a correlate to architecture. The selection and ordering of fragments, whether words or architectural components, offers meaning with the potential for multiple interpretations. Dailibor Vesely writes: "The visual reality of Daniel Libeskind's drawings is situated very far beyond the reality of cubism, constructivism, or collage, close to the horizon where most of the non-figurative movements of this century fought their last battles and where our imagination is permanently challenged by the inner possibilities of abstraction."[25]

Jiří Kolář, *Untitled (With Picasso's Glass and Bottle of Suze, 1912)* (1984) and Daniel Libeskind, *Berlin Cloud-prop* (1987)

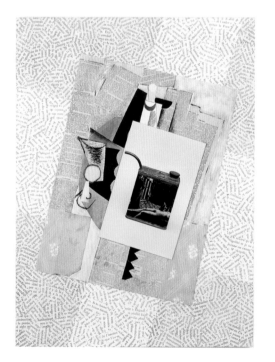

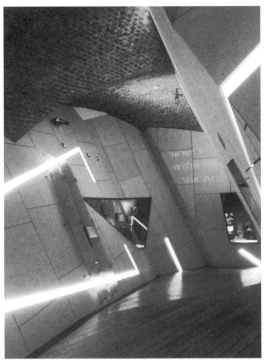

Daniel Libeskind, Danish Jewish Museum (2003)

Libeskind's built work shows evidence of his use of line as an ordering device in the fragmentation and aggregation of form. In his Danish Jewish Museum in Copenhagen, the shard-like surfaces are interwoven with and juxtaposed against the historic building the museum occupies. Libeskind's project statement describes the concept, saying, "Just as the experience of Danish Jews during the Holocaust is as a text within a text, the museum itself is a building within a building. The entire building has been conceived as an adventure, both physical and spiritual, in tracing the lineaments that reveal the intersection of different histories and aspects of Jewish Culture."[26] The fragments of history layered and collected to represent the history of the Jewish population in Denmark during the Holocaust are made manifest in an architectural palimpsest.

The legacy of Libeskind's academic pursuits within the pedagogical rubric offered by Cooper Union in the late 1960s is embodied by his built work of the past decade. In his constructions, he has physically and materially iterated architectural futures ordered and overlaid with history and narrative. We can understand the following strategy for collage-drawing as a prelude to his built work. Libeskind wrote in "End Space" (1979–80): "An architectural drawing is as much a prospective unfolding of future possibilities as it is a recovery of a particular history to whose intentions it testifies and whose limits it always challenges."[27]

Ben Nicholson, *The Appliance House: Sagittal Name Collage* (1990)

BEN NICHOLSON

Like all maps, collage can exist as a guide to what exists on the ground or it can prompt a new set of thoughts suggested by interconnections of terrain and cities. When considered from this angle, the collage becomes a transcription that can accelerate the way one understands the everyday world and how it comes together, without necessarily being an expert of any particular field of knowledge.[28]

Ben Nicholson, *The Appliance House*

Ben Nicholson, a Chicago-based architect and professor at The Art Institute of Chicago, views collage as a critical part of an iterative design process with the capacity to manifest something new from an initial intuition. His collage-making reveals a dialogue between the conscious and intentional decisions of the collagist, subconscious or intuitive acts, and the meaning inherent in the collage fragments that remains outside the control of the collagist. The role of chance and the subconscious recall the collages and assemblages of Dada and Surrealist artists, who appropriated images and objects from contemporary life. Marcel Duchamp's *Readymades* were defined as "an ordinary object elevated to the dignity of a work of art by the mere choice of an artist" in André Breton and Paul Éluard's *Dictionnaire abrégé du Surréalisme*.[29] Nicholson's use of catalogue images reflecting consumer culture in the US echoes Duchamp, as fragments of the everyday and utilitarian are given aesthetic value. Ben Nicholson finds inspiration in the work of Kurt Schwitters and fellow Dada artist Max Ernst, whom he called "the bad boy collagists"[30] for their capacity to challenge the connotation of media in two-dimensional works of art.

Marcel Duchamp, *Bicycle Wheel* (1913/1964)
© 2012 Artists Rights Society (ARS), New York / ADAGP, Paris / Succession Marcel Duchamp

Rare among the collagist/architect, Nicholson has written extensively on the role of collage in his design process, most comprehensively in his essay "Collage-making." He begins the essay by pointing to the unique value of collage as a methodology, saying:

> Amongst the arsenal of thinking methods, the process of collage making, though pervasive, occupies a disruptive position by using trash and deadness to form beauty. Collage is part of everyone's experience and, however well it is understood, it seems to refer to a group of ephemeral things brought together by a logic that disturbs, or negates, the status of the individual elements.[31]

For Nicholson, logic and precision are means by which to accelerate this disruption. He compares the act of collage-making to a surgical procedure. The influence of Bauhaus and Constructivist collage artists is evident in the precise and reductive quality of Nicholson's collages. The negative space of the composition serves a spatial function while highlighting the crisp edges of each accurately excised image fragment. As a transcription or map, collage is the vehicle for constructing geometric order through meticulous and intentional assemblies.

Moving from the two-dimensional to the three-dimensional, Nicholson draws a correlation to the spatial investigations of the Cubists: "The collagist-architect has the same access to the spatial possibilities as does the Cubist painter and can induce

space in the manner that it is experienced through collage making."[32] In his book *The Appliance House* (1990), Nicholson interrogates the spatial possibilities of collage by attempting to synthesize mechanisms of modern life (appliances) with the suburban home. Collage fragments were limited to two sources: the Sears catalogue and the Sweets catalogue. By selecting media outside the normative canon of architectural representation, an examination of the source material for collage-making is foregrounded. Collages contain evidence of the place and time in which they were constructed. The exploitation of consumer catalogues for Nicholson's collages retains for posterity America's preoccupation with catalogue shopping. (This distance between the consumer and the product of course continues today in online shopping, another degree of separation from the physical object.) Nicholson's identification of collage-making as a binary process – a series of yes/no decisions about fragment selection and placement – foreshadows the implication of the computer as a tool for manipulation (both direct and indirect) in collage. Nicholson describes the almost automatic process by which collage can construct order: "the Appliance House loses its preordained trajectory and begins to fabricate the mechanisms and the context for an alternative analysis of the house and domesticity."[33] He believes this to be a result of the ready-made components employed, already imbued with meaning and resulting in unanticipated readings as a result of their juxtapositions.

Within the Appliance House, consisting of six chambers, Nicholson focused on the development of the Kleptoman Cell. The thickened walls of the cell

Ben Nicholson, *The Appliance House: Kleptoman Cell Plan* (1990) – thickened storage/display walls and the Telamon Cupboard represented through a precise and detailed collage-drawing

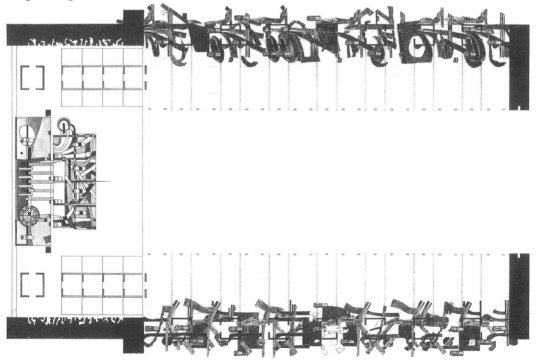

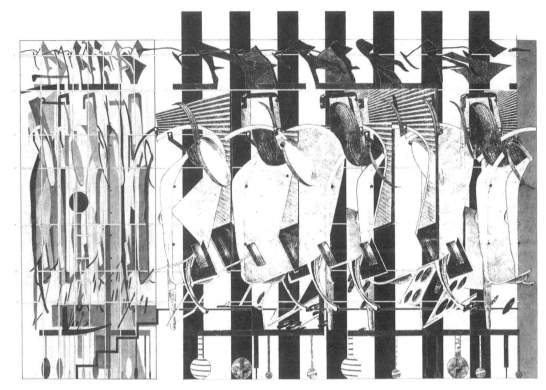

Ben Nicholson, *The Appliance House: Kleptoman Cell Elevation* (1990)

serve as an archive and display for fetishized objects. The Telamon Cupboard occupies a prominent location within the Cell and acts as a cabinet to contain and organize up to 40 of the smallest and most valued found artifacts.

The design of the Kleptoman Cell and Telamon Cupboard developed through a recursive procedure of collage-making and drawing. Text accompanies the collages and is vital to their interpretation. Nicholson describes the naming of a collage as a means of "taming" the image, making it more accessible as an architectural representation and giving it a sense of scale. For example, in *Kleptoman Cell Elevation*, a dynamic and layered abstract composition becomes a complex and kinetic interior elevation of a small room. In his process, "Once the hunches, catalyzed by collages, have been given names, they are then spurred on to be confirmed by drawing and building."[34] The ambiguity of the media utilized in Nicholson's collage-drawings is based on a recursive method. Upon completing a collage, it is fragmented and reassembled into a new collage. Then this process occurs once more, eventually dissolving the semantic meaning of the original fragments. Rubbings (frottage) and pencil drawings interpret these collages. The iterative design process transitioning from collage to drawing to fabrication is most clearly illustrated in the Telamon Cupboard. The conceptual genesis for the Telamon Cupboard is based on Nicholson's observation that the inner workings of appliances are intentionally obfuscated – each has an opaque skin stretched over the complex mechanisms within. In the collages

Ben Nicholson, *The Appliance House: Face Name Collage* (1990) – the first depiction of the Telamon Cupboard, using a mirrored bathroom cabinet

Ben Nicholson, *The Appliance House: Stages in the Life of the Telamon Cupboard* (1990) – recursive process of collage-making and drawing to inform building

depicting the Cupboard, he reveals these devices and their spatial, three-dimensional, relationships.

Nicholson anticipates the three-dimensional implications of the ostensibly two-dimensional medium of collage, beyond the perceived scale or meaning of the image fragments: "The relief created by superimposition can be read as a talisman, as an indication of its three-dimensional qualities. Were the collage to become an object

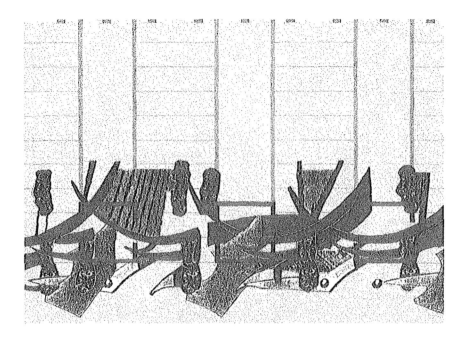

Ben Nicholson, *The Appliance House: Kleptoman Cell Plan – Detail and Rubbing* (1990)

in space, its structure would inform the way it is to be built."[35] For Nicholson, the three-dimensional implications of collage stem not only from the perceived layering of form within the deep space of the canvas, but also from the physical layering of the paper-thin fragments. These fragments reflect light, cast shadows, and draw attention to their subtle yet perceptible three-dimensionality. In the case of the Telamon Cupboard, Nicholson tested this potential through the construction of the Cupboard at full scale, saying: "The transfer of collage into frottage provokes an automatic

evaluation of the potential use of materials. The mechanics of the drawing process informs the mechanics of the building process."[36] Nicholson, through the Appliance House, has developed and articulated a refined design methodology exploiting the pictorial, spatial, and structural potentials of collage.

James Corner, *Rail Networks* (1996)

JAMES CORNER

Composite montage is essentially an affiliative and productive technique, aimed not toward limitation and control but toward emancipation, heterogeneity, and open-ended relations among parts. In particular, analytic and systematic operations can precipitate revelatory and rich effects ... Moreover, composite techniques focus on the instrumental function of drawing with regard to production; they are efficacious rather than representational. In other words, through utilizing a variety of analytic and analogous imaging techniques, otherwise disparate parts can be brought into productive relationship, less as *parts* of a visual composition and more as *means* or agents.[37]

James Corner, "Eidetic Operations and New Landscapes"

Landscape architect James Corner has employed collage-drawing in the processes of both analysis and design as a procedure by which to reveal or construct order that underlies conditions of site and/or program. He is the principal of New York City-based landscape architecture firm Field Operations and is currently chair of the Department of Landscape Architecture at the University of Pennsylvania. Notably, Corner joined the faculty in the Department of Landscape Architecture in 1989, just one year before Robert Slutzky joined the faculty in the Department of Fine Arts. While the degree of interaction between Corner and Slutzky is unknown, the creative and generative potential of collage-making is a common theme in their work. Corner's interest in graphic communication is articulated in his essay "Eidetic Operations and New Landscapes," in which he points out the dearth of representational techniques typically used in the practice of architecture and landscape architecture. He advocates for a wider range of methods for

James Corner, *Powers of Ten* (1996)

the imaging process, particularly for methods that go beyond the purely visual.[38] Emphasizing the correlation between graphic tools used in the design process and the resulting work of architecture or landscape, Corner states: "With regard to design, how one maps, draws, conceptualizes, imagines, and projects inevitably conditions what is built and what effects that construction may exercise in time."[39] Time as an indicator through which to understand process and transformation links Corner's work to that of the Cubists. Collage, beginning with the Cubists, was an attempt to unify disparate images (both formally and conceptually) in order to promote connections between contradictory aspects of our experiences in the world. Corner draws on the methods of the Cubists in his utilization of textured papers while integrating this approach with the techniques of photomontage and line of the Bauhaus and Constructivists. He incorporates image and map fragments and employs line to capture the precision, scale, and measure of the constructed landscape. Corner's collage-drawings also preserve negative space within the composition, like his Bauhaus and Constructivist predecessors. Corner, like Le Corbusier and Bernhard Hoesli, views collage-making as a corollary to the making of architecture as it reveals the process of construction to be as important as the resultant artifact. Corner points out that "The dismantling

James Corner, *Hoover Dam and the Colorado River* (1996)

James Corner, *Long Lots Along the Mississippi River* (1996)

and isolation of layers and elements in plan not only proposes a productive working method akin to montage, but also focuses attention on the logic of making the landscape rather than on its appearance per se."[40]

James Corner's professional work explores the "logic of making" through collage for purposes of both analysis and design. In *Taking Measures Across the American Landscape*, Corner uses collage-drawing to document the dynamic nature of site as it has been inscribed by human inhabitation, accompanied by the photography of Alex MacLean. He addresses the relationship between the human body and how site is both measured and experienced. Corner considers measurement from two perspectives. Measurement serves to relate the human body to activities and materials, and more broadly, to relate "the everyday world to the infinite and invisible dimensions of the universe."[41] The imposition of rationalized metrics on the ground gives humans some sense of control over the vast landscape. Corner's collage-drawings address the scale of site and the human measure of the landscape. In these analyses, he responds to Michelangelo's 'false truth' of measure: graphic representations that seem to more accurately depict the essence of the subject than the "true falsehoods" of objective, quantitative data.[42] The experiential, tangible qualities of site revealed in these collages identify qualities of space and time as a dialogue between the natural and surveyed landscape. Corner, like Colin Rowe, views the built environment as a palimpsest in

James Corner, *The Survey Landscape Accrued* (1996)

which, "Over time, landscapes accrue layers with every new representation, and these inevitably thicken and enrich the range of interpretations and possibilities. Thus, both the idea and artifact of landscape are not at all static or stable."[43] The ground condition in flux, seen as an ambiguity of figure and field, is both a formal condition captured in collage as well as a tangible, physical condition revealed in Corner's analytic collage-drawings.

Moving from analysis into design, Corner proposes that composite montage allows for heterogeneity, emphasizing the relationship between forms rather than an autonomy of parts.[44] Corner's practice employs ideogram collages as generative tools for design, allowing a composition of disparate elements to reveal new potentialities. His ideograms constructed for the Töölönlahti Park competition in Helsinki, Finland reveal an iterative collage-drawing process that serves to generate and evaluate new relationships between landscape fragments. This method echoes the sentiments of Braque as it emphasizes a transformative, relational composition. Corner's collage-drawings for analysis and design demonstrate a collage mentality that pervades each

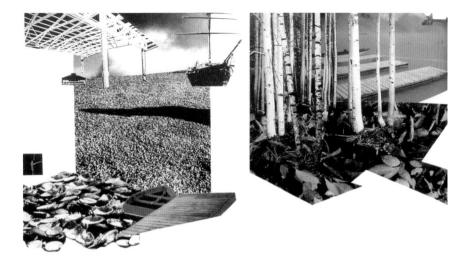

James Corner,
Ideograms,
Töölönlahti,
Helsinki (1997)

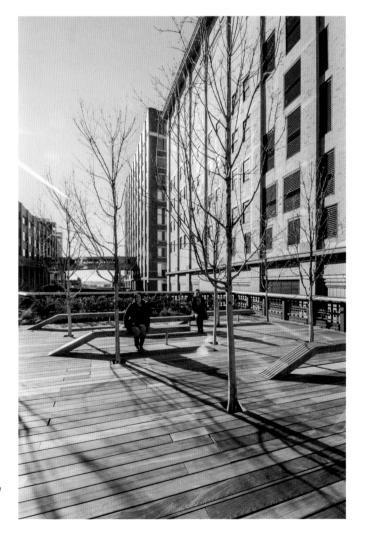

James Corner, *High*
Line, New York
(2004–present)

scale of his work. In his contribution to the High Line project that has reactivated an abandoned rail bed slicing through Manhattan, there is evidence of fragmentation and overlap in the architectural and landscape components of the project. This overlap occurs through an interweaving of textures and a transformation of field to figure as path becomes place. The High Line embodies Corner's theory that "how one 'images' the world literally conditions how reality is both conceptualized and shaped."[45] The precisely ordered and layered collage-drawings common to his design practice are concretized in the completed work. Corner's High Line interventions respond to physical, material conditions while providing a multiplicity of spatial and haptic experiences, just as his collage-drawings capture both formal relationships and experiential characteristics.

Constructs: Narratives of Social Order

An interest in constructs of social order as speculated through utopian/dystopian narratives can be seen in the work of Archigram, Superstudio, Rem Koolhaas, and time[scape]lab. These architects continue the lineage of the Constructivists in their socio-political motivations, as well as in their formal execution. In *Ideological Superstructure* from 1929, El Lissitzky wrote: "We are striving in our architecture as in our whole life to create social order . . . Our times demand shapes which arise out of elementary forms (geometry)."[46] The implications of social order are often tacitly embodied by constructs of geometric order.

The work of Constructivist Vladimir Tatlin, an artist and architect, bears a resemblance to El Lissitzky's in his use of collage as a medium to inform subsequent three-dimensional explorations. As Tatlin's explorations became more three-dimensional, he began to construct corner reliefs out of found materials. These reliefs illustrate a Cubist influence in the fracture and restructuring of geometric forms. Tatlin's relief sculptures investigate the plasticity of space defined through material assemblies as points, lines, and planes as the wall becomes part of the composition. The reductive formal structure of Tatlin's collage and assemblages predicate the role of geometric order in the semantic value of icons of social order.

Tatlin's fame as an architect resulted from his design for the *Monument to the Third International*, also known as Tatlin's Tower – this work in particular is evidence of the evolution from abstract constructions to socially motivated works of architecture. The tower, conceived in 1919, was intended to be one-third taller than the Eiffel Tower, a monument to (and headquarters for) the international Communist organization called the Third International. The tectonic iron and steel spiral form would have housed three pure transparent geometric forms that would rotate within the metal skeleton. Each would rotate at a different rate, as dynamic markers of time.[47] With the Constructivist intent to promote a new society after the Bolshevik Revolution, one in which art and life are fused, we can understand their architectural proposals as constructs of social order. Architects Archigram, Superstudio, Rem Koolhaas, and time[scape]lab, as heirs to this mentality, have created architectural narratives that envision potential urban futures. Like their predecessors, they have found collage-drawing techniques to provide the vehicle for communicating these futures.

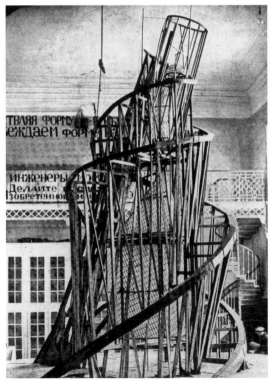

Tatlin, *Monument to the Third International* maquette (1919)

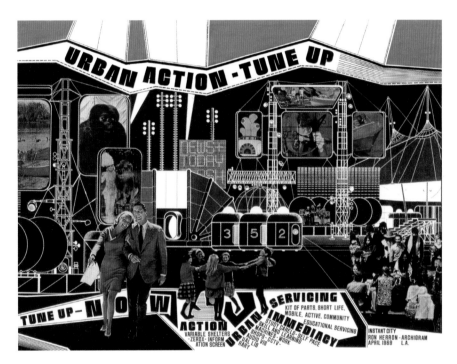

Ron Herron,
Archigram, *IC
Urban Action
Tune-Up* (1969)
Courtesy of the Estate
of Ron Herron

ARCHIGRAM

The drawing was never intended to be a window through which the world of tomorrow could be viewed but rather as a representation of a hypothetical physical environment made manifest simultaneously with its two-dimensional paper proxy. This is how things would look if only planners, governments, and architects were magically able to discard the mental impedimenta of the previous age and embrace the newly developed technologies and their attendant attitudes.[48]

Michael 'Spider' Webb, New York, June, 1999

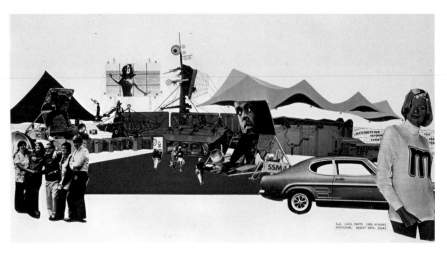

Ron Herron,
Archigram, *IC Local
Parts* (1969)
Courtesy of the Estate
of Ron Herron

Archigram was an avant-garde group of architects collaborating in London in the 1960s who challenged the conventional role of architectural representation. Members Peter Cook, Warren Chalk, Ron Herron, Dennis Crompton, Michael Webb, and David Greene began publishing student work and speculative projects as ARCHItecture teleGRAMs, condensed to Archigram. Archigram viewed consumer culture and the availability and accessibility of consumer goods as evidence of progress. They claimed: "It is now reasonable to treat buildings as consumer products, and the real justification of consumer products is that they are the direct expression of a freedom to choose."[49] This concept of emancipation provides the foundation for their critique of the normative mode of architectural production, one of determinacy, and instead advocated for an architecture of indeterminacy. Peter Cook described "the need to regard the city, or whatever replaces it, as an infinitely intermeshed series of happenings"[50] preceding the event-space of Rem Koolhaas. The ephemeral nature of human activity in the city was, to Archigram, more important than the architecture framing it, a concept that was taken up by Superstudio in Italy. Collage, with its inherent multivalency, became the

Ron Herron,
Archigram, *Tuned
Suburb* (1968)
Courtesy of the Estate
of Ron Herron

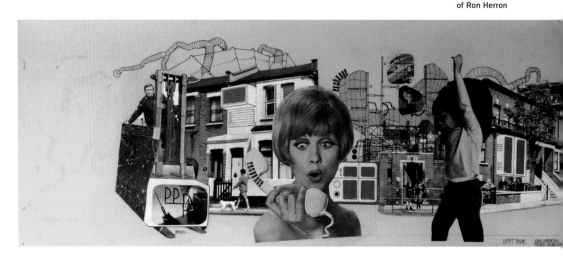

vehicle through which to interrogate indeterminacy. The role of collage-drawing in the work of Archigram is pervasive. Peter Cook described an early project, the *Living City*, as embodying "this notion of the endlessly and cyclical layered, but dynamic collage of speculation."[51] The use of collage-drawing in the paper architecture of Archigram bears a methodological resemblance to the work of the Russian Constructivists and Bauhaus artists. Like these predecessors, line drawings are activated and given depth by the insertion of photographic fragments. Archigram also draws from Constructivism conceptually – both valued the power of media in constructing a new social order. The selection of photographic material from contemporary media sources offered a representational solution to Cook's belief that: "architecture could break out of its narrow-mindedness if it acquired elements (a vocabulary of form) from outside itself."[52]

In reflecting on the work of Archigram, member Michael 'Spider' Webb describes the role of the montaged figures in the collage-drawings. He explains that, unlike normative architectural drawings in which the figures serve to provide a sense of scale, the figures of young, attractive women and men that proliferate in the collage-drawings of Archigram dominate the compositions. Constructed worlds are assembled out of numerous architectural sources: "the bits of building featured in the drawings seem only to act as a backdrop for the activities of our bovine friends . . . in order to reinforce the sense of who and what these young people are, the building design has been appropriated from the ultimate in 'with it' sources."[53] The appropriation of existing architectures suggests spatial and aesthetic qualities imposing an architectural prescription.

In 1968, Archigram was invited to exhibit work at the Milan Triennale. Inspired by the Triennale's theme of the 'greater number problem,' Archigram invented prefabricated architectural units that could be inserted into the existing context. These 'Popular Paks' offered the opportunity to fine-tune the built environment. Ron Herron's collage-drawing for *Tuned Suburbs* shows a 'Popular Pak' being delivered to an invented suburb. He described the proposal as "accretions of modern technology that showed how existing places could be tuned up, lifted to another dimension."[54]

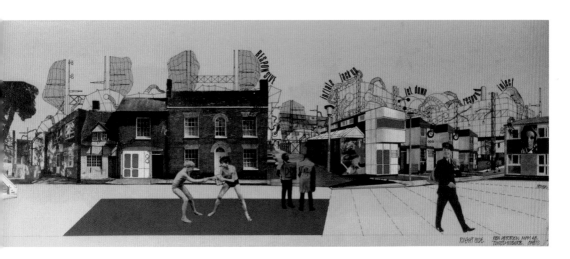

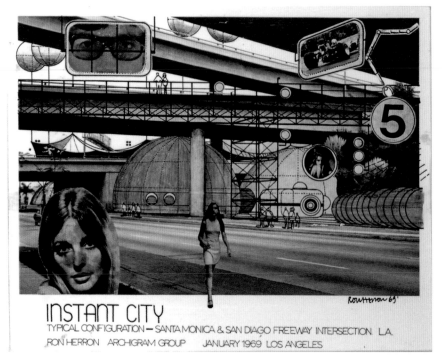

INSTANT CITY
TYPICAL CONFIGURATION — SANTA MONICA & SAN DIAGO FREEWAY INTERSECTION. L.A.
RON HERRON ARCHIGRAM GROUP JANUARY 1969 LOS ANGELES

Ron Herron, Archigram, *Instant City Typical Configuration – Santa Monica + San Diego Freeway Intersection* (1969–70)

Courtesy of the Estate of Ron Herron

A dynamic urban scene results from the composition of line drawing, architectural photographic fragments, and human figures of varying scales. The dialogue between these components within the collage-drawing captures the sense of indeterminacy valued by Archigram while illustrating one of many possible ordered constructs.

Perhaps the most well-known of Archigram's projects, *The Instant City*[55] was an architectural and written narrative developed with funding from the Graham Foundation of Chicago between 1969 and 1970. *The Instant City* is a 'travelling metropolis' that offers an architectural response to the problem of the inaccessibility of major metropolitan culture to the majority of the population. Peter Cook described it as "a package that comes to a community, giving it a taste of the metropolitan dynamic – which is temporarily grafted on to the local centre – and whilst the community is still recovering from the shock, uses this catalyst as the first stage of a national hook-up."[56] To abbreviate "A Typical Sequence of Operations" for *The Instant City*, components of the city are conveyed to their destination via truck and balloon. An existing structure at the destination is converted into an information node. "The 'City'

Ron Herron, Archigram, *Instant City Visits Bournemouth* (1969–70)

Courtesy of the Estate of Ron Herron

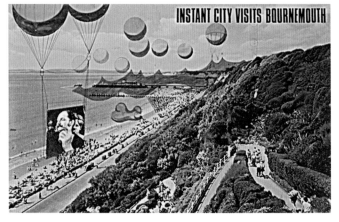

INSTANT CITY VISITS BOURNEMOUTH

arrives. It is assembled according to site and local characteristics. Not all components will necessarily be used. It may infiltrate local buildings and streets, it may fragment."[57] Cultural events instigated by the existing community will be augmented by programming from the 'City' agency. The tensile and inflatable components are erected. The 'City' remains in place for a limited period of time and then moves on to a different community. "Eventually, by this combination of physical and electronic, perceptual and programmatic events and the establishment of local display centres, a 'City' of communication might exist, the metropolis of the national network."[58] The collage-making materials and techniques employed in this series of collage-drawings by Ron Herron for *The Instant City* reflect Pop Art collagists such as Robert Rauschenberg, who appropriated images from pop culture media. The images selected contain an identity bound to 1960s and 1970s British culture, clarifying the correlation between consumerism and architecture. The inherent meaning in the fragments also creates and supports a narrative for each collage-drawing. An inversion of the canvas and line to a black background with white lines is unique to the collage-drawings of Archigram at this time, but is not used exclusively. The variety of perspectives that juxtapose precisely constructed line drawings against architectural image fragments and the human figure tests the development of a 'vocabulary of form' derived from existing sources, as anticipated by Cook. Despite the disillusionment with the architectural avant-garde of the 1960s for their obsession with technology and consumer culture, their visionary projects and experiments in representation, particularly collage-drawing, have had a lasting effect on contemporary architecture.

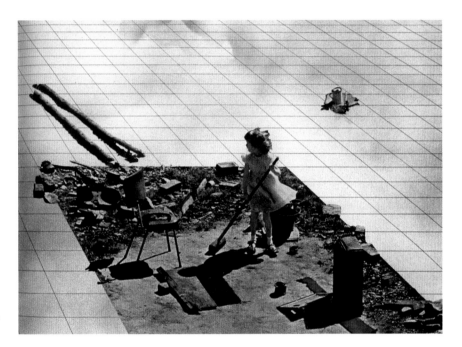

Superstudio,
Untitled in Italy:
The New Domestic
Landscape (1972)

SUPERSTUDIO

The lucid description of a field of multi-directional and sometimes regressive experience leads to ambiguous and unstable results, but ambiguity remains one of the few fixed points in contemporary culture. The tension required to maintain a work open and "in progress" can be born only from ambiguity, the non-solution, the plurality of possible readings.[59]

"Superstudio: Projects and Thoughts," *Domus* 479, 1969

Superstudio[60] was an avant-garde architecture group representing the highly charged political and architectural atmosphere of the 1960s. It was founded in 1966 in Florence, Italy by recent graduates of the University of Florence. Members were influenced by professor and megastructuralist Leonardo Savioli, who taught a course about utopian futures including the work of Archigram. Like Archigram, Superstudio argued for indeterminacy and ambiguity as mandates in contemporary architectural solutions. In contrast with Archigram, however, Superstudio's response offered a critique of consumer culture and modern architecture's role in its perpetuation. Their utopian conjectures and dystopian narratives also stemmed from their anti-historical attitude, anathema in a city such as Florence. This attitude is highlighted in their works such as *Rescue of Historic Centres* (1970) in which the Duomo, the geographic and cultural center of Florence, is portrayed through photomontage as a submerged vestige of Florence's past, with only its iconic dome projecting above the water.

Their research fell into three categories, different lenses through which to speculate on these concerns: 1. *Architecture of the Monument*; 2. *Architecture of the Image*; 3. *Tecnomorphic Architecture*. *Architecture of the Monument*, to Superstudio, "was the only way to create order."[61] They believed that "architecture is one of the few ways to realize cosmic order on earth, to put things to order and above all to affirm humanity's capacity for acting according to reason, it is a 'moderate utopia' to imagine a near future in which all architecture will be created with a single act."[62] Formal concerns of simple geometries, the golden section, and axes of symmetry underpinned this category of research. *Architecture of the Image* led to experiments in graphic representation that included collage-drawings: architectural line drawings integrated with and juxtaposed against photomontage elements. The speculative projects illustrated through collage-drawing were frequently published in architecture magazines including *Domus*, *Casabella*, and *Architectural Design*. The lens of *Tecnomorphic Architecture* considered the rational assembly of tectonic components as a means of realizing the intended geometric order.

Influences on all three categories of research include Russian Constructivism and the narrative of a utopic order. Writing in 2003, Superstudio co-founder Cristiano Toraldo di Francia said:

> Working around the hypothesis of architecture as a means for criticism, using systematically the *demonstratio quia absurdum*, the paradox, the negative utopia, SUPERSTUDIO in 1968 has produced an architectural model for total urbanization: *The Continuous Monument* as the last term in a series of architectures that have signed the planet since the linear cities of the Russian utopians of the 20th century.[63]

In projects like *The Continuous Monument* (1969) and *Supersurface* (1971), the architectural proposals offer the most minimal and neutral space or backdrop for human activity. The architecture does not mediate or guide the interactions of its inhabitants.[64]

Superstudio's *Supersurface* project was created for a MoMA exhibition in 1972. The collage-drawings illustrating this proposal speak to the figure/field dialogue

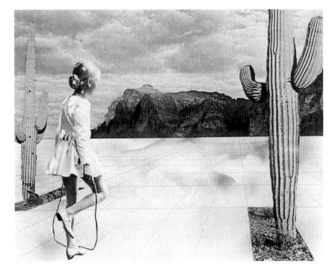

pervading collage-making and modern architecture more broadly, as derived from the spatial reconceptions of the Cubists. This project addresses the homogenization of space as a result of energy and information grids. According to Toraldo di Francia, "having freed the field from the opposition nature-architecture, city-country, from the objectual aspect of architecture as a final monument of totalizing utopias, and of great stories, that in the name of a rational order, had organized a pure synthetic view of reality measured by perspective."[65] Although the utopian speculations find precedence in the Russian Constructivists, the Constructivists worked in predominantly axonometric views while Superstudio employed perspective as a means of drawing the viewer into the fabricated worlds of their creation. Additionally, unlike the Constructivists, the utopian visions of Superstudio did not consider materiality: in fact, as we will see in a closer inspection of their collage-drawings, they negated it. In this way, the collage-drawings of Superstudio bear a closer resemblance to those of Bauhaus artist László Moholy-Nagy in the abstraction of the built environment to an a-material geometry (see p. 69).

Co-founder Adolfo Natalini, in a lecture given at the AA School of Architecture in London in 1971, said, "We could say that the original motive of utopia

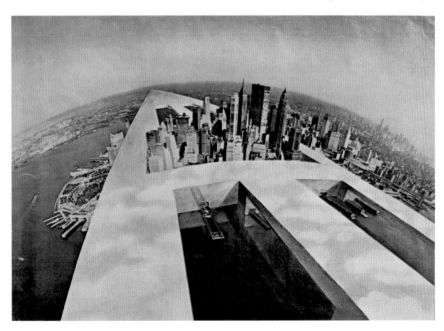

Superstudio,
*Monumento
Continuo* (1969)

is hope . . . The revolutionary charge of utopia, the hope which is at its foundation and the criticism which is its direct consequence, bring back its dignity as a rational, ordering activity."[66] The act of ordering is obvious in the superimposition of the grid at various scales, providing a neutral ground in works such as *The Continuous Monument* and *Supersurface*. Adolfo Natalini described the process by which Superstudio works as reliant on two methods: *inventory* and *catalogue*. He said that: "By comparing and arranging into series, ideas, intuitions, events, information, reciprocal connections come to light, experiences are assimilated and we pass on."[67] This process of extracting 'ready-mades' and considering potential relationships and juxtapositions precisely defines collage-making, revealing Superstudio's design process to be one illustrative of a collage mentality. Superstudio described the physicality of their graphic explorations in a commentary on a 1973 exhibition of their work:

> The marks we left on the paper, or the pieces of photos glued together, and the blueprints of perspectives and axonometrics, and the sheets from the copier, the drawings done with colored pencils or shaded ones done with the airbrush, were ways and maps for ancient or future journeys. They were paths running through the territory of will and hope.[68]

Architecture of the Image prioritized graphic experimentation that tested a variety of media, both independently and as multi-media investigations. The materiality of the architecture in the collage-drawings of Superstudio is typically negated and this occurs in one of two ways. In collage-drawings like *The Continuous Monument*, the architecture occupies the void remaining after the excision of a fragment of a photograph. The architecture is then re-inscribed through line drawing. In a linear gridded structure that extended across the world, Superstudio saw a "synthesizing

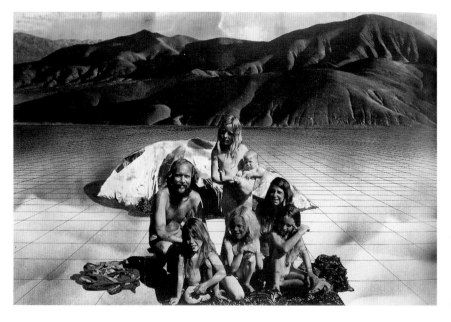

Superstudio,
*Life, Education,
Ceremony, Love,
The Encampment,
The Fundamental
Acts* (1971)

and unifying element."[69] Alternatively, *Supersurface* constructs a gridded architectural ground plane, on and around which photomontage elements of human occupation or natural context are placed. Collage-drawings and photomontages by contemporaries of Superstudio including Hans Hollein (Austria), Cedric Price (England), and Arata Isozaki (Japan) illustrating the superimposition of megastructures on the landscape demonstrate common themes and representational methods.

The grid as a tool to impose geometric order has influenced architects in the subsequent decades, including Richard Meier and Peter Eisenman. The work of Superstudio also foretells the monumentality and megastructures of Rem Koolhaas as well as the program- and event-driven architecture of both Koolhaas and Bernard Tschumi. Adolfo Natalini, in a lecture at the AA School of Architecture, London, 1971, described the void space of their collage-drawings reoccupied by gridded architectural projections as space for human interaction and activity:

> There is a space between architecture and the visual arts, and there is a space between the cultural professions and life. This space is the only "non-alienating" surface in our experience . . . A space for critical activity (or philosophical activity), through which to explore the many ways of doing, and to try, with serene indifference, to order and give a sense to our activity.[70]

The anti-design rhetoric of Superstudio has provided a guiding force behind subsequent utopian narratives and dystopian critiques. Former MoMA curator Terence Riley observed that "Archigram's Walking City by Ron Herron of 1966 and Superstudio's The Continuous Monument project of 1969 trumped the scale of prewar architectural visions, and ushered in the megastructure movement."[71] An examination of the work of a later generation of architects suggests that the collage-drawing techniques of dissection, extraction, and geometricization developed by Superstudio have permeated the discourse in the decades that followed.

REM KOOLHAAS

If there is a method in this work, it is a method of systematic *idealization*; a systematic overestimation of the *extant*, a bombardment of speculation that invests even the most mediocre aspects with retroactive conceptual and ideological charge.[72]

Rem Koolhaas, "The Terrifying Beauty of the Twentieth Century

Pritzker-Prize-winning Dutch architect Rem Koolhaas studied scriptwriting and worked as a writer and a journalist before beginning his architectural education. These experiences would come to inform his narrative-driven approach to design, crafted by program as event. He began his design studies at the Architectural Association in London in 1968, at the age of 24. Attending the AA at this time immersed him in the legacy of Archigram as well as an approach to architectural pedagogy that fostered the avant-garde in the broadest definition of architecture. After his studies at the AA, he continued his education at Cornell University in 1972 under the tutelage of Colin Rowe.

Koolhaas's speculative projects and built works seek to balance order and indeterminacy like Archigram, using the first to create opportunities for the second. His urban strategies constructed as an act of ordering illustrate a strong lineage to the Russian Constructivists. In the mid 1970s, Koolhaas spent time researching Russian Constructivist architect and painter Ivan Leonidov. Leonidov's treatise on "dis-urbanism" from 1930 advocated an alternative to the dense city blocks of the Soviet state. The Constructivist concept of architecture as a *social condenser* pervades the urban scale proposals of Koolhaas. *Social Condenser* is defined by Koolhaas himself in the OMA book *Content* as "Programmatic layering upon vacant terrain to encourage dynamic coexistence of activities and to generate through their interference, unprecedented events."[73] This vacant terrain is commonly manifested as an a-material grid, in the work of Koolhaas as well as Superstudio. Leonidov's competition entry for the new town of Magnitogorsk applied this strategy to an idealized socialist settlement.[74] The gridded linear diagram is overlaid with a diversity of programmatic elements and formal structures.

Jean-Louis Cohen, in an essay entitled "The Rational Rebel, or the Urban Agenda of OMA," discusses Koolhaas's use of the grid. "The grids OMA uses . . . sanction the recognition of an existing spatial order, constituted in the solidification of lines (and functions, as well), and the recognition of a new social order, stemming from a process of inquiry and conjecture, very scrupulously taken into account by the architects."[75]

Koolhaas himself references the importance of the work of Archigram in the 1960s and the influence of their "anti-historical" and "optimistic" approach

Diagram of Ivan Leonidov's *Socialist Settlement at Magnitogorsk Chemical and Metallurgical Combine* competition entry (1930)

through "architectural stories supposing a vast expansion of the territory of the architectural imagination" on his early work, particularly *Exodus or the Voluntary Prisoners of Architecture* (1972).[76] Koolhaas, along with Madelon Vriesendorp, his mentor Elia Zenghelis, and Zoe Zenghelis developed *Exodus* as a competition entry for the Italian architecture magazine *Casabella*, which sought projects that offered new visions of the city. Koolhaas subsequently furthered this research for his thesis project at the AA. An elaborate textual narrative provides a framework for the collage-drawings, photomontages, and architectural drawings. The concept for the project was based on Koolhaas's visit to the Berlin Wall, about which he stated, "Neither those in the West nor those in the East are free, only those trapped in the wall are truly free."[77] The project was an investigation into the subversive role of architecture in the city, and its potential "to host fringe activities and unexpected events." The project narrative begins as a city divided into two parts, the good half and the bad half. The inhabitants of the bad half, in a mass exodus, flocked to the good half. Authorities attempting to prevent this migration built a wall around the good half, preventing movement between the halves.

In the series of collage-drawings created for *Exodus*, we can see the importance of meaning embodied by the fragments of photographs and the new meaning acquired by their proximity to or juxtaposition against other fragments saturated with meaning. The collage-drawing techniques employed by Koolhaas have clearly been adapted from the collage-drawings of Archigram. In *The Strip, Project, Aerial Perspective*, the composition consists primarily of photomontage elements, extending to the boundaries of the image frame – in this case an aerial view of the city of London.

Rem Koolhaas (b. 1944) © Copyright. Zenghelis, Elia (b. 1937), Vriesendorp, Madelon (b. 1945), and Zenghelis, Zoe (b. 1937). *Exodus, or the Voluntary Prisoners of Architecture, The Strip, Project, Aerial Perspective*. 1972.

Cut-and-pasted paper with watercolor, ink, gouache, and color pencil on gelatin silver photograph (aerial view of London), 16 × 19⅞" (40.6 × 50.5 cm). Gift of Patricia Phelps de Cisneros, Takeo Ohbayashi Purchase Fund, and Susan de Menil Purchase Fund. May have restrictions.

Digital Image © The Museum of Modern Art/Licensed by SCALA / Art Resource, NY

The Museum of Modern Art, New York, NY, U.S.A.

Portions of the photograph and thus portions of the city have been excised and infilled with the proposed architectural intervention conveyed through line. This strategy heightens the contrast between the texture and idiosyncrasies of the city and the vast scale and rigorous geometric order of the proposal. The dialogue between the imposed geometry and the richness of human inhabitation is an obvious successor of Superstudio's *Supersurface*. Another method minimizes the use of photographic fragments beginning with a line drawing and adding scale, activity, and context through photomontage. These methods vary in their capacity to convey atmosphere, context, human occupation, and architectural order, and are used strategically in support of the *Exodus* narrative.

Koolhaas's interest in cross-programming, or hybridizing disparate functions, is evidence of a collage mindset in which he seeks to synthesize unrelated fragments. Two projects, one unbuilt and one built, demonstrate this attitude towards programmatic hybridization. Koolhaas's proposal for Parc de la Villette (Paris, 1982–83) is described as "the proposition of a 'method' that combines architectural specificity with programmatic indeterminacy."[78] The design seeks to achieve this through the superimposition of five ordering strategies. The first layer establishes bands of program; the second layer, point grids locating small-scale elements of the program; the third layer, access and circulation; the fourth layer, large programmatic components; and

Rem Koolhaas (b. 1944) © Copyright. Zenghelis, Elia (b. 1937), Vriesendorp, Madelon (b. 1945), and Zenghelis, Zoe (b. 1937). *Exodus, or the Voluntary Prisoners of Architecture, The Baths*, project. Plan. Drawing date: 1972.

Cut-and-pasted paper, photolithograph, and gelatin silver photographs with ink on paper, 16⅛ × 11½". Patricia Phelps de Cisneros Purchase Fund, Takeo Ohbayashi Purchase Fund, and Susan de Menil Purchase Fund. (369.1996) May have restrictions.

Digital Image © The Museum of Modern Art/Licensed by SCALA / Art Resource, NY

The Museum of Modern Art, New York, NY, U.S.A.

the fifth layer, connections to the city of Paris. The collage – or superimposition and synthesis – of unrelated layers provides, in the words of OMA, "a framework capable of absorbing an endless series of further meanings, extensions, or intentions."[79]

OMA's McCormick Tribune Campus Center for the Illinois Institute of Technology in Chicago was completed in 2003 and sits across the street from Mies van der Rohe's Crown Hall. Setting aside the critiques of the execution of the concept, this project follows a similar methodology to that employed in the Parc de la Villette proposal: the superimposition of layers. In this project, a one-story building containing student activity services including a bookstore, coffeeshop, and post office imposes a new layer of program on the site. A layer of circulation is superimposed that consists of pre-existing paths that criss-crossed the site as mapped by the architects. Finally, the elevated train running directly over the site is enclosed in a stainless steel tube that deforms the volume of the one-story building below. According to Koolhaas, "By not

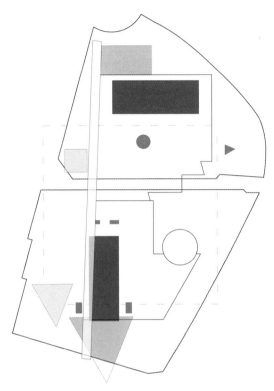

Diagram of Rem Koolhaas and OMA's Parc de la Villette proposal, Paris (1982–83)

stacking activities, but by positioning each programmatic particle as part of a dense mosaic, our building contains the urban condition itself."[80] This could be considered a collage as well as a mosaic, as a synthesis of unrelated fragments of program. The composition absorbs layers of program and circulation that function at multiple scales to both expand out to the city and internalize the urban context.

Event space and narrative, like collage, necessitate a consideration of the fourth dimension. Time plays a role in the work of Koolhaas in his use of narrative and indeterminate strategies, revealing a common thread between his early speculative work at the AA and his subsequent architectural proposals and built work. Within this conceptual framework his methods are collage-like, as according to Cohen, "Rem Koolhaas measures and slices the body of architectural history with his retroactive scissors," a process of decontextualization and transformation.[81] Koolhaas employs a formal strategy of superimposing layers of geometric order to create space for human activity within the narrative construct of social order.

Diagram of Rem Koolhaas and OMA's McCormick Tribune Campus Center, IIT, Chicago, IL, USA (1997–2003)

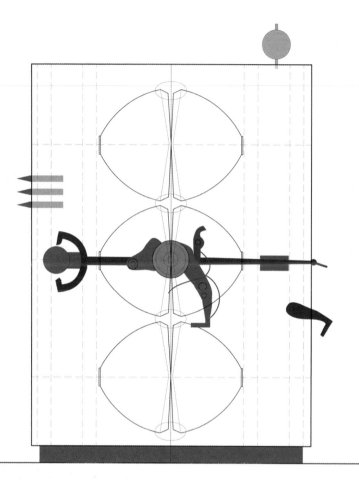

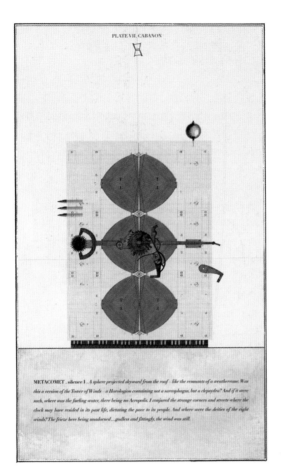

PLATE VII. CABANON

METACOMET . *silence I . A sphere projected skyward from the roof - like the remnants of a weathervane. Was this a version of the Tower of Winds - a Horologion containing not a sarcophagus, but a clepsydra? And if it were such, where was the fueling water, there being no Acropolis. I conjured the strange corners and streets where the clock may have resided in its past life, dictating the pace to its people. And where were the deities of the eight winds? The frieze here being unadorned...godless and fittingly, the wind was still.*

time[scape]lab,
*Plate VII. Cabanon
– Metacomet*
(2011)

TIME[SCAPE]LAB

Is the process of collage making not a subtractive one as it begins by extracting components from their original context to join the arsenal of the collagist? The sculptor of stone removes material in seeking the form residing within, the residue and dust gathering at his feet, while the collagist readily covets and seeks to sever it from its environment to establish new relationships, new trajectories and narratives previously unimagined. The form can be like an organ, infusing a composition with new life. The waste generated by a collagist can often be reused, the void left by the object possessing a haunting quality.[82]

Brian Ambroziak and Andrew McLellan, time[scape]lab, *Confabulatores Nocturni: The Cabanon Series*, 2012

Designers Brian Ambroziak and Andrew McLellan of time[scape]lab share a fascination with qualities of architecture as it is experienced at night. They propose that "A *resurrection of night* challenges our conceptions of space as seen by a more majestic light than the sun, reconstituting the poetics of the night and reestablishing the potential for a symbiotic relationship between the design process and the written word."[83] This premise prompted the development of a narrative and design project founded in the *confabulatores nocturni*, storytellers of the night whom Alexander the Great employed to ease his insomnia. Like other architects who have utilized collage-drawing in their design process, time[scape]lab uses this method as a vehicle for constructing a narrative of social order through geometric form. They describe the role of the narrative in their architectural practice, saying: "The writing around you shares a symbiotic relationship with image. Our writing defines each CABANON and the text allows conversations to occur between each image in the form of a colloquy."

The term Cabanon (French for 'cabin') refers to a summer retreat that Le Corbusier designed and built for himself in Cap-Martin on the Côte d'Azur in 1952.

The scale and articulation of each Cabanon designed by time[scape]lab follows the personal and idiosyncratic nature of Le Corbusier's retreat, developed through narrative. Collage-drawing precedent can be identified in the precise and reductive work of Ben Nicholson, selecting image fragments from limited sources. Ambroziak and McLellan were also influenced by the photomontages of David Wild, a British architect and collagist who taught with them at the University of Tennessee (see Chapter 1.3). They also reference the etchings of Peter Milton, Erik Desmazières, and Piranesi, and the collages of Raimund Abraham, Hans Hollein, and Nils-Ole Lund. They have found architectural inspiration in the surreal paper architecture of Douglas Darden and Brodsky and Utkin.

Drawing on the haptic yet uncanny qualities of image-making embodied by these precedents, Ambroziak and McLellan appropriated images from a single source: Diderot and d'Alembert's *Encyclopédie* from 1751. This 28-volume encyclopedia was intended to collect all the knowledge of the world at that point in time and archive it in a single source. Organized alphabetically instead of thematically, the encyclopedia encouraged a cross-fertilization of ideas. Ambroziak and McLellan's methodological premise for *Confabulatores Nocturni* was that:

> The visual equivalent to the Library of Borges, [Diderot and d'Alembert's] *Encyclopédie* serves as a visual taxonomy of all human knowledge catalogued under the three primary branches of *memory, reason,* and *imagination* – past, present, and future. *Is it possible that the volumes of the Encyclopédie possess all of our collective spatial fictions?* Through the narrative morphosis of collage, each CABANON acquires the personality of a scribe. New fictions surface.

A brief synopsis of the *Confabulatores Nocturni* narrative must precede an analysis of their collage-drawing methods. The narrator, a traveler, happens upon a vast edifice defined by the geometry of a gridded square – in essence, a chessboard turned vertically. A raven serves as a host to the narrator, moving as a knight among the 64 compartments of the massive wall or columbarium. Some of these compartments are occupied by Cabanons and inhabited by diverse occupants. Dialogues between various occupants of the Cabanons are revealed to the narrator each night in a dream. Authors become characters, extracted from their spatio-temporal location and given new identities as storytellers in the great wall. One colloquy occurs between Antoine de Saint-Exupéry (the pilot) and Henry David Thoreau (the woodsman). Their conversation "addresses issues of language, slowness and scale (particularly the contrast between observing the world from 30,000 feet and 5'-8")."

Each cabanon reflects the values and passions of the inhabitant, as Le Corbusier's Cabanon reflected his. The pilot's cabanon reaches skyward, a copper shell drawn up and relieved with an oculus, for an inhabitant more at home in the sky than on earth. The woodsman's cabanon stretches horizontally, its weathered wood skin bound with metal strapping. Operable panels reveal the tectonic nature of the enclosure. A glimpse of the top of a chimney is the only hint at verticality, belying the immense extension into the earth below. The collage-drawing elevations convey the character, scale, and proportion of each cabanon. The designs have been further developed through analogue drawing methods, as demonstrated in a series of section drawings for each Cabanon. A dialogue between analogue and digital techniques offered a greater degree of control and precision, as well as a diversity of aesthetic effects. A digital version of Diderot's *Encyclopédie* was culled for image fragments.

They describe their process for the construction of one collage in the series:

> With our collage section through the Columbarium wall for the Cabanon Series, there was a necessity to make convincing the play of light and shadow across the vast façades and surfaces while conveying an aged materiality, connecting to the written

time[scape]lab, *Plate I. Cabanon – Saint-Exupéry* (2011)

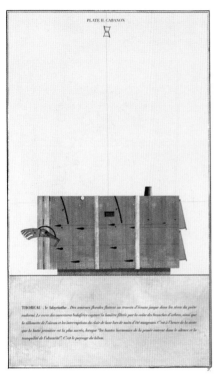
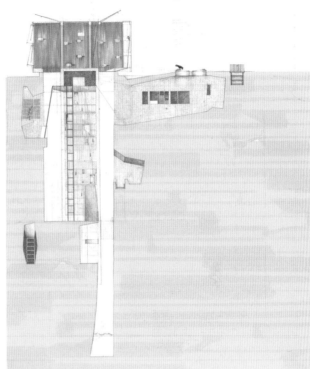

time[scape]lab, *Plate II. Cabanon – Thoreau* (2011)

narrative of a structure firmly rooted in the landscape for many years. We depicted a sense of time by washing images in the acid bath that is the facsimile. This process unified the textures by giving them an atomized or static pixelated appearance. Suddenly there was a thickness to the air. Fissures and surface flaws that were once almost imperceptible became more pronounced; the work of eroding elements. Moss and lichen established the north face. Surfaces were then subjected to the freeze and thaw of time. All forms in this collage, as with most in our analogue collages, were christened in the light of the photocopier.[84]

The imagination and experimentation evident in the collage-making techniques of time[scape]lab reinforce the promotion of these activities as articulated in their thesis. Ambroziak and McLellan propose that darkness and increasing obscurity facilitate "a kind of intellectual twilight where vision succumbs to the imagination"[85] – a rare circumstance in the technological age. The suppression of the visual as a critique of ocularcentrism parallels the development of collage as a vehicle for exploring the material and multivalent properties of space. The narrative of a social order provides a framework for this interrogation.

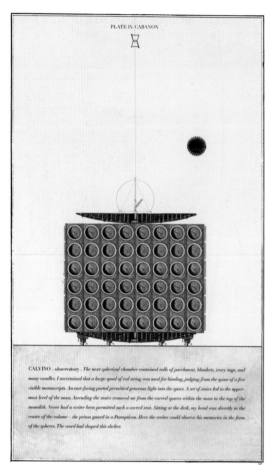

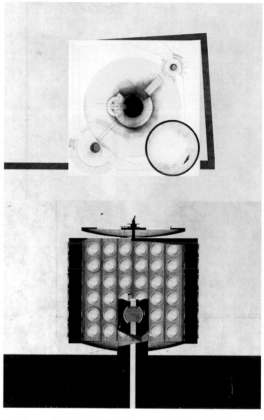

time[scape]lab, *Plate IV. Cabanon – Calvino* (2011)

Notes

1 Christine Poggi, *In Defiance of Painting: Cubism, Futurism, and the Invention of Collage* (New Haven: Yale University, 1992), 6.
2 Hal Foster, "Some Uses and Abuses of Russian Constructivism," in *Art Into Life: Russian Constructivism 1914–1932,* eds. Henry Art Gallery, Richard Adams, and Milena Kalinovska (New York: Rizzoli, 1990), 253.
3 Selim O. Khan-Magomedov, "Early Constructivism: From Representation to Construction," in *Art Into Life: Russian Constructivism 1914–1932,* eds. Henry Art Gallery, Richard Adams, and Milena Kalinovska (New York: Rizzoli, 1990), 62.
4 Christine Railing, "The Idea of Construction as the Creative Principle in Russian Avant-Garde Art," *Leonardo*, Vol. 28, No. 3 (1995), 196.
5 O. Khan-Magomedov, "Early Constructivism," 73.
6 Railing, "The Idea of Construction," 201.
7 Anatole Senkevitch, Jr., "The Sources and Ideals of Constructivism in Soviet Architecture," in *Art Into Life: Russian Constructivism 1914–1932,* eds. Henry Art Gallery, Richard Adams, and Milena Kalinovska (New York: Rizzoli, 1990), 171.

8 Juhani Pallasmaa, "Six themes for the next millennium," *Architectural Review*, Vol. 194, No. 1169 (July, 1994), 74–79.

9 El Lissitzky, *DeStijl*, Year V, No. 6, June, 1922.

10 Jeannine Fiedler, *Laszlo Moholy-Nagy 55* (London: Phaidon Press, 2001), 3.

11 Fiedler, *Laszlo Moholy-Nagy 55*, 14.

12 Dawn Ades, "G," in *The Dada Reader. A Critical Anthology*, ed. Dawn Ades (Tate Publishing : London 2006), 306.

13 Detlef Mertins, "Mies's Skyscraper 'Project': Towards the Redemption of Technical Structure," in *The Presence of Mies*, ed. Detlef Mertins (New York: Princeton Architectural Press, 1994), 58.

14 Mies van der Rohe's collage-drawing is held in the collection of the Museum of Modern Art.

15 Dan Hoffman, "The Receding Horizon of Mies – Work of The Cranbrook Architecture Studio," in *The Presence of Mies*, ed. Detlef Mertins (New York: Princeton Architectural Press, 1994), 105.

16 Detlef Mertins, "Mies's Event Space," *Grey Room*, No. 20 (Summer, 2005), 62.

17 Mies van der Rohe's collage-drawing is held in the collection of the Museum of Modern Art.

18 Neil Levine, "'The Significance of Facts': Mies's Collages Up Close and Personal," *Assemblage*, No. 37 (December, 1998), 87.

19 Arthur Drexler, *Ludwig Mies van der Rohe* (New York: George Braziller, 1960), 17.

20 John Hejduk, *Education of an Architect: The Cooper Union School of Art and Architecture, 1964–1971* (New York: Cooper Union, 1971), 280.

21 Hejduk, *Education of an Architect*, 5.

22 Hejduk, *Education of an Architect*, 5.

23 Hejduk, *Education of an Architect*, 47.

24 Stan Allen, "Libeskind's Practice of Laughter: An Introduction by Stan Allen," in "Between the Lines: Extension to the Berlin Museum," Daniel Libeskind, *Assemblage*, No. 12 (August, 1990), 18–57.

25 Dalibor Vesely, "The Drama of the Endgame," in *Between Zero and Infinity*, Daniel Libeskind (New York: Rizzoli International Publications, 1981), 105.

26 http://daniel-libeskind.com/projects/danish-jewish-museum

27 Daniel Libeskind, "Between the Lines: Extension to the Berlin Museum," *Assemblage*, No. 12 (August, 1990), 18–57.

28 Ben Nicholson, "Collage-Making," in *Appliance House* (Cambridge, MA: The MIT Press, 1990), 17.

29 http://en.wikipedia.org/wiki/Readymades_of_Marcel_Duchamp

30 Ben Nicholson, in conversation with author.

31 Nicholson, "Collage-Making," 16.

32 Nicholson, "Collage-Making," 20.

33 Ben Nicholson, "The Kleptoman Cell, Appliance House," *Assemblage*, No. 13. (December, 1990), 106.

34 Ben Nicholson, "What's in a Name?," *Appliance House* (Cambridge, MA: The MIT Press, 1990), 12.

35 Nicholson, "Collage-Making," 22.

36 Nicholson, "Collage-Making," 72.

37 James Corner, "Eidetic Operations and New Landscapes," in *Recovering Landscape: Essays in Contemporary Landscape Architecture*, ed. James Corner (New York: Princeton Architectural Press, 1999), 166.

38 Corner, "Eidetic Operations and New Landscapes," 163. Corner cites W.J.T. Mitchell in clarifying the distinction between picture and image as the difference between the concrete and the phenomenal, or between intentional and passive/automatic.

39 James Corner, "Introduction," in *Recovering Landscape: Essays in Contemporary Landscape Architecture*, ed. James Corner (New York: Princeton Architectural Press, 1999), 8.

40 Corner, "Eidetic Operations," 164.

41 James Corner and Alex S. MacLean. *Taking Measures Across the American Landscape* (New Haven: Yale University Press, 1996), 33.

42 Corner and MacLean, *Taking Measures*, 33.

43 Corner, "Introduction," 5.

44 Corner, "Eidetic Operations," 166.

45 Corner, "Eidetic Operations," 153.

46 Railing, "The Idea of Construction," 199.

47 A cube would rotate once a year, a pyramid, once a month, and a cylinder, once a day.

48 Peter Cook, ed., *Archigram* (New York: Princeton Architectural Press, 1999), 2.

49 Cook, ed., *Archigram*, 78.

50 "Amazing Archigram: A Supplement," *Perspecta*, Vol. 11 (1967), 133.

51 Peter Cook, "Accurate Reminiscences," in *Archigram: Symposium zur Ausstellung*, eds. Louis, Eleonora et al. (Vienna: Kunstalle Wien, 1997), 39.

52 Matilda McQuaid, ed., *Envisioning Architecture: Drawings from The Museum of Modern Art*. (New York: The Museum of Modern Art, 2002), 142.

53 Cook, ed., *Archigram*, 2.

54 Ron Herron, Archigram Archive.

55 Project Authors: Peter Cook, Dennis Crompton, Graham Foundation, Ron Herron, Gordon Pask.

56 Cook, ed., *Archigram*, 86.

57 Cook, ed., *Archigram*, 89.

58 Cook, ed., *Archigram*, 89.

59 "Superstudio: Progetti E Pensieri," *Domus*, Vol. 479 (1969), 38–(43).

60 Members include Adolfo Natalini, Cristiano Toraldo di Francia, Andrea Branzi, Roberto Magris, G., Alessandro Magris, Piero Frassinelli, Massimo Morozzi, and Alessandro Poli (1970–72).

61 "Superstudio: Progetti E Pensieri," *Domus*, Vol. 479 (1969), 38–(43).

62 Superstudio, *The Continuous Monument: An Architectural Model for Total Urbanization* (Archivio Superstudio, Firenze, 1969).

63 Cristiano Toraldo di Francia, "Memories of Superstudio," in *Superstudio: Life Without Objects*, Peter Lang and William Menking (Milano: Skira Editore, 2003), 69.

64 Common themes can be seen in the work of Constant Neiwenhuys and The Situationists in Paris, where the city as playground was conceived of through collage and assemblage.

65 Toraldo di Francia, "Memories of Superstudio," 70.

66 Peter Lang and William Menking, *Superstudio: Life Without Objects* (Milano: Skira Editore, 2003), 166.

67 Lang and Menking, *Superstudio*, 167.

68 "Mindscapes: An Exhibition Organized By Walker Art Center," *Design Quarterly*, Vol. 89 (1973), 17–31.

69 Terence Riley, ed., *The Changing of the Avant-Garde: Visionary Architectural Drawings from the Howard Gilman Collection* (New York: The Museum of Modern Art, 2002), 72.

70 Lang and Menking, *Superstudio*, 164.

71 The Museum of Modern Art, *The Changing of the Avant-Garde: Visionary Architectural*

Drawings from the Howard Gilman Collection (New York: The Museum of Modern Art, 2002), 12.

72 Rem Koolhaas, "The Terrifying Beauty of the Twentieth Century" (1985), in *OMA-Rem Koolhaas: Architecture 1970–1990*, ed. Jacques Lucan (New York: Princeton Architectural Press, 1991), 155.

73 Rem Koolhaas / OMA, *Content* (New York: Taschen, 2004).

74 Excerpt from "Arkhitektura SSSR," No, 3 (1930), http://utopia.ru/english/e_leonidov/e_index.htm

75 Jean-Louis Cohen, "The Rational Rebel, or the Urban Agenda of OMA," in *OMA-Rem Koolhaas: Architecture 1970–1990*, ed. Jacques Lucan (New York: Princeton Architectural Press, 1991), 14.

76 Rem Koolhaas, "Sixteen Years of OMA" (1988), in *OMA-Rem Koolhaas: Architecture 1970–1990*, ed. Jacques Lucan (New York: Princeton Architectural Press, 1991), 162.

77 Jeffrey Kipnis, *Perfect Acts of Architecture* (New York: Harry N. Abrams, 2001), 14.

78 Jacques Lucan, *OMA-Rem Koolhaas: Architecture 1970–1990* (New York: Princeton Architectural Press, 1991), 86.

79 Lucan, *OMA-Rem Koolhaas*, 91.

80 "Rem Koolhaas – McCormick Tribune Campus Center," *Arcspace.com*, ed. Kirsten Kiser, February 18, 2004 (accessed February 19, 2012): www.arcspace.com/architects/koolhaas/McCormick-Tribune/.

81 Cohen, "The Rational Rebel," 9.

82 Note to author.

83 Brian Ambroziak and Andrew McLellan, "A Resurrection of Night," *MADE: Design Education and the Art of Making*, Proceedings of the 26th National Conference on the Beginning Design Student, University of North Carolina, Charlotte, 2010, 201.

84 Note to author.

85 Ambroziak and McLellan, "A Resurrection of Night," 201.

1.3 Photomontage

Photomontage is any photographic image created by combining multiple photographic image fragments extracted from various sources. While photomontage is sometimes differentiated from collage, it is a juxtaposition and assembly of unrelated fragments, and as such, is a subset of collage. Traditionally, due to the nature of the source material as representational, resultant photomontages tend to be representational – though interpretive – depictions of forms and spaces rather than abstract compositions, with some exceptions. Artists and architects included in this chapter demonstrate an appropriation of image fragments for texture, pattern, and color rather than solely form and meaning, presenting opportunities to test spatial and material concepts. Photomontage as defined here contains image fragments exclusively, in contrast with collage-drawing which synthesizes image fragments with other media.

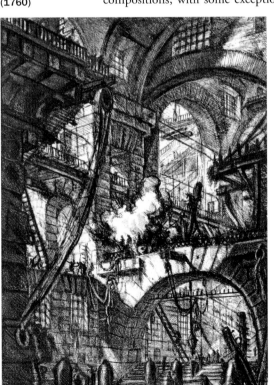

Giovanni Battista Piranesi, *Untitled [The Smoking Fire]* (1760)

The work of eighteenth-century Italian artist Giovanni Battista Piranesi serves as an early precedent for photomontage. His engravings, particularly the *Carceri* series (The Prisons), meld diverse architectural fragments to envision monumental and fantastic architectures. Aldous Huxley wrote about the *Carceri* in 1949: "Considered from a purely formal standpoint, the Prisons are remarkable as being the nearest eighteenth-century approach to abstract art. The raw material of Piranesi's designs consists of architectural forms; but, because the Prisons are images of confusion, because their essence is pointlessness, the combination of architectural forms never adds up to an architectural drawing, but remains a free design

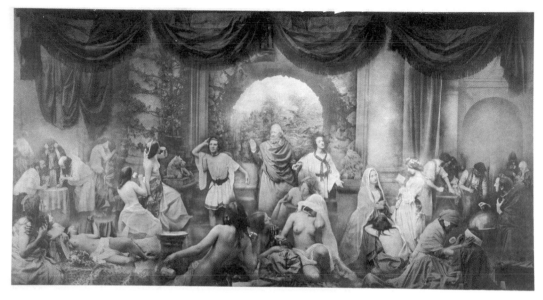

Oscar Rejlander,
The Two Ways of Life (1857)

. . . designs which resemble the abstractions of the Cubists in being composed of geo-metrical elements,"[1] but which integrate pure geometries with conceptual and emotive content. This strategy re-emerges in late nineteenth and early twentieth century inno-vations in photomontage.

Artists in the Victorian era first explored photomontage after the invention of the photograph. An early example of the layering and synthesis of multiple photo-graphic images is *The Two Ways of Life* created in 1857 by Swedish photographer Oscar Rejlander through a process called combination printing, in which the resultant image is a seamless composition of 32 images. The intent, use of media, and techniques of photomontage shifted at the turn of the twentieth century, as cameras became mass-produced and readily accessible. Photographic printing in the mass media became commonplace, marking the subsequent proliferation of photomontage.

Dada artist Raoul Hausmann claimed the invention of photomontage in 1918, although other Dada artists including Hannah Höch and John Heartfield as well as artists in the Russian Avant-Garde were experimenting with this technique around the same time. As a medium re-invented in the movements following Cubism, photomontage, like other forms of collage, owes much to the re-conception of space initiated by the Cubists. Klaus Honnef, in an analysis of John Heartfield's photo-montages, stated that, "Even if the Cubist painters initially left the pictorial surface untouched, they replaced the 'plastic' and comprehensible space of the now traditional painting with the heterogeneous and discontinuous space of montage."[2] This complex and variegated space is where the potential for spatial and material exploration occurs.

Images employed in photomontage have been acquired from a variety of sources, ranging from photographs to catalogues to magazines, to larger-scale repre-sentational material such as posters and billboards. The image sources can be divided into two camps: the found and the constructed. Artists and architects working in

photomontage may work with images that are appropriated from print media – *found* images – or they may themselves take photographs for use in photomontages – *con-structed* images. This chapter will organize artists and architects according to this dichotomy.

In the process of analysis and design, architects have utilized each of these two distinct approaches to photomontage – the found and the constructed. Photomontage has been described by Honnef as "a territory that mediated, so to speak, between art and reality,"[3] which defines the architect's role as (s)he transforms design concepts into built form. The architects employing the first approach, following in the footsteps of many artists utilizing appropriated images in photomontage, include Nils-Ole Lund and David Wild, who have explored the relationships between found image fragments both spatially and semantically.

In contrast, architects and designers such as Gordon Matta-Clark, Mary Miss, Enric Miralles and Benedetta Tagliabue, and Teddy Cruz have constructed images to create dynamic, layered compositions that speak to a simultaneity of spatial and material experience. In addition to the spatial dimension to which photomontage lends itself, it is equally suited to capture the temporal dimension. Like many of the artists and architects working in collage-drawing, photomontage has been used to address immediate cultural concerns about the state of the practice of architecture, manifesting critical commentaries on existing or future utopic/dystopic conditions. The spatial and temporal conditions of architecture suggest photomontage as an exemplary collage technique for use in the process of analysis and design, as we recognize its proliferation in the field of architecture throughout the past century.

Photo Fragments: Found

Under the rubric of *found* photomontages, the aggregation of images may take on one of two means of synthesis: fragmented and multiplicitous, or seamless yet contradictory. In the first, the characteristics of the image fragments may vary greatly, creating a tension and a disjuncture between the fragments. In this case, the synthesis stems from the juxtaposition of meaning held by each image and their meaning in relation to other fragments. Examples of this approach in photomontage include the work of Raoul Hausmann, Hannah Höch, and Romare Bearden. Alternatively, the images composing the photomontage may exhibit commonalities of color, contrast, line, and/ or scale, allowing for a highly synthesized and seamless image. It is difficult to identify the individual image fragments in the photomontages of John Heartfield, Max Ernst, and Joseph Cornell. Constructed photomontages tend to fall into the first category, in that there are obvious disjunctures and multiple viewpoints.

Fragmented and multiplicitous compositions are characteristic of the work of Raoul Hausmann and other Dada artists. Hausmann claimed that "the first type of photomontage was the shattering of the surface by the multiplication of points of view and by the whirling interpenetration of many surfaces of images."[4] This mentality

reflects the unique conceptual framework established by the Cubists, investigated through a new medium. Artists working with photomontage as a means to embody simultaneity typically use appropriated images from print media.

Artists and architects working with images extracted from print media select image fragments based on characteristics such as content (first-order meaning), scale, texture, and color. Often collage artists will keep folders or boxes with images collected over time, to be selected, compared, and juxtaposed for use in a particular composition. In a discussion of spatial and temporal distance, Sergei Tretyakov points out that "the relative size of the objects in a photomontage plays an important semantic role,"[5] the relative size serving to either give second-order meaning or to establish depth. The perceived scale also serves to heighten or minimize the disjuncture between fragments.

Hannah Höch was a pioneer in photomontage and one of the few women recognized in Dadaism. Kristin Makholm, in an analysis of Höch's photomontages, observes that the appropriation of mass-market media allowed her and other Dada artists to reconfigure "the images of daily life into abstracted works reminiscent of the hectic pace of modern urban life."[6] In the 1920s she was exposed to the collages of friends including fellow Dada artists Kurt Schwitters, Jean Arp, and Sophie Tauber-Arp, Bauhaus artist László Moholy-Nagy, and De Stijl artists Theo and Nelly van Doesburg. Some of Höch's photomontages address the canvas by filling it, flattening the space implied by the photomontage and implying an extension of the images beyond the boundaries of the canvas. Others aggregate the images into a complete figure within the field of the canvas, allowing the photomontage to become an autonomous object.

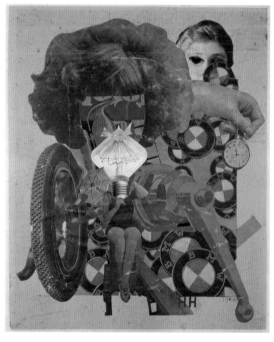

Hannah Höch, *Das schone Madchen [The Beautiful Girl]* (1920)

© 2012 Artists Rights Society (ARS), New York / VG Bild-Kunst, Bonn

Another important artist responsible for advancements in photomontage theory and technique is Romare Bearden, a Charlotte, North Carolina native who lived in Paris in the 1950s. As a friend of Georges Braque, evidence of a Cubist influence is embodied in the shallow pictorial space of Bearden's photomontages. Bearden took art classes at New York University from Dada artist George Grosz, a collaborator of collage artist John Heartfield who created highly synthesized photomontages. In Bearden's *Projections* series, he photographed and reprinted his colorful collages as larger-scale black and white images. Removing color serves to integrate and synthesize the images, so that, other than contradictions of scale, it becomes more difficult to identify individual fragments. Bearden has been linked to the Abstract Expressionism movement in the US, which intended to merge elements of reality with imagination by combining the familiar with the unknown, the personal with the universal. He

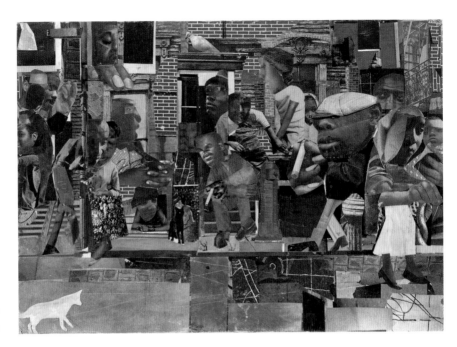

Romare Bearden,
The Dove (1964)

Art © Romare Bearden
Foundation / Licensed
by VAGA, New York, NY

began to work in collage during the 1960s civil rights movement in order to draw attention to this cultural struggle. Unlike the abstract figuration of the other artists in this movement, Bearden turned towards representational work. It is important to note the weathered quality that is achieved in the image fragments through the use of a printmaker's brayer, as the paper wrinkles and becomes worn under the roller. The weathered condition of the collage demonstrates the specificity of techniques developed by artists working in photomontage to reinforce their conceptual intent. Bearden was considered the nation's foremost collagist at the time of his death in the late 1980s.

The second approach to photomontage shows the potential to assimilate disparate images, creating a seemingly unified composition from a single viewpoint which upon closer inspection reveals disjunctures and contradictions. Artists exploiting photomontage from this perspective include John Heartfield, Max Ernst, and Joseph Cornell. Both approaches imbue photographic fragments with another layer of meaning as a result of their compositional or contextual relationship with other fragments, offering new spatial or conceptual meaning.

John Heartfield, a Dada artist skilled in photomontage, and Max Ernst, considered one of the pioneers of both Dadaism and Surrealism, were famous for their collages that appear to create a unified, seamless image. Heartfield's photomontages focused on conveying the evils of the Nazi regime, while Ernst's collages were not socially or politically motivated but instead focused on surreal, imaginary spaces and events.

Freud's concept of condensation is evident in Ernst's collages: "the pushing together of two or more elements into a new word or phrase so that each original element retains its own character while effectively interacting with the others."[7] This

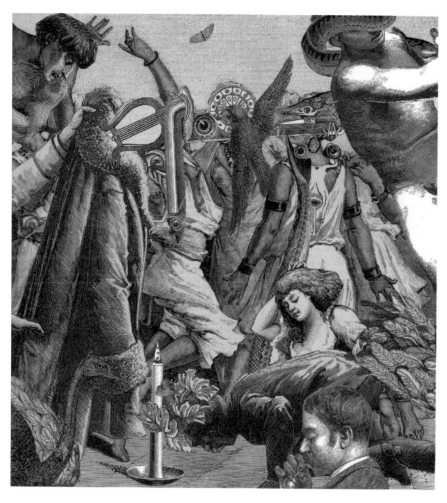

Max Ernst, *Women Reveling Violently and Waving in Menacing Air* (1929) – demonstrates a seamless technique of aggregation; fragments can only be identified through different paper tones

© 2012 Artists Rights Society (ARS), New York / ADAGP, Paris

refers to semantics in language, but has an obvious technical correlation to collage. Ernst's source materials at this time were magazines and encyclopedias; in 1921 he began using wood engravings found in turn-of-the-century magazines. In 1934, Ernst completed a graphic novel, *Une Semaine de Bonté* (*A Week of Kindness*) in just three weeks, consisting of 182 collages composed of illustrations from Victorian novels and encyclopedias. In his essay "Beyond Painting," Ernst described his collage process as "something like the alchemy of the visual image. The miracle of the total trans-figuration of beings and objects with or without modification of their physical or anatomical aspect."[8] Ernst invented a number of techniques to incorporate into his collage-making process, and the process itself was invaluable to him. These techniques include *frottage*, a method of rubbing, and *grattage*, which entailed scraping dried paint off of the surface of the canvas.

The tactility and layered/weathered surfaces lend themselves to a reading of both Ernst's and Cornell's collages as a microcosm of an architectural experience. Joseph Cornell was famous for his boxed constructions or assemblages of found

objects. Cornell produced fewer boxed assemblages in the 1950s and 1960s and instead focused on the creation of two-dimensional collages. Drawing from Cubist themes, Cornell explored fragmentation and new relationships and understandings that might be revealed as a result. He valued found objects and images, compelled by a sense of nostalgia. His photomontages have a sense of mystery and poetic calm, moving the viewer to create his/her own narrative and encouraging personal reflections to inform perception of the work. Some of his photomontages literally establish frames through which the viewer can look and reflect. Cornell wanted to suggest "the world of the imagination – the entire realm of fantasy – that lay beyond the realm of the real."[9] The creation of imagined worlds as amalgamations of semantically rich imagery in the vein of the aforementioned artists drives the work of architects Nils-Ole Lund and David Wild.

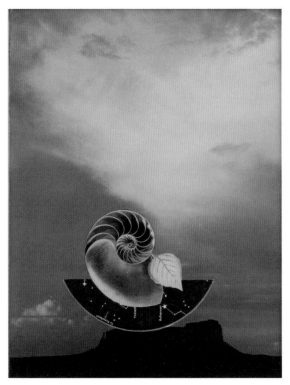

Joseph Cornell, *Madame Mallarmé's Fan* (1954)

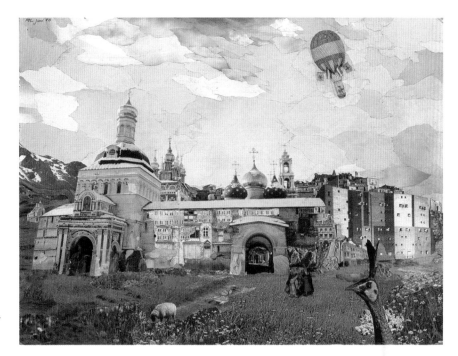

Nils-Ole Lund, *401. The Town in the Landscape* (1980)

NILS-OLE LUND

As a practising architect and later as a critic I have learned how the profession works, where the architects get their ideas and how they translate these ideas into forms. During this process the original content is normally watered down and a gap opens between theory and practice. As architecture is an art of the practicable and the constrained, it cannot of course respond to all new bodies of thought, and when the architects desperately try, their efforts create tensions between content and form, tensions which can be exploited and turned into pictures. In the collages it is possible to mix the world of ideas with the world of building and the resulting imagery can be read in a way which supplements the normal professional dialogue.[10]

Nils-Ole Lund, Introduction to *Collage Architecture*

Nils-Ole Lund, a Danish architect and academic, has sought to bridge the divide between the theory and practice of architecture through collage. Lund began making photomontages in the 1960s but his collage-making accelerated in the 1970s as a visiting professor at the University of Washington in St. Louis, as a means of reconciling cultural differences. Collage-making served a cathartic purpose amidst the social conflict and instability of American urban culture at the time. "The collage," Lund says, "can illustrate the distance between the specific utopias of our profession and its actual professional means and possibilities, and, moreover, you can vivisect architectural trends and tendencies by collages whose composed images come closer to actual architecture than the written word."[11] The disjuncture between the idealism of the academy and the social unrest of the city around him could be considered and explored through photomontage. The advent of Pop Art in the US at this time, particularly the collage work of Robert Rauschenberg, was influential in Lund's own collage-making.[12] Irony and parody as tools to critique Modern architecture and technology provided the conceptual underpinnings for much of Pop Art, as well as the analytical photomontages of Lund. A selection of his collages was published as a monograph entitled *Collage Architecture* in 1990.

 Although Lund's collages often serve as a critique of the destructive potential of the architectural profession in its impact on cities and landscapes, Christian W. Thomsen describes Lund's approach as one that draws deeply from architectural history and theory to situate the critique in a spatial and temporal context. He has made visible "beyond distances in space and time dimensions of artistic and historical depth by putting together seemingly heterogeneous elements into new unities which also develop aesthetic and philosophical qualities of their own."[13] These qualities bear comparison with the Surrealists. The highly synthesized and calmly surreal worlds created by Lund through photomontage are indebted to the work of Max Ernst and Joseph Cornell, albeit with a more overtly architectural intent. Color palette, image sources, and relative scale are reductive, conspiring to create the dreamlike natural and architectural environments of the Surrealists and Nils-Ole Lund.

Nils-Ole Lund, *806. Architectural Outlook* (1987)

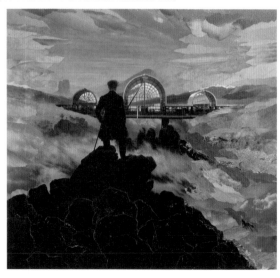

 Lund's sources for image fragments include magazines, journals, and advertisements. These images have been extracted from their source documents in a process of image acquisition, to be filed according to content. These files, with names such as *monsters*, *flying women*, and *caves*, provide temporary homes to these image fragments until they are identified for use in a photomontage.[14] Lund talks about his process, saying: "When I start making collages in most cases I have one or two basic pictures, two contrasting images, the rest is added, ideas, details, accessories."[15] While Lund's work certainly

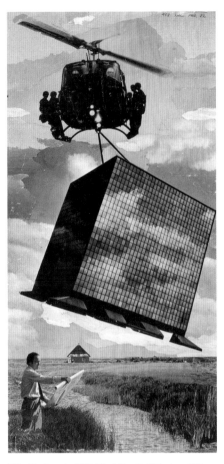

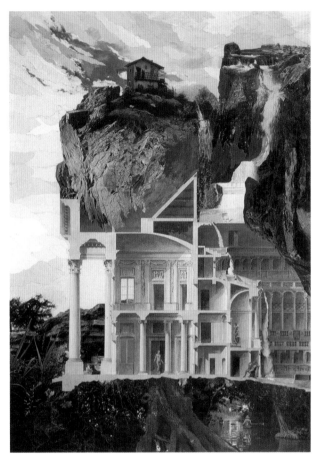

Nils-Ole Lund, *488. First the Building and Then the Site* (1982)

Nils-Ole Lund, *763. The Mountain* (1986)

addresses broader cultural and architectural themes, each collage has a rich haptic quality, speaking to the materiality and experiential conditions of the fictional places that he has created.

In an analysis of Lund's highly synthesized photomontages, Thomsen identifies three types. In the first, Lund combines heterogeneous architectural elements into a unified architectural entity as a simulation of an alternative reality. The individual image fragments lose their autonomy and identity apart from the composition, blending into a single homogenous view.

In the second approach, Lund transplants existing works of architecture into alternative environments, creating homogenous and holistic yet artificial scenes by juxtaposing architecture and nature. Lund's *The Mountain* is a unique expression of this dialogue between nature and artifice as the dominant architectural image is a Beaux-Arts section drawing. The geometric figure of the section plays off the rough organic textures of the mountain in which it is embedded. As a subset within this method, Lund's photomontage series *The Future of Architecture* from 1979 illustrates

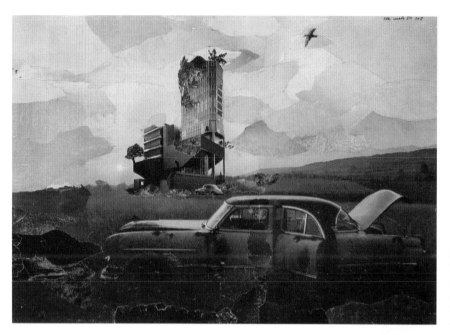

Nils-Ole Lund,
*The Future of
Architecture –
James Stirling's
Engineering
Building* (1979)

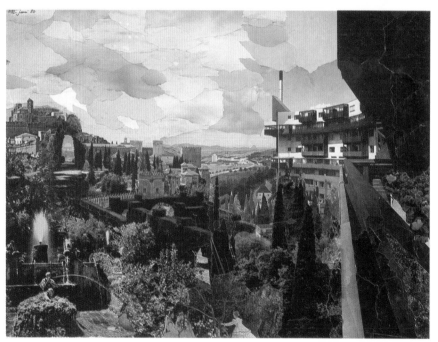

Nils-Ole Lund, *402.
The Town Inside
the Walls* (1980)
– photomontage
includes fragments
of Erskine's Byker
Wall, the Alhambra,
and the Villa d'Este

existing works of modern architecture in an anticipated future context. These collages
satirize Modernism's lack of character, materiality, and capacity to weather gracefully,
and buildings are often depicted as ruins. Lund often calls out specific iconic build-
ings and architects, such as Louis Kahn's Salk Institute, juxtaposed against nature
that has invaded the space of what once was a pristine concrete courtyard, or James

Sterling's Engineering Building, an abandoned machine akin to the rusting car in the foreground.

The third method envisions large-scale urban constructs. Lund considers harmony and overlap between diverse structures and landscapes, creating fictitious architectural realities combining fragments of history and modernism. These three approaches to the synthetic photomontage offer a diversity of scales for critical analysis while maintaining an aesthetic language.

Lund's consideration of collage as a concept and practice for analyzing the urban environment parallels the publication of Rowe and Koetter's *Collage City* (1978). Both mount a critique of the intended purity of Modern architecture and the city, instead advocating a multivalent, layered, and eclectic approach. Lund has written little on his technical or conceptual approach to collage, relying instead on the semantic value contained within each of over 900 photomontages to convey his architectural theory and criticism. The high level of refinement, precision, and synthesis in the photomontages of Nils-Ole Lund anticipates these strategies in contemporary practices that have begun to interrogate the role of digital methods in collage-making.

David Wild, *The Age
of the Machine:
Portrait of Engels*
(2002)

DAVID WILD

By the time of *Fragments of Utopia* (Hyphen Press, 1998) it became harder to say
which came first, the collage or the text . . . Current compositions could be said to
include an element of nostalgia for a vision of the future lost in the past, continuing
the antique method of cut and paste.[16]

David Wild (writing to author)

The architect and academic David Wild, author of *Fragments of Utopia: Collage Reflections of Heroic Modernism*, was educated at the Architectural Association in the early 1960s under faculty that included members of Archigram. In 1969, he was invited to return to teach at the AA by Archigram's Peter Cook. He subsequently found a political voice in Britain during the Vietnam War as editor of leftist architectural magazine *ARse*. The acronym ARSE stood for "ARCHITECTURAL RADICALS, STUDENTS & EDUCATORS OR WHATEVER YOU WANT TO CALL US." The intent of the magazine was "to analyse and do propaganda on the position of the architect in capitalist society,"[17] and was published from 1969 to 1972. Wild was significantly influenced by the Russian Constructivists in his writing and collage-making, as he points out, having been introduced to their work at the AA by Kenneth Frampton. Wild describes Archigram (the magazine and the group) as "a rip off of Russian constructivism, but without the politics,"[18] however the critical social perspective and narrative framework for architectural interrogation is common to both Archigram and Wild, and has continued throughout Wild's career.

David Wild, *ARse No. 3* (1969)

 Two decades later, in 1990, a fire at Wild's house and studio provided the impetus to begin constructing photomontages. He had only recently designed and completed the house and studio in 1989. Fire and water damaged books that he had collected over three decades, and he points out that the "salvage operation was the starting point for the first collages."[19] In 1992, Wild used fragments gleaned from the damaged books to create a Christmas card, "showing the house in an idealized setting."[20]

David Wild, *Christmas Card* (1992)

David Wild, *De Stijl*
(1995)

The photomontages that were to follow are indebted to Russian Constructivism both thematically and technically, drawing on his interests and motivations going back to the 1960s. In its precision and seamlessness, his work also bears an aesthetic resemblance to the work of Nils-Ole Lund, whom he met in Norway in 1969. Wild describes Lund as "the master of architectural collage."[21] The link between these two collage architects continued when Lund included an image of Wild's house in one of his photomontages for the book *Collage Architecture* ("The good habitat 3"): as Wild explains, "at the centre of which stood the stove that caused the catastrophic editing of my library."[22] The cultural commentary and visionary spirit of the Constructivists and Lund has been taken up by Wild, as he describes utopia. "Utopia, by its very nature, will always be elusive and fragmentary. But a spirit of hope and a refusal to accept conservative resignation to the idea that the present state of affairs cannot be improved and that the human condition will never change: these are the things that provide the radical, utopian impulse."[23]

Wild's book of photomontages, *Fragments of Utopia*, is divided into three sections, considering utopian themes in the Netherlands, the USSR, and the work of Le Corbusier around the world, beginning in the 1910s in each case. In his series on the Netherlands, Wild investigates the social equity of Dutch society. This is an outcome of the integrated building infrastructure and density necessitated by the instability of the landscape. The architecture of De Stijl also figures prominently in the collages in this series. The compositional strategies of De Stijl inform the frontality and geometry of the photomontage of the same name. Postage stamps are incorporated into many of the collages in the book, offering both content and form to the compositions. Each stamp highlights an important personage, a work of modern art or architecture of the era, the meaning interwoven with the content of the collage composition.

The political instability of Russia in the early twentieth century stands in stark contrast to the cohesion and progressive nature of the Netherlands at this time. This instability and oppression motivated the Russian Avant-Garde both politically and formally in their art and architecture. Meaning and form in this era has been captured by Wild's photomontage series. *Heroes of Labour* is unique in its monochromy – the greyscale images serve a semantic purpose, conveying the power of industrialization and suppression of the individual. Aesthetically, greyscale images facilitate a synthesis of fragments. The fragment edges become almost indefinable as the consistency

David Wild, *Heroes of labour* (1998)

of color and tone creates an assimilated composition. In this photomontage, the juxtaposition of scale is the only visual cue to the autonomy of the original image fragments.

In the third series, Wild considers "Le Corbusier's Utopianism" on three continents. The political climate of the early twentieth century had significant impact on the life and work of Le Corbusier, ranging from his contribution to economic

social housing in Germany (with Mies van der Rohe as master planner), to the 1940 occupation of Paris that displaced Le Corbusier, to his commissions in the US and India. In *Naked Graffiti*, Wild captures the absurdity of Le Corbusier's lifestyle amid the growing terror in Germany in 1939. Wild says, "Le Corbusier was to be found in the nude, painting on the walls of the empty villa of Eileen Gray and Jean Badovici, on the Côte d'Azur."[24] (Eileen Gray considered Le Corbusier's graffiti as vandalism.) The small cabin shown above the house in Wild's photomontage likely represents Le Corbusier's Cabanon that he would build nearby shortly after the war. The use of the German stamp containing Hitler's likeness contrasts the Bohemian lifestyle of the Côte d'Azur with the growing authoritarian repression. Each of the photomontages in *Fragments of Utopia* developed as a visualization of the content of the associated narrative. Although there is a thematic consistency, the execution of the photomontages varies from the highly assimilated to the minimal and fragmented, more akin to the collage-drawing techniques of the Constructivists.

Wild's recent photomontages have a nostalgic quality that stems from the more consistent and prolific use of fragments of etchings and engravings. A recently completed photomontage, *The Age of Steam: Portrait of Marx*, is highly synthesized through the use of image fragments with similar color and texture, in contrast with

David Wild, *Naked Graffiti* (1997)

David Wild, *The Age of Steam: Portrait of Marx* (2011)

many of his earlier collages that establish more obvious juxtapositions. Wild's photo-montages continue to interrogate the role of memory and history in collage through the meaning embodied in the image fragments, more narrowly focused on the histori-cal dialogue between society and technology.

The physicality of collage-making parallels the realities of architectural con-struction, both significant pursuits for Wild. An essay in *Architecture Today* speaks to his architecture, describing how, "For Wild, architectural work must have a theme, it must embody a discussion of ideas, some of which might appear to be in opposi-tion."[25] Wild was both architect and builder of the Cypher House completed in 2009 in London as a composition of walls defining two courtyards. The essay articulates that while it is the "Modernist intention to allow the full volume to be sensed or understood; here structure is suppressed . . . These walls are modulated first by vari-ations within the split-level section and second by a series of transparencies."[26] The legacy of De Stijl, Constructivism, and Le Corbusier is not only manifested in Wild's photomontages, but embodied by his works of architecture in the prioritization of construction, composition, and abstraction.

David Wild, Cypher House (2009)

Photo Fragments: Constructed

The juxtaposition of image fragments in photomontage and the multivalent meaning of the fragments that results from this juxtaposition inform the image selection, and ultimately, the power of the photomontage. Hausmann asserted: "By its oppositions between the rough and the smooth, between the aerial view and the cinematic close-up, between perspective and the flat surface, photomontage offers the greatest technical variety – that is, the most compelling elaboration of the dialectic of forms."[27] (While a similar methodology is employed in digital photomontages, the potential for fluid transformations from image to image is unique, and is discussed in Chapter 1.4.) As an alternative to extracting images from existing publications, some artists and architects have created photomontages from photographs that they have taken, giving them substantially more control over the content, scale, perspective, and super-imposition. El Lissitzky, noted for his role in the development of collage-drawing techniques, also worked in photomontage and combination printing using his own photography. In the birth announcement he created for his son in 1930, El Lissitzky used combination printing to seamlessly layer an image of the infant over a ground of soviet propaganda images.

El Lissitzky, *The Constructor (Self-Portrait)* (1924)

In El Lissitzky's photomontage *The Constructor (Self-Portrait)*, he embodied critical dualities that were thematically consistent in the work of the Constructivists. He addressed the integration of a mechanical aesthetic with handcraft, and the dualities of the eye/hand, vision/touch, surface/space, and composition/construction. Crucial to the Constructivist ideology, compositions are passive and introspective, while constructions are active, in real space, with specific materiality. An interest in material constructs is common to the architects creating photomontages in this vein. Russian Constructivists associated with LEF (Left Front of the Arts), "cultivate photomontage (conditionally) precisely because they see it as a bridge from 'abstraction' to 'material,' from 'cognition' to 'construction,' from the illusionistic and symbolic 'general' to the concrete and real 'particular,'" according to LEF member Nikolai Chuzhak.[28] Gordon Matta-Clark, Mary Miss, Miralles Tagliabue, and Teddy Cruz all demonstrate a dedication to tectonic construction as explored and concretized through photomontage.

Like these artists/architects, British artist David Hockney has exploited the value of photomontage as an analytical tool with which to understand existing conditions, in addition to material potential. Hockney's interest in photomontage stems from his critique of photography as indexical: that it is generally an accurate depiction of reality at a moment in time, without offering multiple readings or ambiguities. His early photomontages combine Polaroid images taken in a given location from a multitude of vantage points. Although the media differs, the spatial and formal frag-

mentation and collapse that occurs through the implication of multiple viewpoints is certainly indebted to the Cubists. Whether investigating the scale of an urban space or a piece of furniture, Hockney "seeks to select, to discriminate, to describe as a painter does, to add layers of time to the photographic moment" through the creation of his 'joiners.'[29] Numerous artists and architects have been drawn to this technique due to the capacity for photomontage with constructed images to capture temporal conditions of the existing context. This paired with a dedication to construction and materiality links the work of the following architects in their conceptual and technical intent.

Gordon Matta-Clark, *Circus – The Caribbean Orange* (1978) – retention of the edges of the film negatives emphasizes the temporality of the image

© 2012 Estate of Gordon Matta-Clark / Artists Rights Society (ARS), New York

GORDON MATTA-CLARK

There is collaging and montaging. I like very much the idea of breaking – the same way I cut up buildings. I like the idea that the sacred photo framing process is equally "violatable." And I think that's partly a carry-over from the way I deal with structures to the way I deal with photography. That kind of rigid, very academic, literary convention about photography which doesn't interest me. Oh, it's not that it really doesn't interest me. It's that I find that for what I do, it's necessary to break away from it. I start out with an attempt to use multiple images to capture the "all-around" experience of the piece. It is an approximation of this kind of ambulatory "getting-to-know" what the space is about. Basically it is a way of passing through the space.[30]

Gordon Matta-Clark in an interview with Judith Russi Kirshner, February 1978

Gordon Matta-Clark's work addresses the human experience of space that lies outside what can be measured or quantified. His work, temporary and time- and labor-intensive in its (de)construction, reveals the layering and complexity of existing structures while often simultaneously highlighting social concerns. He used photomontage and art installations as a form of activism, offering commentary on the decay of the American city and the evaporation of the American dream. As the son of Chilean Surrealist painter Roberto Matta, Matta-Clark's work demonstrates a legacy extending back to both Surrealism and Dada. Matta-Clark described the importance of Dada to his work as theoretical rather than stylistic, saying: "Dada's devotion to the imaginative disruption of convention is an essential liberation force."[31] The "disruption of convention" is a strategy evident in Matta-Clark's work, regardless of medium. Encouraged by his father to attend architecture school (Roberto Matta had been trained as an architect and apprenticed under Le Corbusier in Paris), Matta-Clark studied architecture at Cornell in the 1960s but never practiced. He worked as an artist until his tragic death at the age of 35.

Matta-Clark's experience in architecture school was influential in the trajectory of his work. He critiqued his pedagogical experience at Cornell, describing how, "the things we studied always involved such surface formalism that I had never a sense of the ambiguity of a structure, the ambiguity of a place, and that's the quality I'm interested in generating in what I do."[32] An interest in ambiguity with regard to spatial and material experience led him to articulate the concept of *Anarchitecture*. *Anarchitecture* was a stand against formalism and the status quo in the architecture profession. An aversion to the institutional and professional conception of architecture maintained by Matta-Clark paralleled the attitude of Superstudio. Superstudio member Adolfo Natalini wrote in 1971: "if design is merely an inducement to consume, then we must reject design . . . until all design activities are aimed towards meeting primary needs. Until then, design must disappear. We can live without architecture."[33]

Didactic themes such as this were often investigated through interventions in abandoned structures. Matta-Clark scavenged existing structures in the same way collage artists scavenge existing publications for raw material, creating new forms and spaces through subtraction and displacement. Matta-Clark's interest in the detritus of the city links him to the collage methodologies of artists such as Joseph Cornell and Robert Rauschenberg in the reclamation of waste, valued for its meaning as well as its haptic material char-

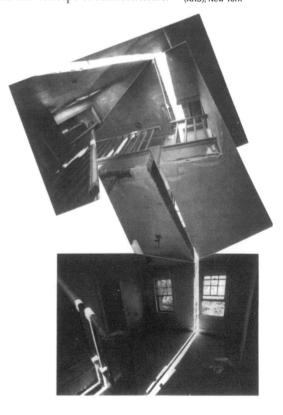

Gordon Matta-Clark, *Splitting* (1974)

© 2012 Estate of Gordon Matta-Clark / Artists Rights Society (ARS), New York

acter. Matta-Clark's most famous work, *Splitting* (1973), consisted of an installation, video, photographs, and photomontages. The project entailed Matta-Clark methodically sawing an abandoned New Jersey house in two. The video recorded the physical process and documented the violence in the act of demolition. As one side of the house was lowered the split appeared, with the intention of evoking the disintegration of the American family and the American dream. As an ephemeral work, photography and photomontage became the vehicles with which to archive the project.

Matta-Clark described the role of photomontage as a correlate to his physical installations:

> It's gone from just the snapshot to a process documentation to a kind of personalized process documentation to a sort of voyeuristic interpretation and then finally into some sort of thing where the whole looking at the piece being made and having been finished becomes a narrative which is subject to all kinds of variations. What's happened is that I've become systematically interested in the way of doing photographs. I'm interested in working with photographs and trying to avoid and overcome some clichés that have been developed dealing with multiple images.[34]

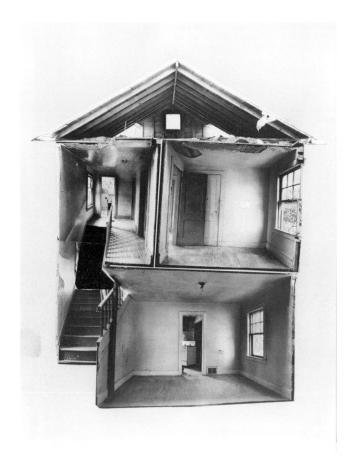

Matta-Clark found photography and the construction of photomontages to necessitate the same intentionality as the work being documented, becoming artifacts in and of themselves. In an analysis of Matta-Clark's photomontages, Stephen Walker points out: "The results of these experiments in representation can not only be read back over, and clarify, the kind of kinesthetic experience available within the buildings; they can arguably extend and complicate it."[35] Photomontage offers the most suitable medium with which to capture the fractured spatial and temporal experience provided by Matta-Clark's installations, layering and superimposing multiple viewpoints and physical fragments and synthesizing them into a comprehensible whole. The first-person process of experiencing, absorbing, and evaluating a Matta-Clark installation in a series of sensory events is collapsed into a single visual image. In the photomontage for *Splitting*, Matta-Clark reconstructs a perspectival section through the house, taken at the cut, portraying simultaneous viewpoints while serving as an homage to architectural orthodoxy (see pp. 152–53).

In *Conical Intersect*, created in Paris in 1975, Matta-Clark invaded a condemned seventeenth century apartment building that was slated for demolition in service of urban renewal. The building was demolished within a few days of the completion of Matta-Clark's installation. Revealed in the photomontages is the juxtaposition of scales, contrasting the room and the city. Through the distortion and fragmentation of the room, the body's relationship to space and surface is modified

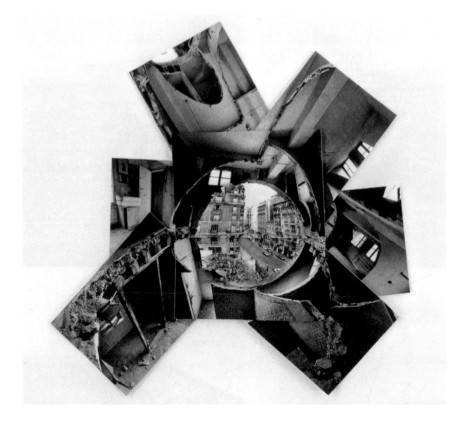

Gordon Matta-Clark, *Conical Intersect* (1975)

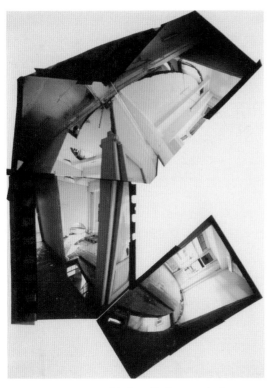

Gordon Matta-Clark, *Office Baroque* (1977)

© 2012 Estate of Gordon Matta-Clark / Artists Rights Society (ARS), New York

and thus foregrounded. Walker explains that: "it is difficult to establish a clear-cut distinction between experience and representation."[36] Matta-Clark's installations are simultaneously human-scaled and scale-less. The unique activation and interrogation of structure, enclosure, and space constructs an inhabitable montage through a one-to-one displacement and dissociation. This strategy informs the fragmentary nature of the photomontages which cannot be neatly contained by a rectilinear frame, but rather reveal the original format of the numerous photographs composing the photomontage. The indefinable boundaries reflect the intent of Matta-Clark in the full-scale installation.

Office Baroque, completed in 1977, was Matta-Clark's first work in which photomontage served as the primary exhibition, as the work itself was inaccessible. The only artifact extracted from the site was a section through the floor that was hung from the gallery ceiling. Thomas Crow recognizes a direct influence of Cubism on Matta-Clark in both his installations and photomontages: "He exploited the artifacts of the process – the sprocket holes along the edges of the filmstrips, the colors and shapes of the tape pieces used to hold the elements of his compositions in place – to stage an elegantly offhand revival of Cubist collage principles."[37] Like the physical installations, photomontages such as *Office Baroque* create an ambiguity of scale. The content of each photo can be identified with the scale of a room, despite the destruction and distortion. Concurrently, the film negative edges identify a much smaller scale, an artifact at the scale of the hand. Through installation and photomontage, Matta-Clark suspends scale, construction, and destruction in continuous flux, negating a linear temporal context.

While the works themselves are quite powerful in the simplicity of their concept and physicality of their execution, there is also value in the methods by which these temporary interventions have been documented and reconstructed through photomontage. The method of representation in the fragmented and simultaneous nature of the image reflects the embodiment of these qualities of collage in the built work.

Mary Miss,
Collapsed Pier
(1996)

MARY MISS

The photo/drawings are a great release because I can investigate things without actually building them, looking for that which is so compelling to me, the physicality of a situation . . . To do something where I can just come in my studio, shut the door, get out the photographs and the scissors and start.[38]

<div align="right">Mary Miss</div>

Mary Miss, *Untitled #90 (Vermont Fire Tower)* (1996)

Since the late 1960s, Mary Miss, a site artist and sculptor of public art, has challenged preconceived boundaries of sculpture. In Rosalind Krauss's seminal essay "Sculpture in the Expanded Field," she cites Mary Miss's work as an example of the trending multi-disciplinary nature of sculpture. Rather than defining sculpture as that which is neither architecture nor landscape, sculpture could be defined as simultaneously architecture and landscape.[39] In addition to many independent projects that blur these boundaries, Miss has worked collaboratively on a number of projects with architects and landscape architects, facilitating larger-scale interventions. Working at the threshold of architecture and landscape, Miss recognizes the value of an authentic relationship between intervention and context. She proposes a physical and visual integration with context, natural or built, while privileging authentic, haptic experience.[40] These ambiguous boundaries find their voice initially through a collage-making process, in which Miss constructs photomontages of existing structures and sites. She uses the term photo/drawing to describe her collage artifacts. She then uses concepts embodied by these photo/drawings to inform her design work. The multivalence intentionally facilitated in Miss's process and built work references the inherent nature of collage as well as themes explored by collage-makers from the Cubists to contemporary artists. Miss's photo/drawings begin initially as analyses of existing conditions, evolving to interpretive and generative investigations. In addition to serving an analytical and interpretive purpose, she also uses her photo/drawings to clarify her proposals, as she believes the experience of place is difficult to capture through normative drawings or photos. Like Gordon Matta-Clark, Miss also uses these techniques to document finished projects, particularly her temporary installations. With regard to method, Miss's photo/drawings take on one of two forms. The first type is photomontage composed exclusively of constructed photographic material, typically used in the analytical phase. The second type is collage that combines constructed photographs and architectural drawings, which Miss typically employs to record completed projects. Miss describes her photomontages as "an exploratory graphic form – a species of photo-collage in which several views of a single structure or site are spliced together to form a slightly altered whole."[41] This method allows her to investigate spatial and material conditions through representation rather than construction. Through this interpretive lens, Miss

employs photomontage as a means of quickly generating design ideas. Evident in her photo/drawings and built work are themes of phenomenal transparency, and juxtaposed perspectives and material properties. Like the photo/drawings, the complete experience of her built projects necessitates the viewer in motion around a static figure. While the Cubists considered themes of simultaneity and transparency – themes Miss investigates – methodologically Miss draws upon the use of photomontage by the Dada, Bauhaus, and Constructivist movements. Like these collage artists, she recognizes the dynamic nature of the oblique view and the value of negative space. According to Sandro Marpillero:

> She constructs a "new experience" by emphasizing a spatio-temporal quality, built up through accumulation of particular details and multiplication of them in layers within the collage. The collaboration of multiple photographs constructs a second condition of reality about the place depicted, another way of exploring the spaces and forms of those structures.[42]

The intentionality in framing each photographic image as well as aggregating a selection of images into a cohesive composition facilitates the abstraction of existing materials and geometries. The resulting analytical image provides fodder for design inspiration.

Mary Miss's translation from the two-dimensional medium of collage to three-dimensional full-scale intervention seems to confirm James Corner's projection that built form is a direct corollary of the methods of representation employed in the

Mary Miss, *Untitled #19* (1989–90)

design process. Corner suggests that "both the site and materiality of landscape provides an experimental laboratory, a cultural testing ground to be directly engaged and experienced."[43] Miss's projects, including the *Battery Park Landfill* installation (1973) and the *Pool Complex: Orchard Valley* (1982–85), demonstrate this correlation as the collage mentality of her photo/drawings is manifested in her built work.

Just as collage compels the viewer to play an active role in the perception of a plurality of interlaced images, Miss's work relies on the perception of an ambulatory viewer absorbing multiple images.

> I try to take visual, physical, or emotional experiences of some potency and make them accessible to the viewer. What is absolutely essential to me is the involvement of the viewer with the work. In a sense, when I am working in a public place, I am doing only half the piece. It is completed by the people who are moving through it and the association they bring to the situation.[44]

The importance of the relationship between the viewer and the object, as well as the primacy of negative space, is essential to the powerful perceptual experience of projects such as *Battery Park Landfill*, completed in 1973. Eleanor Heartney describes Miss's methodology, stating that: "Miss has, since the late 1960s, worked to engage the viewer in environmental works that offer multiple vantage points. Her cues come from the physical characteristics of the site, the historic or social resonances that she uncovers during a period of research, and from the more personal associations that the site conjures up for her."[45] *Battery Park Landfill* is an early example of this approach that illustrates these themes. This temporary installation consisted of solid parallel panels, with circles excised, spaced 50 feet apart across the vast uninterrupted landscape of a capped landfill in New York. The sculpture is the void itself, defined or implied by the wood plank panels. An exploration of the site culminates in a single revelatory viewpoint, revealing the Gestalt of the implied figure.

In projects such as the *Pool Complex: Orchard Valley*, the collage mentality is demonstrated through the ambiguity of figure and field and a juxtaposition of

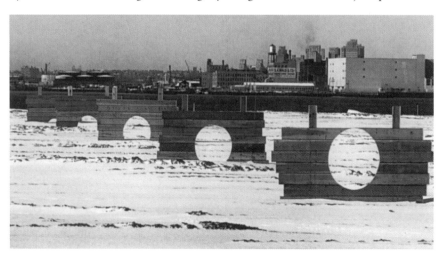

Mary Miss, *Battery Park Landfill,* New York, NY (1973)

Diagrams of
Battery Park
Landfill

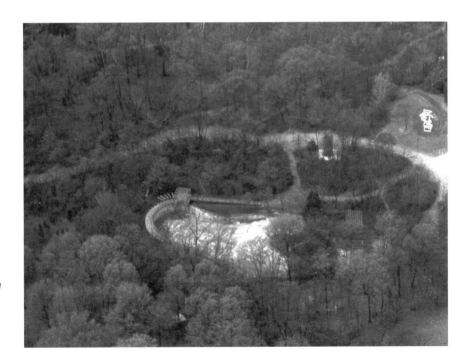

Mary Miss, *Pool
Complex: Orchard
Valley*, Laumeier
Sculpture Park,
St. Louis, MO
(1982–85)

expectations, in which fragments of architecture and landscape must be synthesized in the mind of the viewer. The latent information embedded in the site serves as the raw material for the project.[46] The site of the Laumeier Sculpture Park offered architectural remnants from a previous estate, with the remains of a swimming area, building foundations, and walkways. In Miss's words, "Unused, abandoned, and common engineering elements became the raw material for this project. The work builds upon existing associations, adding another layer of content to what was already there, making a new place to be used."[47] Miss's superimposition of new wooden pavilions and walkways, organized along the existing concrete pool edge, created a dialogue between the memory of the site and the new constructs and activities. As a composition that appropriates discarded and varied materials and imbues them with new meaning, this project is a collage at the landscape scale. Miss documented the project through photo/drawing, combining photos of the site with axonometric pencil drawings of the tectonic elements inserted into the site. Miss's recursive process of collage and intervention demonstrates the integral nature of representation and construction.

The temporal conditions of Miss's work are revealed in her interpretation of "the American landscape as transitory palimpsests, incomplete erasures of

earlier time and use . . . Miss's referential landscapes are broad and open, marked and measured, fenced and lightly settled, transitional and liminal," in the words of Daniel M. Abramson.[48] A heightened awareness of the environment is evoked through the subtle juxtapositions of architecture and landscape. Miss's collage methodology in both design process and built form demonstrates a simultaneity of perception through an intentional engagement with the phenomenology and materiality of the sites in which she has chosen to intervene.

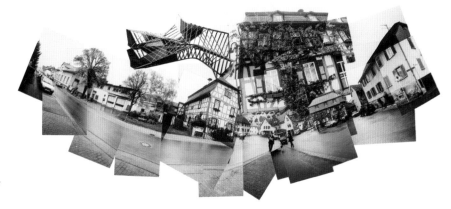

EMBT,
Rosenmuseum,
Frankfurt, Germany
(1994)

MIRALLES TAGLIABUE [EMBT]

These montages aim to make one forget the ways of representing and thinking about the physical reality of things characteristic of the perspectival tradition. In a certain sense they are like simultaneous sketches, like multiple and distinct visions of one single moment. There are many points of attention and many different thoughts in them. A collage is a document that fixes a thought in a place, but it fixes it in a vague way, deformed and deformable; it fixes a reality in order to be able to work with it. [49]

Enric Miralles

The collages and photomontages of Enric Miralles in collaboration with Carme Pinós and later in partnership with Benedetta Tagliabue in EMBT have played a crucial role in the design and execution of their architectural works. The built and paper projects resonate with the theme of juxtaposing disparate elements of a place through the actions of excavation, addition, and reconfiguration. Photomontage has been employed at various stages of the design and construction process, as we've seen in the work of Gordon Matta-Clark and Mary Miss. EMBT has utilized constructed photographs in site analysis, design studies, and as a means of documenting the rapid transformations of the site and building during construction. Like Miss, the architecture of EMBT integrates sculpture, architecture, and landscape. This interdisciplinary approach reveals and establishes a dialogue with the underlying order of the site.

A study of Enric Miralles's (and later, EMBT's) collages and photomontages reveals a development of representational methods and means. These collages include photomontages exclusively constructed from a multitude of photographs, as well as collages that use predominantly photographic material but incorporate line drawings and other materials that suggest three-dimensional relief. Although the methods have evolved, a few constants have persisted: first, the boundaries of the photomontage are critical to the interpretation of the composition, regardless of the additive or subtractive nature of the photomontage. Miralles describes how: "A project is always made up of these different moments, of different fragments that are contradictory at times. These collages, like a puzzle, represent a space in a way that repeats the process of making a project itself. They are like a surprise, continually offering new definitions of the limits and contours."[50] Subtractive techniques offer a means of analyzing existing boundaries embedded in the site and foregrounding conditions of order. Benedetta Tagliabue reflects on the beginnings of this process in their photomontages: "The very first cut-outs, around 1990, were done simply to eliminate an unwanted background. But later the scissors became a kind of liberating tool, creating the illusion that the building, in its final, constructed form, could still be worked on, varied. They seemed to bring the projects back to the drawing board."[51] The second commonality is an insistent curiosity about perspective, point of view, and simultaneity demonstrated in the collages and resultant architecture. Like the Cubists, Miralles and Tagliabue utilize collage as a means of destabilizing perspective. The multiplicity of their photomontages as an assemblage of views is described as: "aim[ing] to fix, in a single view, all the different images which accompany the eye as it moves along the profiles and sections. They attempt to explain a complete and simultaneous kind of perception, to convey all knowledge contained in all the drawings and perspectives of a project."[52] Miralles's focus on perspective and fragmentation began with his doctoral research in the 1980s. In his thesis, he discusses drawing as a collection of fragments. He describes the making of the drawings as "the beginning of the dialogue between thought and construction."[53] In these drawings, Miralles assimilated varied architectural elements through line, much like the surreal drawing assemblages of Piranesi. Miralles compares his thesis to "the enthusiastic awareness of eighteenth-century travelers, in whom active contemplation

is conflated with creation."[54] This kind of active contemplation aligned with creation also describes his collage-making.

Miralles's transition to the use of constructed photographs permitted the indexing of existing site conditions that could be subsequently manipulated and abstracted through photomontage. This process integrates phenomenal characteristics with physical ones, envisioning potential futures for the site. The creation of dynamic, layered compositions speaks to a simultaneity of spatial and material experience that informs the design intervention. Three projects illustrate the varied collage methods and intents of Miralles and Tagliabue: the Igualada Cemetery, the International Garden Fair, and the Prado Museum Extension.

The Igualada Cemetery project demonstrates Miralles's use of the cut-out method of photomontage. This project took eleven years (1985–96) to complete, and began with the partnership of Miralles and Carme Pinós but transitioned in 1992 to the partnership of Miralles and Benedetta Tagliabue. The design of the chapel in 1990 marks the beginning of Miralles's use of photomontage. Using photographs of the work completed up to that point, Miralles revisited his work by cutting into the images. Miralles says, "In this way we returned to the initial character of the building, tying together the distant stages of beginning and end, re-establishing the direct relationship that exists almost independently of the development of the work."[55] Tagliabue states, "Within this framework, the built work is not the 'main' stage of the architectonic process, but simply another stage."[56] The extraction of irrelevant data from photographs of existing site and building components renders them analytical. The negative space of the canvas takes on a figural quality, its boundaries augmented through the juxtaposition of rich textures and pure white space. While the architectural elements are intentionally embedded and integrated with the existing topography, black and white photography further abstracts and assimilates fragments of natural and built context.

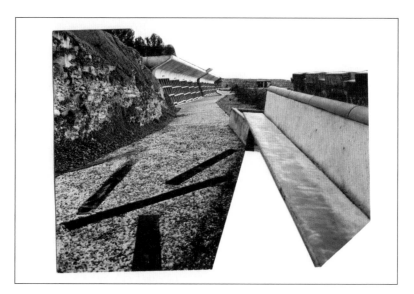

Enric Miralles,
Igualada Cemetery,
Igualada, Spain
(1990)

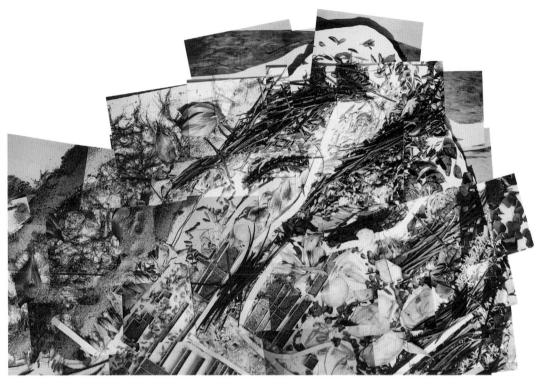

EMBT, *International Garden Fair Competition*, Dresden, Germany (1995)

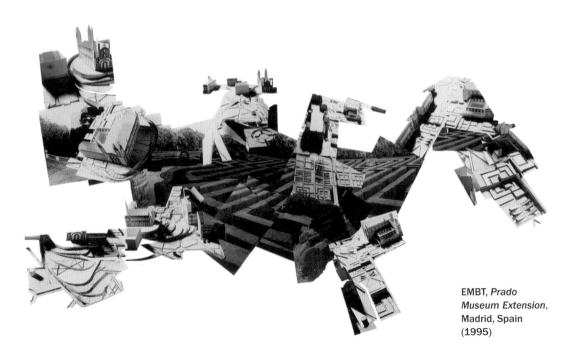

EMBT, *Prado Museum Extension*, Madrid, Spain (1995)

In the proposal for the International Garden Fair in Dresden (1995), photomontage brings into question its role as representation or as design, while exploiting its potential for scalar juxtaposition. In this photomontage, photographs of a site model are composed with images of flower petals, grasses, and dirt. The seemingly irreconcilable scalar differences permit a reading of the petals and grasses as symbols of landscape elements. The integration of material images and model photos with images of the existing context marks a development in the collage-making methods of Miralles and Tagliabue.

The photomontages of the Prado Museum Extension Competition in Madrid (1995) mark another level of photographic manipulation. In this case, images of French gardens are combined with photos of a model representing a design proposal. In this case, the model is not only being represented, but reconfigured. Unlike the proposal for the Garden Fair in Dresden, the photographs of the model are trimmed, reassembled, and rescaled. A plurality of viewpoints of both the gardens and the architecture exhibits a conscious rethinking of the model, offering multiple design iterations.

EMBT, *Public Library Enric Miralles*, Palafolls, Barcelona, Spain (2007)

After Miralles's death in 2000, Tagliabue took control of the firm, completing the unfinished projects, and continues to direct a successful practice today. Photomontages completed by the firm under Tagliabue's direction demonstrate a continued interest in construction and the cataloguing of the construction process through photomontage. Advancing Miralles's understanding: "As if construction were not the final stage of the work process, but simply another of the unconnected instants that are always demanding a new response."[57] Collage remains a generative vehicle for the firm, but the nature of the photomontage has shifted from an abstracted dialogue between perspective and boundary towards a more literal representational device. Despite the variety of methods and intent, the collages and photomontages of EMBT continue to reflect an interest in construction and materiality, a common theme in the work of artists and architects utilizing photomontage. Miralles explains that: "I work with constructive, not visual criteria, and so repetition is extremely important. Each new sketch is an operation of oblivion, and the laws that are generated have an internal coherence."[58] Like other photomontagists, EMBT values the precision and potential for geometric analysis found in this method. The collages and photomontages of EMBT are unique in their diversity, appropriating techniques and materials as called for by the varied thematic strands of each project.

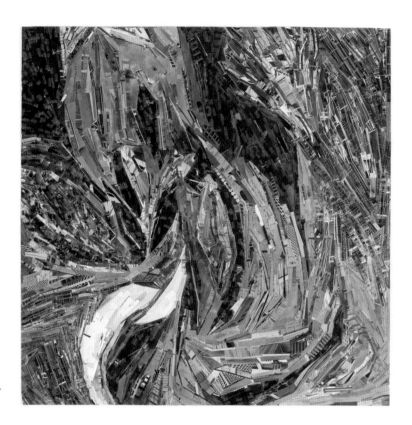

Teddy Cruz, *Border Postcards* (2000)

TEDDY CRUZ

It seems necessary to re-encounter the city not only as a virtual phenomenon, but as a physical territory, a journey, a set of experimental episodes and multiple readings. To map the city's multidimensionality requires an openness to absorb its different narratives and identities . . . This act of excavation through the spaces of the city manifests itself primarily as a sense of possibility; the origin of a process of contamination by the city's multiple voices and ignited by the simple act of placing ourselves in the midst of the city's flow of visual information, like a whirlpool. [*Border Postcards* represent] fictional landscapes, fields of observation and infrastructure, out of the vacant spaces of the city. Mirroring these empty spaces' potential for appropriation, these images are ready to be occupied and activated by other narratives and events.[59]

Teddy Cruz

Teddy Cruz, an architect and professor of public culture and urbanism in the Visual Arts Department at the University of California in San Diego, has rooted his work in the dynamic threshold that exists at the border between Tijuana, Mexico, and San Diego, California. He has developed, in his words, "a practice and pedagogy that emerge out of the particularities of this bicultural territory and the integration of theoretical research and design production."[60] He describes a dichotomy "between two radically different ways of constructing city"[61] and the potential that lies in the

interface between the two. Investigations into the nature of the urban context south of the border, both physically and sociologically, have revealed thriving informal economies and social conditions that have the potential to inform new strategies for redevelopment in the US. Drawing from this research, *New York Times* architectural critic Nicolai Ouroussoff has described Cruz's proposal for a redevelopment project in Hudson, NY as "a complex interweaving of rich and poor, old and new, public and private, a fabric in which each strand proclaims a distinct identity."[62] The aggregation and synthesis of unrelated elements into a cohesive composition as described by Ouroussoff defines collage, Cruz's medium of choice for analysis and design. Photomontage specifically has served as a vehicle for the interrogation of this complex territory. Cruz explains, "Photocollages make a graphic activist point."[63] This statement was likely influenced by Cruz's educational experience in Florence, Italy under Superstudio founder Christiano Toraldo di Francia. Yet rather than rejecting consumer culture outright in the manner of Superstudio, Cruz cultivates the subtle and varied economies that develop organically. In contrast with the homogenization of space pervading the collage-drawings of Superstudio, Cruz's work advocates for an intentional heterogeneity.

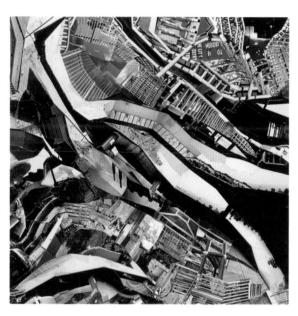

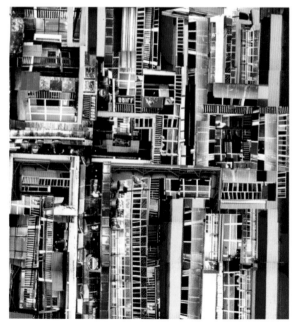

Cruz voices a "dissatisfaction with the way representation has produced levels of commentary without producing actual tactics for intervention."[64] Like other architects exploring photomontage with constructed images (as discussed in this chapter), Cruz encourages an

interdisciplinary approach to design in order to address this issue. He proposes a procedural exchange among professionals engaged in the production of urban space, "borrowing their procedures so as to operate differently in constructing critical observational research and alternative spatial strategies . . . to actually contaminate each other with the alternative procedures of each other."[65] In the work of Teddy Cruz a political agenda reemerges, echoing the architecture of the Russian Constructivists, Archigram, and Superstudio. Yet Cruz has ventured beyond the dominantly paper architecture of these precedents to intervene in existing communities. He describes a new perspective on urban development that reconsiders density and land use, "a counter form of urban and economic development that thrives on social organisation, collaboration and exchange."[66] Inherent collisions and conflicts provide the inspiration for architectural intervention, thematically similar to the work of Gordon Matta-Clark. Photomontage offers the greatest representational potential for the dynamic nature of the community envisioned here.

Although Cruz's photomontages are motivated by a social agenda, they are highly abstract. The constructed image fragments appropriate colors, forms, textures, and patterns from the context under consideration. The *Border Postcards* are a series of photomontages produced in a studio taught by Cruz at SCI-ARC in Los Angeles, in which photomontage served as a means of establishing a dialogue between the student and the context of the San Diego/Tijuana border. Cruz explains: "The students constructed a series of photographic narratives as tools to reveal that which is hidden beneath the reality of the city's fragments."[67] Cruz describes the ambiguity of this border condition as simultaneously defined yet in flux;[68] complex and ambiguous conditions are captured through the method of photomontage. The value of a constructed photomontage in this case is two-fold: the collage-maker utilizes the initial photography as an in-situ analytical tool, while the construction of the photomontage facilitates another level of analysis and abstraction. These photomontages reference the conflict between the desire for division and containment, and the openness and fluidity of transnational information networks.

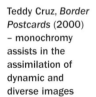

Teddy Cruz, *Border Postcards* (2000) – monochromy assists in the assimilation of dynamic and diverse images

Continuing this research agenda, Cruz's *Manufactured Sites* project (2004–07) and his contribution to the 2008 Venice Biennale entitled *60 Linear Miles of Trans-Border Conflict* capture the collage-like quality of the built environment south of the border. Cruz describes the north to south flow of waste as Tijuana recycles the

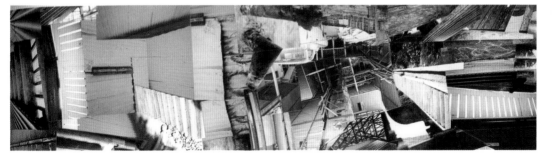

Teddy Cruz,
Manufactured Sites
(2004–07)

discarded building materials of San Diego, an appropriation of refuse which renews function and meaning. Photomontages describe a potential procedure for the reclamation and reuse of waste based on a "pixelization of the large with the small."[69] The resulting scalar juxtapositions and "the pairing of ambiguity and specificity"[70] describe both the content of the photomontage and the photomontage as an artifact and aggregate of image fragments.

Cruz's polemic is one of balance between the academic and the pragmatic. He describes a desire to merge poetics with politics, saying:

> My education came out of phenomenology in the '80s, and it stressed that we all engage in the reality of the world through our perceptions and interpretations of that reality. At the same time I feel the poetics in architecture remain too isolated from the politics of the construction of the city. And somehow many of these images should be bridges to reconnect the poetic and the political.[71]

The work of Teddy Cruz serves as a paradigm for the implication of constructed photomontages in architectural activism that extends beyond the academic and into our socio-cultural reality.

Notes

1 Aldous Huxley, *Piranesi's Carceri d'Invenzione* (London: Trianon Press, 1949).
2 Klaus Honnef, "Symbolic Form as a Vivid Cognitive Principle: An Essay on Montage," in *John Heartfield*, eds. Peter Pachniche and Klaus Honnef (New York: Harry N. Abrams, 1992), 56.
3 Honnef, "Symbolic Form," 60.
4 Raoul Hausmann and John Cullars, "Photomontage," *Design Issues*, Vol. 14, No. 3 (Autumn, 1998), 67–68.
5 Sergey Tretyakov "Remarks About Heartfield's Photomontages," in *John Heartfield: Photomontages of the Nazi Period*, Gordon Fraser Gallery (London: Universe Books, 2nd edition, 1977), 26.
6 Kristin Makholm, "Strange Beauty: Hannah Höch and the Photomontage," *MoMA*, No. 24 (Winter–Spring, 1997), 19–23.
7 Charlotte Stokes, "Collage as Jokework: Freud's Theories of Wit as the Foundation for the Collages of Max Ernst," *Leonardo*, Vol. 15, No. 3 (Summer, 1982), 199–204.
8 Evan M. Maurer, "Images of Dream and Desire: The Prints and Collage Novels of Max Ernst," in *Max Ernst: Beyond Surrealism*, ed. Robert Rainwater (New York and Oxford: The New York Library and Oxford University Press, 1986), 57.
9 Diane Waldman, *Collage, Assemblage, and the Found Object* (New York: Harry N. Abrams, 1992).
10 Nils-Ole Lund, *Collage Architecture* (Berlin: Wilhelm Ernst & Sohn Verlag fur Architektur und technische Wissenschaften, 1990), 5.
11 Lund, *Collage Architecture*, 8.
12 Lund, *Collage Architecture*, 8.
13 Lund, *Collage Architecture*, 8.
14 Lund, *Collage Architecture*, 12.
15 Lund, *Collage Architecture*, 6.
16 Note to author.
17 Beatriz Colomina and Craig Buckley, eds. *Clip, Stamp, Fold: The Radical Architecture of Little Magazines, 196X to 197X* (New York: Actar, 2010), 118.
18 www.iconeye.com/read-previous-issues/icon-097-%7C-july-2011/20/20-clip-stamp-fold
19 David Wild, *Fragments of Utopia: Collage Reflections of Heroic Modernism* (London: Hyphen Press, 1998), 6.
20 Note to author.
21 Note to author.
22 Note to author.
23 Wild, *Fragments of Utopia*, 7.
24 Wild, *Fragments of Utopia*, 94.
25 Charles Rattray, "Hidden Dimensions: David Wild and Sacks Maguire's Cypher House," *Architecture Today*, Vol. 201 (2009), 38.
26 Rattray, "Hidden Dimensions," 38.
27 Raoul Haussman and John Cullars, "Photomontage," *Design Issues*, Vol. 14, No. 3 (Autumn, 1998), 67–68.
28 Christina Lodder, "Constructivism and Productivism in the 1920s," in *Art Into Life: Russian Constructivism 1914–1932*, eds. Henry Art Gallery, Richard Adams, and Milena Kalinovska (New York: Rizzoli, 1990), 114.
29 Alan Woods, "Photo-collage," in *David Hockney*, ed. Paul Melia (Manchester: Manchester University Press, 1995), 123.
30 Gloria Moure, *Gordon Matta-Clark: Works and Collected Writings* (Barcelona: Ediciones Poligrafa, 2006), 332.

31 Moure, *Gordon Matta-Clark*, 63.

32 Moure, *Gordon Matta-Clark*, 172.

33 http://en.wikipedia.org/wiki/Superstudio

34 Moure, *Gordon Matta-Clark*, 332.

35 Stephen Walker, "Gordon Matta-Clark: Drawing on Architecture," *Grey Room*, No. 18 (Winter, 2004), 122.

36 Walker, "Gordon Matta-Clark," 127.

37 Thomas Crow, "Away from the Richness of Earth, Away from the Dew of Heaven," in *Gordon Matta-Clark* ed. Corinne Diserens (London: Phaidon Press, 2003), 113–14.

38 Mary Miss, *Mary Miss* (New York: Princeton Architectural Press, 2004), 74.

39 Rosalind Krauss, "Sculpture in the Expanded Field," *October*, Vol. 8 (Spring, 1979), 38.

40 Miss, "On a Redefinition of Public Sculpture," *Perspecta*, Vol. 21 (1984), 52–69, 61.

41 Miss, *Mary Miss*, 74.

42 Miss, *Mary Miss*, 76.

43 James Corner, "Introduction," in *Recovering Landscape: Essays in Contemporary Landscape Architecture*, ed. James Corner (New York: Princeton Architectural Press, 1999), 16.

44 Joan Marter, "Artists and Architects on Public Sites," *Art Journal*, Vol. 48, No. 4, Critical Issues in Public Art (Winter, 1989), 318.

45 Miss, *Mary Miss*, 11.

46 Miss, *Mary Miss*, 17.

47 www.marymiss.com

48 Miss, *Mary Miss*, 49.

49 Enric Miralles, *Enric Miralles: Works and Projects, 1975–1995* (New York: The Monacelli Press, 1996), 173.

50 Miralles, *Enric Miralles: Works and Projects*, 173.

51 Benedetta Tagliabue, "Don Quixote's Itineraries," in *Enric Miralles: Mixed Talks* (New York: Academy Editions, 1995), 120.

52 Enric Miralles and Bendetta Tagliabue, *Enric Miralles: Mixed Talks* (New York: Academy Editions, 1995), 36.

53 Benedetta Tagliabue and Enric Miralles, *Enric Miralles: Works and Projects, 1975–1995* (New York: The Montacelli Press, 1996), 27.

54 Tagliabue and Miralles, *Enric Miralles: Works and Projects*, 35.

55 Miralles and Tagliabue, *Enric Miralles: Mixed Talks*, 29.

56 Benedetta Tagliabue, "Don Quixote's Itineraries," in *Enric Miralles: Mixed Talks*, 120.

57 El Croquis 144: EMBT Enric Miralles / Benedetta Tagliabue 2000–2009 – After-life in Progress, 78.

58 El Croquis 144: EMBT Enric Miralles / Benedetta Tagliabue 2000–2009 – After-life in Progress, 268.

59 Anne Boddington and Teddy Cruz, eds., *Architectural Design: Architecture of the Borderlands* (Oxford: John Wiley & Sons, 1999), 112.

60 http://visarts.ucsd.edu/~gd2/faculty/teddy-cruz

61 http://archinect.com/features/article/93919/with-teddy-cruz-on-power-and-power-lessness

62 Nicolai Ouroussoff, "Learning From Tijuana: Hudson, N.Y., Considers Different Housing Model," *The New York Times*, February 19, 2008.

63 *Architectural Record*, Vol. 196 Issue 10 (October, 2008), 240.

64 http://archrecord.construction.com/features/humanitarianDesign/0810cruz-1.asp

65 http://archinect.com/features/article/93919/with-teddy-cruz-on-power-and-power lessness

66 "Manifesto #47: Teddy Cruz" from "50 Most Influential Designers' Manifestos," *Icon Magazine*, No. 50 (August, 2007).

67 Boddington and Cruz, eds., *Architectural Design,* 112.

68 Boddington and Cruz, eds., *Architectural Design,* 112.

69 Teddy Cruz lecture at the Interdisciplinary Seminar at the Cooper Union School of Art, March 23, 2009.

70 Teddy Cruz lecture, March 23, 2009.

71 http://archrecord.construction.com/features/humanitarianDesign/0810cruz-1.asp

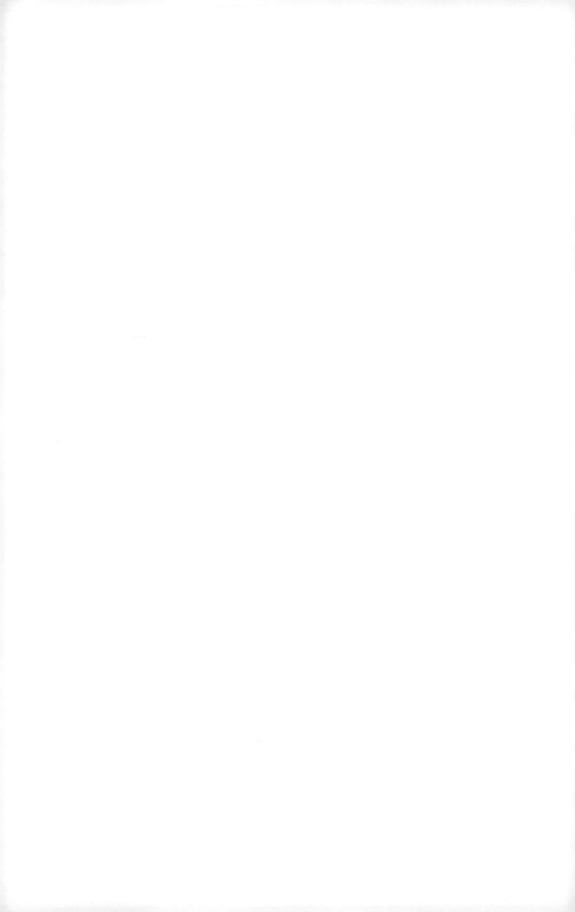

1.4 Digital Methods

Digital methods in collage exploit the capacity for digital media to both facilitate analogue techniques and devise new techniques for collage-making through direct and indirect manipulation. All tools for representation can be seen as extensions of the human body, guided by mental and physical processes. The interface, or shared boundary, between the body and the instrument is the first degree of separation between the artist and the work. The research of Marshall McLuhan is essential to a discussion of the role of media in graphic communication. McLuhan was a philosopher and an English literature professor whose work has been fundamental in the development of media theory. (He predicted the Internet 30 years before its invention.) He was known to popular culture, not only from his articles in Yale's architecture journal *Perspecta*, but also from his bestselling book and an interview to *Playboy* magazine. In this interview, McLuhan explains: "all media, from the phonetic alphabet to the computer, are extensions of man that cause deep and lasting changes in him and transform his environment."[1] And as extensions of ourselves, either mentally or physically, these media cause gradual changes to our sensory balance and eventually become invisible. McLuhan claims: "It's always been the artist who perceives the alterations in man caused by a new medium, who recognizes that the future is the present, and uses his work to prepare the ground for it."[2] McLuhan points to several critical moments in history that have marked shifts in communication and perception, including the development of the phonetic alphabet, the printing press, and the telegraph.

McLuhan describes two types of spatial perception: acoustic space and visual space. Prehistoric (wo)man inhabited acoustic space, engaging all senses in his/her perception of the world. McLuhan writes:

> I mean space that has no center and no margin, unlike strictly visual space, which is an extension and intensification of the eye. Acoustic space is organic and integral, perceived through the simultaneous interplay of all the senses; whereas "rational" or pictorial space is uniform, sequential

VISUAL SPACE	ACOUSTIC SPACE
sequential	simultaneous
asynchronous	synchronous
static	dynamic
linear	non-linear
vertical	horizontal
left brain	right brain
figure	ground
specialism	holism/generalism
tonal	atonal
isotropic	anisotropic
container	network
mechanical	electrical
particle	field, resonance

Marshall McLuhan's Characteristics of Visual and Acoustic Space according to Gordon Gow

... the ear, unlike the eye, cannot be focused and is synaesthetic rather than analytical and linear. . . . the auditory field is simultaneous, the visual successive.[3]

Acoustic space is multi-sensory and experiential, while visual space is mono-sensory and rational. Acoustic space, like collage, is founded in the relationships between elements and the perceiver rather than the autonomous identities of objects. The dimension of time is crucial to the perception of acoustic space as these relationships in flux are evaluated. McLuhan hypothesized that the development of the phonetic alphabet (as distinct from the logographic alphabet) fostered a shift from acoustic to visual space, establishing the hegemony of the eye. The phonetic alphabet, in which the letters are arbitrary symbols for sounds, encouraged abstract thinking and the rise of Euclidian geometry. Euclidian geometry describes space as infinite, featureless, and homogeneous.[4] Johannes Gutenberg's printing press of the 1450s, to McLuhan, accelerated the perception of visual space. Suddenly this symbolic system of communication was available to the masses. He claims that printing "was the first mechanization of a complex handicraft; by creating an analytic sequence of step-by-step processes, it became the blue-print of all mechanization to follow . . . Movable type was archetype and prototype for all subsequent industrial development."[5] Literacy facilitated by this technological innovation coincided with the invention of perspec-

Papyrus of Ani (sixteenth c. BC) and *Gdansk Manuscript* (1733)

tive. In linear perspective, the emphasis is on what is perceived by the eye. Prior to this, elements in composition were often sized according to subjective hierarchical importance, rather than objective distance from the viewer. Albrecht Dürer's early-sixteenth-century *Four Books on Measurement* describe linear geometry, typography, linear perspective, and mechanisms for the construction of perspective. The invention of a perspective machine established the first substantive interface, separating the artist from his/her subject in a rationalization and abstraction of space.

The invention of the telegraph in 1844 ushered in the electronic age, according to McLuhan. He proposes that "electric media," rather than extending only one sense or function as mechanical media did, are an extension of our central nervous system – a multi-sensory extension.[6]

McLuhan argues that this new age marks a return to acoustic space by re-engaging other senses. Complementing this theory is the work of nineteenth-century painter Paul Cézanne that acts as a bridge between Impressionism and Cubism, paralleling the transition from the mechanical to the electronic age. Philosopher Maurice Merleau-Ponty describes Cézanne's move beyond the perspectival, saying: "By remaining faithful to the phenomena in his investigations of perspective, Cézanne

Albrecht Dürer, *Perspective Projection* (1532)

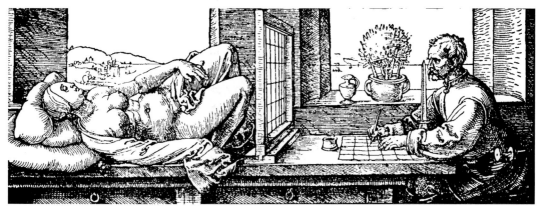

discovered what recent psychologists have come to formulate: the lived perspective, that which we actually perceive, is not a geometric or photographic one."[7] The use of abstraction to extract sensory information prompted further artistic developments. In *The Medium is the Message*, McLuhan points out that Cubism marked a significant shift in spatial thinking, arguing that it "drops the illusion of perspective in favor of instant sensory awareness of the whole. Cubism, by seizing on instant total awareness, suddenly announced that *the medium is the message.*

Paul Cézanne, *Annecy Lake* (1896)

Is it not evident that the moment that sequence yields to the simultaneous, one is in the world of the structure and of configuration?"[8]

This statement summarizes the theory that the communication tool, as an extension of our senses, has a greater impact on shifts in cultural behavior than the actual output of the tool. McLuhan argues that electronic media are returning us to the perception of acoustic space. He uses the term 'global village' to describe a transition from individualism to a collective identity driven by electronic media. Echoing McLuhan's statement that the artist is the first to perceive and contend with these cultural shifts, Michael Dashkin, curator of "From Drawing to Montage: Computers in Art," an exhibition at Parsons School of Design, New York in 1994 maintains that

Matt Britt, *Map of the Internet* (2007)

"each generation must confront the peculiar ways in which a human touch is distanced through its technology . . . [while the] enrichment and challenge to preexisting art practices and conceptions can be considered, in fact, the premiere contribution that the twentieth century has made to the process of visual artmaking."[9]

A critical question that arises with regard to this distancing was first expounded in *The Work of Art in the Age of Mechanical Reproduction* (1936) in which Walter Benjamin addresses the prerequisites for authenticity in a work of art. His critique of the reproduction of works of art was founded in the question of authenticity, claiming that an authentic work required: (a) an original,[10] and (b) an aura resulting from the accrual of time

and experience.[11] Benjamin claims that "Even the most perfect reproduction of a work of art is lacking in one element: its presence in time and space, its unique existence at the place where it happens to be."[12] This question seems even more relevant in the electronic age in which there is no original artifact, or evidence of time in its creation. What does authenticity mean when there is no original? Digital media confront us with a similar debate to that described by Benjamin. In the nineteenth century, there was debate as to the value of photography as an artistic medium compared with painting. However, according to Benjamin: "The primary question – whether the very invention of photography had not transformed the entire nature of art – was not raised."[13] One approach to this question is evident in the work of the Dadaists in their use of ready-mades – as Benjamin explains: "What they intended and achieved was a relentless destruction of the aura of their creations, which they branded as reproductions with the very means of production."[14] Perhaps authenticity is achieved in the recognition that the properties previously viewed as fundamental to a work of art are no longer relevant, and authenticity itself must be redefined.

French philosopher Jean Baudrillard continued to develop the theme of interdependence between social dynamics and media originating with McLuhan. His theory of Simulacra describes a culture so saturated with signs and symbols (simulacra) that reality, and authenticity, no longer exist. Like McLuhan, who identified key moments in history as marking a shift in perception, Baudrillard associates three orders of simulation with three historical developments. The first order of simulation, prior to the Industrial Revolution, describes a representation of something that exists in reality (i.e. a painting or map), which is clearly artificial. The Industrial Revolution marked a shift to second order simulation in which boundaries between reality and representation are indistinct. The commodification and mass production of objects renders the original almost irrelevant. The third order of simulation exists in postmodernity. The distinction between the real and the facsimile disappears, and we inhabit the 'hyperreal,' in which the simulacrum is constructed prior to the original. In the hyperreal, one is both engaged in and distanced from the situation, causing "a collapsing of perspectival space."[15]

An important procedural development facilitated by digital media that speaks to the question of authenticity, as evidence of artistic process, is indirect manipulation. Manipulation in this collage discussion is defined as the handling and control of a material or image towards a particular end. While digital media can accelerate the direct manipulation and composition of images, as a correlate to analogue techniques, it more importantly offers the opportunity for indirect manipulation. Indirect manipulation refers to the use of commands, or a series of commands (a script) to execute an action on an image, increasing the depth of interface between the artist and the work. Like the production of collage through analogue techniques, the potential for 'happy accidents' in the work that result from unknown factors in the process are still viable. Dashkin describes the work of artists utilizing digital methods, saying: "That they have used computers to produce their work certainly arises as an issue for them, informing their content and method; but a work that is informed by its methods of

production differs markedly from one that is manifestly centered on them."[16] A discussion of digital methods in collage-making must be rooted in process and procedure as they influence the resulting work. Common to the methods discussed in this book, the specific methodology used in collage-making has a symbiotic relationship with the content and intent of the collage, but is not an end in and of itself.

The material fodder for collages using digital methods is often founded in photographic images. (As of 2011, there were over 6 billion photographs on Flickr alone.) The ease and speed of digital photography facilitates the use of constructed images in digital photomontage as well – comparable to the work of Matta-Clark and Mary Miss. Dadaist Raoul Hausmann, in an essay on photomontage published in 1931, claimed that "As for future photomontage, the exactitude of the material, the particular clarity of objects, the intensification of its plasticity, in spite of, or just because of, the juxtaposition of these things, will play the greatest role."[17] Two contemporary artists have used the concept of indirect manipulation in the creation of digital photomontages, confirming the speculations of Hausmann – Chris Jordan and John Maeda.

Chris Jordan is a photographer who uses digital methods to replicate images in the creation of large-scale photomontages. He uses photomontage to further a social agenda, generally focused on consumerism and waste. His series *Running the Numbers* communicates a sense of scale that allows the viewer to visualize an enormous quantity of a given object. Jordan describes how: "*Running the Numbers* looks at contemporary American culture through the austere lens of statistics. This project visually examines these vast and bizarre measures of our society, in large intricately detailed prints assembled from thousands of smaller photographs."[18] Some photomontages in the series establish a non-hierarchical field or network composed of a single discarded object, while others use the duplication of the object to compose larger patterns or images. In *Paper Bags*, Jordan uses the elevational view of a stack of paper bags to create vast towers, organizing various scales and opacities to create a sense of depth in the composition. The precision, control, and ease of replication offered by digital media serves Jordan's agenda of activism through visual communication.

John Maeda is a graphic designer and computer scientist, a former director of the MIT Media Lab and current president of the Rhode Island School of Design. Maeda calls himself a 'post digital' 'humanist technologist,' explaining:

> It is a term that I created as a way to acknowledge a distinction between those that are passed [sic] their fascination with computers, and are now driven by the ideas instead of the technology . . . If we are to consider the book by Nicholas Negroponte *Being Digital* as an affirmation that the computer has arrived, then the 'post digital' generation refers to the growing few that have already *been* digital, and are now more interested in *Being Human.*[19]

For his 2003 project entitled F00D (F-zero-zero-D), he created a series of images using condiments as the original medium. His tools for working with this unusual medium included a digital camera and a flatbed scanner. After photographing the food, Maeda scanned and enlarged the images in order to manipulate them pixel by pixel. He

Chris Jordan,
Paper Bags (2007)
– depicts 1.14
million brown
paper supermarket
bags, the number
used in the US
every hour

© Chris Jordan

describes an image evoking a waterfall, created from a photograph of soy sauce on paper which was then processed by a custom script. For another image, Maeda created a gelatin mold from every flavor of Jello. He scanned the cast and digitally reorganized the colors into an RGB color spectrum. These images are collage-making at the scale of a pixel as existing imagery is extracted and reassembled into a new composition.

Maeda addresses the issue of the human/computer interface by attempting to re-engage the fourth dimension. He explains: "I then proceeded to strengthen the viewer's involvement with the time form, and began to create 'reactive' graphics, visual experiences that respond to user input in realtime in a way that defies physics (not virtual reality) and are devoid of content (not interactive media in the ordinary sense)."[20] Prompting interactivity between the user and the graphic begins to evoke aspects of acoustic space as McLuhan defined it, including simultaneous, dynamic, and non-linear characteristics. However, the growing invisibility of the interface between the human mind/body and our media prompts the question of the boundary between reality and fiction. Alberto Perez-Gomez and Louise Pelletier consider architectural representation beyond the perspectival, proposing that it is the role of the artist to investigate the distance "between reality and the appearance of the world."[21] These theories and observations prompt numerous questions about the role of the representational tool as an extension of the human mind and body, the nature of the physical artifact, and the characteristics of the relationship between the consumer/observer and the work. The architects discussed in this chapter have begun to consider these themes, specifically interrogating the interface between the artist and collage, as well as between the inhabitant and the built environment.

Point Supreme,
*Archipelago Cities
– Athens* (2011)

POINT SUPREME

Collage is deeply seminal to the work of Le Point Supreme. We are interested in spaces of contradiction, disruptions of meaning, unexpected associations. Collage assists storytelling; it mirrors our ambition to transform reality with the minimum means necessary, investing a given context with narrative, revealing and enriching its identity and features. Images have incomparable evocative power and our contemporary physical world is full of readily available ones.

Collage brings signifiers together in a kind of semiotic collision, reducing the role of consciousness, one's own inevitable subjectivity, questions of style and taste. We aim at inventing a new collage language which combines the precise spatial information of architectural perspective drawing with the informal, psychological, invisible cultural properties of space hidden in popular representations such as postcards. The city, collective memory and the political are contained inside every project through slow, static, staged and accessible forms of representation that encourage the viewer to reflect critically about what he sees.[22]

Konstantinos Pantazis and Marianna Rentzou, Point Supreme

Point Supreme architects, based in Athens, Greece, integrate collage, hand drawing, photography, physical model making, and digital models in their design process as extensions and manifestations of narrative. Their diverse work includes graphic design, art installations, and residential, commercial, and urban-scale projects. Speculative explorations and competition entries complement their built work. Their collages have been published in numerous periodicals including *The Architectural Review* and *A+U*, as well as the book *Architects' Sketchbooks*. Partners Konstantinos Pantazis and Marianna Rentzou founded the firm in Rotterdam, Netherlands in 2007 where they worked for MVRDV and OMA/Rem Koolhaas. The aesthetic qualities of their collages are quite diverse, but the legacy of Koolhaas's representational techniques is evident, specifically in the assimilation of photomontage elements with architectural drawing. Pantazis and Rentzou describe a desire to combine the technical with the atmospheric drawing, an approach taken in the collage-drawings of Koolhaas.[23] Other collages by Point Supreme bear a resemblance to the dense and colorful photomontages of Pop Art and collage-drawings of Archigram. Pantazis and Rentzou also point to the importance of Surrealism to their work,[24] as the role of semantic juxtapositions in the work of the Surrealists has informed their interest in metaphor: "non-literal and in-direct qualities and narratives that could be applied on a space, and collage is an appropriate technique for this goal with its automatic superposition of contexts and worlds."[25]

Point Supreme uses collage as a generative tool at the beginning of the design process. Their collages integrate analogue and digital methods, often using physical models to provide the three-dimensional information for the collage. (This strategy is similar to that of Miralles Tagliabue.) They prefer physical models to digital models for their simplicity and abstraction.[26] The photographic fragments are extracted from magazines and books, or they take photographs for use in collage. For Pantazis and Rentzou, limiting the source material to the physical avoids the potential for being drawn away "from what is your precise goal and ambition"[27] that could occur as a result of the meta-data available to the collage-maker virtually. Digital tools in collage-making are typically employed as a correlate to analogue methods. Point Supreme's research project *Archipelago Cities* (2011) echoes the Pop Art sensibilities of Archigram's urban speculations. This project considers the conflation of the natural geography of the Greek archipelago with the urban context of Athens. They describe the circular organization of mountains set within the urban fabric, perceived in a fragmentary way in relation to the Acropolis and the city edge. Point Supreme asks: "Can we imagine a parallel urban archipelago using a different landscape as the inspiration? If Athens is the city that corresponds to the Cyclades 'circular' archipelago, what kind of city would correspond to Hawaii, a 'linear' archipelago?"[28]

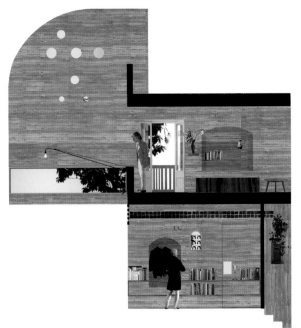

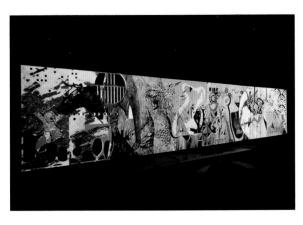

Through photomontage, Point Supreme speculates on a potential manifestation of this linear archipelago. In contrast with the simultaneous nature of the perception of Athens' topography, "The elongated side views of Kawaii reveal the hills in breathtaking simultaneity while the experience of the city depends on one's direction of movement. Due to the specific arrangement of the hills the perception and experience of Kawaii becomes *objective*."[29]

An interest in the dialogue between the aggregative quality of the built environment of Athens and the dynamic topographic conditions reveals itself in a project under construction in 2012. The Petralona House Extension is the future home of Pantazis and Rentzou, an addition to an existing one-story house in the center of Athens. Extending it vertically draws light into the house and into the enclosed rear garden. Collages created for this project capture spatial and haptic qualities rather than tectonic details. They convey Point Supreme's intent to hybridize the atmospheric with the technical, illustrating inhabitation through normative architectural views including elevation and section. "The diversity of elements from different architectural traditions and environments, in combination with the pixelated outline of the existing structure, the narrow plot and the fragmented garden create a living experience surprisingly rich in spatial qualities and conditions."[30] The use of collage in their design process facilitates the embodiment of this diversity in the built work.

An installation entitled *Marble Mural* was created for an Interior Design Show in Athens in 2010. This project is a collage as artefact, utilizing analogue and digital methods in the design and fabrication of the work. Point Supreme describes it as "a hymn to marble" in a 10m × 2m wall of seven varied pieces of marble. Marble, as synonymous with Greek architecture, in this case defies its stereotomic

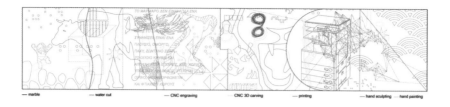

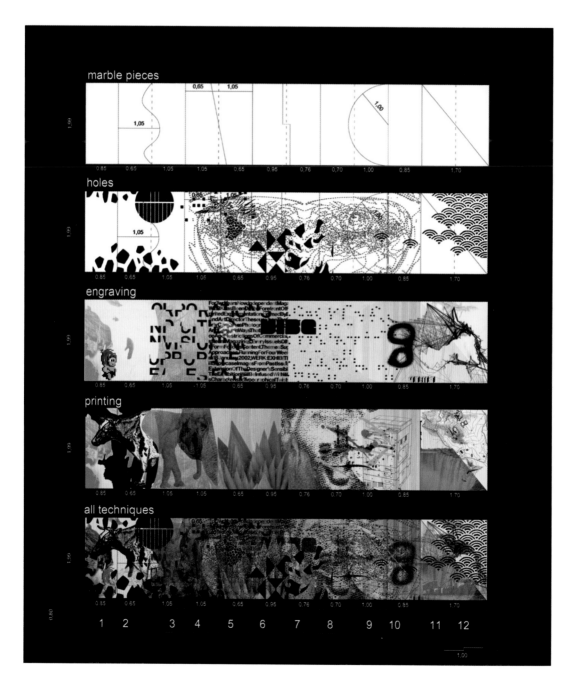

properties and becomes a screen or skin. Techniques for treatment of the surface are layered to build up the final collage image. These techniques include water-cut excisions, CNC engraving, digital printing, hand sculpting, and hand painting. *The Architectural Review* describes the mural as "a rich palimpsest of artistic processes."[31] The unique character and heritage of each piece of stone informed the subsequent layers of imagery, as the veiny Athens marble provides the substrate for a topographic map. Point Supreme explains: "Consequently, marble is revealed not as the clean and current matter we are accustomed to seeing it as, but rather as a rich, thick live object that hides and reveals stories, can be transformed into a painting, stands up and even creates space."[32] This project illustrates Point Supreme's experimentation with the hybridization of analogue and digital techniques beyond image-making, extending to the real and tactile nature of materials and fabrication. Working with these materials and techniques at the 1:1 scale offers insight into opportunities for their application to architecture. Point Supreme as a practice embodies a collage mentality that pervades their design process, architectural proposals, and built work. They explain: "The qualities of collage are a goal for our actual built work much more than a design technique and working method. It is spatial contradictions and the poly-semantic that we are aiming for our built work to express."[33] These qualities manifest themselves at the various scales of design in which their practice is engaged.

Mathur/da Cunha,
Draining Waters
from *Mississippi*
Floods (2001)

MATHUR/DA CUNHA

The medium of screen printing afforded a unique way to sediment and erase, layer and juxtapose, reveal and conceal the wealth of information that confronted us as well as to structure relationships and appreciate serendipitous occurrences. It makes the map-prints constructions in addition to presentations of the landscape that we traversed.[34]

Anuradha Mathur and Dilip da Cunha, *Mississippi Floods*

Mathur/da Cunha,
Arresting Time
from *Mississippi*
Floods (2001)

Mathur/da Cunha have focused their practice and research on controversial terrains, viewing nature and culture as inextricably linked. Anuradha Mathur and Dilip da Cunha practice as landscape architects and architects, and are faculty members in the University of Pennsylvania Department of Landscape Architecture. Their work considers landscapes and the layering of the physical and cultural history of each site, represented through collage-drawings. Their travels have taken them across many landscapes including Mississippi, New York, Bangalore, Mumbai, and Jerusalem. Research projects addressing particular dynamic landscapes have been published as *Mississippi Floods: Designing a Shifting Landscape* (2001), *Deccan Traverses: The Making of Bangalore's Terrain* (2006) and *SOAK: Mumbai in an Estuary* (2009). The collage-drawings created to communicate this research integrate line drawings with photographs and textures, first through fully analogue methods but beginning to hybridize analogue and digital techniques in *Deccan Traverses*. While methodologically similar to the architects who have explored collage-drawing (see Chapter 1.2), we are considering them as a contemporary practice demonstrating the evolution of collage-drawing by engaging digital methods as well as analogue tools in their representation.

Their first significant investigation into contentious landscapes considers the Mississippi River. *Mississippi Floods* is based on the great flood of 1993 that spread across the American Midwest covering over 10,000 square miles. This flood was con-

sidered by the USGS to be one of the most costly and devastating in America's history. Mathur and da Cunha rooted their research in an understanding of the Mississippi as a living phenomenon and working landscape rather than the more pervasive scenographic perception. Traveling along the Mississippi, Mathur and da Cunha investigated four terrains of conflict: meanders, flows, banks, and beds. Their analytical process integrated first-person experience and documentation with historical and artifactual research including surveys, maps, histories, and even folklore to guide their inquiry. Mathur and da Cunha's methods introduce a new way of understanding existing landscapes and revealing what lies below the surface. Their process of analysis includes 'map-prints' (screen prints with layered and erased information), 'photo-transects' (photomontages combining maps and panoramic images), historical maps, line drawings, and paintings.

As a graphic analysis of the Mississippi floodplain and an account of the architects' research and personal experiences of the river, they claim: "It was truly the inhabiting of a shifting terrain."[35] Their photomontages and screen print collage-drawings reveal the landscape in flux, illustrating a constantly shifting relationship between the river and human settlement. Their collage process was both additive and subtractive, much like Archimedes's palimpsest or the Cubist collage. The accumulation of graphic fragments mirrors the aggregative properties of the landscape itself.

The collage-making process captures the role of time in the construction of this landscape through physical layering: "Shifting laterally over time the meandering Mississippi has constructed an archaeology of its vagrant travels."[36] In the collage-drawing or 'map-print' entitled *Arresting Time*, Mathur and da Cunha capture the transformations of a portion of the Mississippi caused by both natural and engineering processes. In an attempt to foresee and forestall future transformations, the US Army Corps of Engineers "in effect stopped time in terms of the distribution of flows," according to General Thomas Sands. This screen print collage-drawing evokes the sedimentation of the landscape under consideration, layering relevant imagery to document the rich history of the site. The resulting aesthetic as well as the scale of analysis is reminiscent of the map collage-drawings of James Corner, although less reductive. Retaining a diagrammatic quality, the collage-drawings of Mathur/da Cunha derive an ambiguity through superimposition. Mathur and da Cunha describe how: "Water challenges us to consider ambiguity as a condition to embrace rather than erase. Water constructs a keen awareness of time through its absence and its presence; it draws us into a sectional world, an appreciation of depth."[37]

Deccan Traverses: The Making of Bangalore's Terrain "is about the power of landscape to determine the nature of place and the eye through which it is seen."[38]

Mathur/da Cunha,
Mantap I from
Deccan Traverses
(2006)

Like *Mississippi Floods*, it seeks to graphically reveal a landscape in flux. This landscape was first surveyed and dimensioned in the late 1700s by the East India Company, identifying and representing objective characteristics through maps, sketches, and paintings. Building on this centuries-old tradition, Mathur and da Cunha create collage-drawings to analyze both the dimensional constructs and the material experience of the landscape:

> Here our focus was to show how the enterprises of war, surveying, picturing, and botanizing – the four sections of this book – served in the late 18th century to construct the identity of Bangalore as the "Garden City of India." We showed how these scientific and artistic acts, undertaken by British colonials, had marginalized various local material practices . . . and also ways of inhabiting place . . . that are often dismissed as "informal."[39]

These screen prints are pulled by hand, combining images from existing maps, line drawings, notations, found photographs, and data that have been digitized or constructed digitally. The hybridization of analogue and digital methods facilitates the creation of a haptic artifact while retaining the accuracy and precision of source material. These collage-drawings merge fragments of the constructed landscape with textures evocative of the terrain to convey an amalgam of sensory information.

Mathur and da Cunha explain that in each of their research projects: "we have been singularly concerned with revealing and probing lines of demarcation and

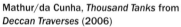

Mathur/da Cunha, *Thousand Tanks* from
Deccan Traverses (2006)

categories, lines which can be literal or conceptual – such as the lines between city and river, urban and rural, formal and informal, infrastructure and landscape, land and sea, among many others."[40] In this theme, we can see a conceptual link between the analytical collage-making of Mathur/da Cunha and Teddy Cruz. The investigation of contested landscapes analyzed and communicated through collage is manifested through very different methods with a similar intent.

Like Teddy Cruz, Mathur and da Cunha consider their work an activist practice:

> By activist practice we also include the visualization of landscape – how landscapes are seen, imagined and drawn. Visualization underlies history, geography, politics, and policies, and of course design and planning approaches as well. We question the assumptions and limits of the visualizations that we've inherited. We've found that this inquiry cannot reside wholly within academia.[41]

The reach of the work of Mathur/da Cunha outside the academic realm echoes the agenda of Teddy Cruz. For both practices, experimentation in representational methods offers the opportunity to communicate critical practical issues and provide a conceptual framework for intervention. "One way is to construct boundaries, material or representational, and aim to separate, control, predict and manage what's within. Another way is to construct what we call anchors in an open, mutable field – a process that begins with material specificity but extends in ways we cannot entirely predict."[42] Fluid boundaries and dynamic relationships as described here, inherent in the natural and constructed landscape, find a correlate in the acoustic space articulated by McLuhan that has reemerged in the electronic age. Viewing their collage-drawings as both art and information communication, the narratives embedded begin to synthesize and distill the complex histories and dynamics of the controversial landscapes under analysis. These critical analyses provide the foundation for potential futures to be manifested.

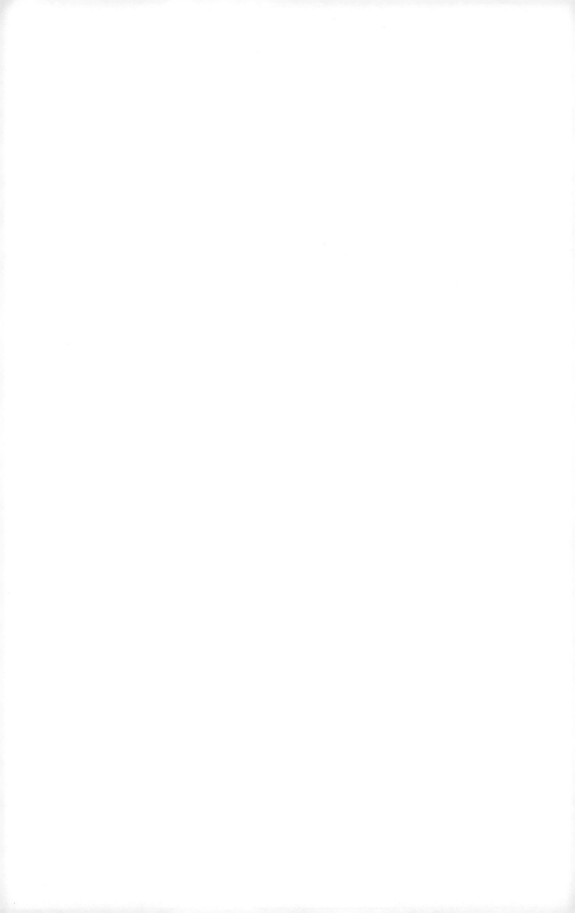

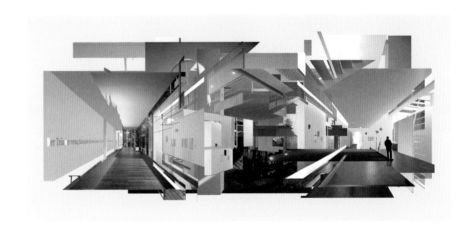

FELD studio,
*Extracts of Local
Distance: Arp
Museum* (2010)

FELD STUDIO

Using a vast archive of fragments of scanned architectural photographs, new archi-
tectural images are created as multilayered collages of these fragments. The images,
created as complex reconstructions of fragments of real images, introduce a third,
abstract point of view to the original views of architect and photographer.[43]

FELD studio

The FELD studio of digital crafts (established in 2007) has developed innovative techniques for indirect manipulation deployed in the construction of photomontages. They are self-described as "a group of Berlin based designers who share a common language of digital thinking in their work process."[44] Their portfolio includes work diverse in media and scale, including collage, handheld interactive devices, and urban sculptures.

The intellectual background driving the design work coming out of FELD studio is 'post digital' in nature. Their design installations incorporate digital fabrication and processing tools in a way that demands human interaction in order to be understood. The design group describes their thoughts regarding design with respect to digital methods of fabrication and representation:

> Transcending any definition in the tools or target media, . . . FELD balances what computers and what people are good at: Leveraging the relentless, precise and high-speed computational processes or custom machines to unfold their works, but having the designers always at the helm result in thought provoking, aesthetic and elegant works.[45]

Much of their work considers human cognition pertaining to memory and perception. The invention of custom machines and computational processes serves to reinterpret, enhance and/or encapsulate memory and human perception. These projects, in the interface between human and machine, foreground the properties of acoustic space through synaesthetic engagement. Two projects heighten our attention to the quotidian ritual of dining. The *Table Recorder* calls attention to the ritualistic activities associated with the use of a table by capturing patterns of use and generating sonic responses to such uses. Regardless of type of use, "otherwise unremarkable movements become part of a sonic performance which repeats, can be added to, and slowly fades from the memory of the table."[46] To achieve this sonic palimpsest, sensors are embedded within the surface of the table. These sensors are linked to solenoid hammers that respond to human interaction by striking everyday objects that are embedded within the body of the table. "The table is raised from a passive to an active participant in the action it normally plays a silent part in, also raising the table in the consciousness of the user, by subjectively sonifying everyday action."[47] This installation attempts to heighten human perception in regard to the use of everyday objects as well as encapsulate a type of sonic memory of the ritualistic use of the table by embedding the recorded memory of such use into the object itself.

In *Rewriting Traces*, a tablecloth installation visually responds to human activity (heat or pressure) by generating color fields on its surface. These color fields are indexes of activity captured by pressure and heat sensors that are embedded within the cloth. The after image from the imprint on the tablecloth may remain embedded in the memory of the fabric, appearing much later than the time of its indexing. Similarly to the *Table Recorder*, we can see the studio's interest in exploring means of capturing and representing memory, both individual and collective, through the use of digital methods.

Recalling the text collages of Dada, *Figures of Perception* is "a concept for a toolset to generate and share collective data-fictions about an imaginary person and

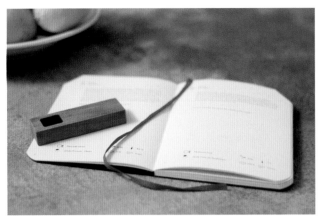

place."[48] This data fiction can be likened to the "exquisite corpse" of narrative development, where one user continues the story from a previous user's narrative. An innovative interface integrates the analogue and the digital: "It introduces devices to facilitate the communication of collective imaginations proposing a paper-based interface comprising an augmented notebook, pen and micro printer,"[49] allowing multiple users to communicate in their imagination of the life of a deceased

FELD studio, *Figures of Perception* (2011)

friend. Although these projects are not technically collage as defined in this book, the digital methodology employed by FELD is very much a humanization and reengagement of multiple senses in the digital interface. FELD's *Extracts of Local Distance* draws on these themes for collage generation through digital means.

 Extracts of Local Distance employs a series of customized photo-analysis scripts to deconstruct photographs and then reassemble the fragments in service of creating new 'common perspective' photomontages. FELD collaborated with architectural photographer Klaus Frahm, whose large-format analogue photographs became the source material for this project. The developed software is customized to work with architectural photography. They were driven by the potential "to use computational possibilities in order to achieve a much more complex result but still not lose the personality and artistic control of a conventional collage."[50]

FELD studio, *Extracts of Local Distance: Untitled 2* (2010)

 In the academic paper that accompanied the presentation of *Extracts of Local Distance* at the University of the Arts Berlin, FELD describe their process.

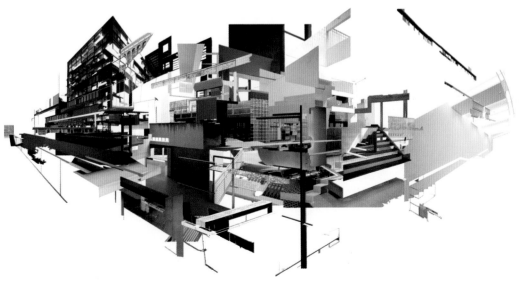

The generation of photomontages from the metadata involves two steps: first, the analysis and segmentation of the individual photographs, and second, the composition of new images from these segments.[51] The first step is the most labor-intensive. It entails conducting a vanishing point analysis of each photograph, defining the segmentation within each photograph, extracting image segments, and assigning the segments to corresponding vanishing points. In the second step, the composition of the new image is initiated by setting the new vanishing point for the collage image and con-

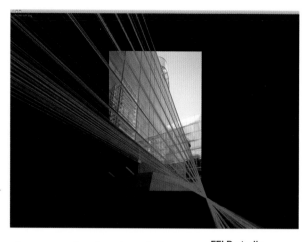

FELD studio, *Extracts of Local Distance: Vanishing Points and Perspective Grid* (2010)

structing a coarse geometry for a perspective grid, to be associated with each applied image segment. (FELD's academic writing on the project unpacks the technical details regarding the algorithms used to analyze, segment, and recompose the original photographs.)

What makes *Extracts of Local Distance* of interest to our discussions regarding digital collage is the way in which FELD intends to control the output of the generated collage, particularly in the composition of the image segments. After the input images are processed, and before the final collage is generated, vanishing points and a corresponding perspective grid can be mapped in infinite space at the complete discretion of the user. This allows the user to create the compositional framework that will guide the collage. In addition to setting the perspectival map, the algorithm can be adjusted by a series of input sliders that provide the user the ability to narrow the selection range in the collage-making process.

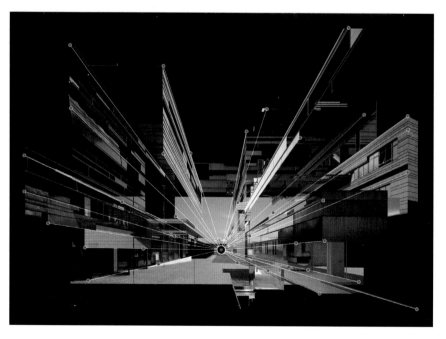

A 'distance threshold parameter' allows the expansion and contraction of the positioned perspectival nodes. This directly affects the amount of possible fragments that can associate with each point. The 'border percentage parameter' controls the source location and size of the selected fragments. Additionally, each photograph in the database is tagged with a series of keywords, providing another means of filtering

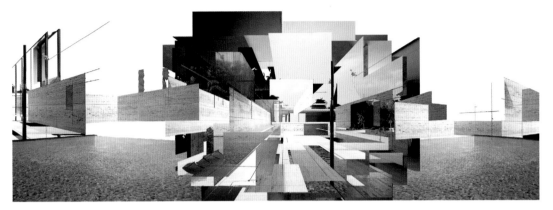

FELD studio, *Extracts of Local Distance: Barcelona Pavilion* (2010)

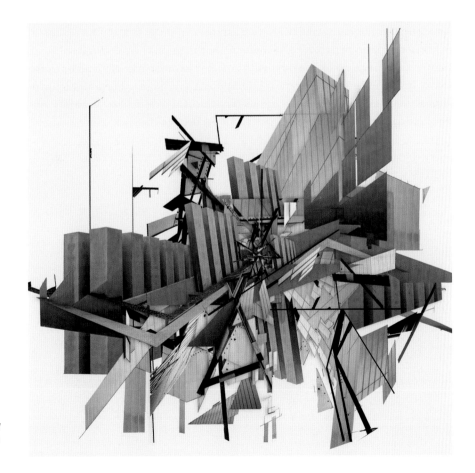

FELD studio,
Extracts of Local Distance: Jewish Museum (2010)

the image segments. The subjective process of selecting individual fragments for the collage-making is automated through this keyword input process.

After the algorithm runs its course and the collage is generated, an XML file is created. This XML file can be opened in Photoshop, where the layers can be adjusted, relocated, or removed so that "the final collage can be fine tuned from the designers' point of view."[52] By allowing the user to control the number and type of source photographs, the composition of the perspective grid, as well as the composition of the white space upon the page, *Extracts of Local Distance* harnesses the computational processing power and precision of the computer to create highly synthesized perspectival photomontages.

With respect to broader architectural discourses, FELD studio points out that "many associations with the architectural movement of 'Deconstructivism' arose, due to the process of recombining architectural fragments."[53] FELD in fact deconstructs a Deconstructivist building, creating a photomontage out of image fragments of Daniel Libeskind's Jewish Museum in Berlin. FELD anticipates additional uses for this procedure of image making, including animation, three-dimensional representations, large-scale projections, and the appropriation of image segments drawn from renderings and sketches, leading to "unpredictable visual mash-ups, going against the grain of the evermore photorealistic representation."[54] The work of FELD studio anticipates the application of synthetic human/digital processes to the design and fabrication of architecture. Their interactive projects prompt questions of the role of technology in indexing and foregrounding relevant data from our environment, while allowing the user or inhabitant a degree of control and manipulation. Envisioning potential architectural futures through photomontage offers opportunities for design – while like analogue collage, the methods promote the 'happy accident' in the visualization of space.

Notes

1 "The Playboy Interview: Marshall McLuhan," *Playboy Magazine*, (March, 1969).
2 "The Playboy Interview."
3 "The Playboy Interview."
4 Gordon Gow, "Spatial Metaphor in the Work of Marshall McLuhan," *Canadian Journal of Communication* (Online) (January 1, 2001), 26.
5 "The Playboy Interview."
6 "The Playboy Interview."
7 Maurice Merleau-Ponty, "Cezanne's Doubt," (1945), from *Sense and Non-sense* (Evanston, IL: Northwestern University Press, 1964).
8 Marshall McLuhan, "The Medium is the Message," Noah Wardrip-Fruin and Nick Montfort, eds. *The New Media Reader* (Cambridge, MA: The MIT Press, 2003), 205.
9 Michael Dashkin, "From Drawing to Montage," *Leonardo*, Vol. 28, No. 1 (1995), 4.
10 Walter Benjamin, *The Work of Art in the Age of Mechanical Reproduction* (1936). Source: UCLA School of Theater, Film and Television; Transcribed: Andy Blunden 1998; proofed and corrected February, 2005. Part II, Paragraph 2.
11 Benjamin, Part II, Paragraph 3.
12 Benjamin, Part II, Paragraph 1.

13 Benjamin, Part VI, Paragraph 1.
14 Benjamin, Part XIV, Paragraph 2.
15 David Lane, *Jean Baudrillard*, Second Edition (Routledge Critical Thinkers) (London: Routledge, 2008), Kindle Edition, Location 1847.
16 Dashkin, "From Drawing to Montage," 5.
17 Raoul Hausmann and John Cullars. "Photomontage," *Design Issues*, Vol. 14, No. 3 (Autumn, 1998), 67–68.
18 www.chrisjordan.com/gallery/rtn/#about
19 www.maedastudio.com
20 www.maedastudio.com
21 Alberto Perez-Gomez and Louise Pelletier, "Architectural Representation Beyond Perspectivism," *Perspecta*, Vol. 27 (1992), 34.
22 Konstantinos Pantazis and Marianna Rentzou, "The Use of Collage in the Design Process of Point Supreme," written for *Collage and Architecture*, 2012.
23 Note to author.
24 Note to author.
25 Note to author.
26 Note to author.
27 Note to author.
28 www.pointsupreme.com/content/research/archipelago-cities.html
29 www.pointsupreme.com/content/research/archipelago-cities.html
30 www.pointsupreme.com/content/housing/petralona-house-extension.html
31 *The Architectural Review* (March, 2011), 83.
32 www.pointsupreme.com/content/research/mural.html
33 Note to author.
34 Anuradha Mathur, and Dilip da Cunha, *Mississippi Floods: Designing a Shifting Landscape* (New Haven: Yale University Press, 2001), 11.
35 Mathur, and da Cunha, *Mississippi Floods*, xii.
36 Anuradha Mathur, "Blues Meanders," *Architectural Design*, Vol. 69, No. 7–8 (July–August, 1999), 48–51.
37 Nicholas Pevzner and Sanjukta Sen, "Preparing Ground: An Interview with Anuradha Mathur + Dilip da Cunha," Design Observer: http://places.designobserver.com/feature/preparing-ground-an-interview-with-anuradha-mathur-and-dilip-da-cunha/13858/
38 Anuradha Mathur and Dilip da Cunha, *Deccan Traverses: The Making of Bangalore's Terrain* (New Delhi: Rupa & Co., 2006), vii.
39 Pevzner and Sen, "Preparing Ground."
40 Pevzner and Sen, "Preparing Ground."
41 Pevzner and Sen, "Preparing Ground."
42 Pevzner and Sen, "Preparing Ground."
43 FELD www.feld.is/projects/local-distance/
44 FELD studio for digital crafts, www.feld.is/
45 FELD, www.feld.is/
46 FELD, www.feld.is/projects/table-recorder/
47 FELD, www.feld.is/projects/table-recorder/
48 FELD, www.feld.is/projects/figures-of-perception/
49 FELD, www.feld.is/projects/figures-of-perception/
50 Fredric Gmeiner, Benjamin Maus, and Torsten Posselt, *Common Perspective Images* (University of the Arts Berlin, Digital Media Class), 2.
51 Gmeiner et al., *Common Perspective Images*, 4.
52 Gmeiner et al., *Common Perspective Images*, 4.
53 Gmeiner et al., *Common Perspective Images*, 5.
54 Gmeiner et al., *Common Perspective Images*, 5.

Architecture as Collage

LE CORBUSIER's
Casa Curutchet

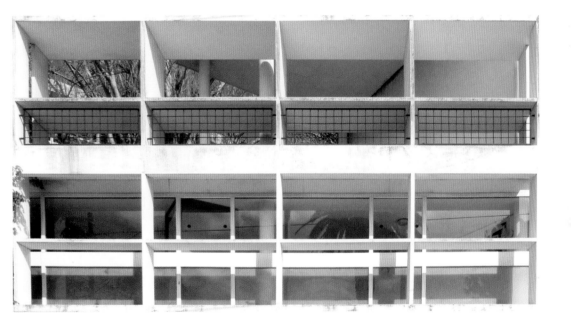

Architecture is the masterly, correct, and magnificent play of masses brought together in light.[1]

Le Corbusier, *Towards a New Architecture*

Casa Curutchet in La Plata, Argentina (near Buenos Aires) exemplifies this "magnificent play of masses," and was designed by Le Corbusier beginning in 1948 with construction completed in 1953.[2] Although it is a lesser-known work in his prolific career, Casa Curutchet was intended to serve a didactic purpose and demonstrates the evolution of his ideas regarding a collage mentality in architecture and urbanism. Le Corbusier's own collage-making practices have influenced the formal, spatial, and material execution of his architectural works, and Casa Curutchet is evidence of a three-dimensional manifestation of this collage methodology. Bernhard Hoesli, who was integral to the realization of Casa Curutchet, described this approach, saying: "It would seem that transparent form-organization would be the instrument of design par excellence that permits *collage* as an attitude."[3] A 'collage attitude' is evident throughout the oeuvre of Le Corbusier, but will be dissected in an analysis of Casa Curutchet.

Le Corbusier first visited Argentina in the fall of 1929 where he spent an extended period of time traveling and lecturing, in addition to establishing new connections for potential work internationally. The relationships forged by Le Corbusier during his time in Argentina led to several residential commissions, however none of these were realized. In 1937–38, Le Corbusier used Buenos Aires as the vehicle through which to test his urban planning concepts. He was critical of Buenos Aires, describing its landscape as "one single and same straight line: the horizon."[4] A singular reading of the city stood in opposition to the ambiguity and simultaneity inherent in a collage strategy. He produced a master plan for the city (despite never receiving a commission) and a decade later his proposal was considered for implementation by the government. It was during these discussions that a Dr. Curutchet approached Le Corbusier for the design of a home and medical office in La Plata. Le Corbusier's acceptance of the commission came at a pivotal moment in his career: at the time, he and his office were at work on the Unité d'Habitation. Le Corbusier was optimistic that accepting the commission would lead to future projects in Argentina, potentially including the adoption of his master plan.[5]

After accepting the commission in 1948, Le Corbusier formed a project team consisting of Roger Aujame and Bernhard Hoesli. The early design process occurred through sketching, drafting, and clay modeling as means of iterating potential spatial configurations for the project.[6] This process resulted in the basic massing of two volumes linked by a ramp spanning a small courtyard. The project team's completed design package included detailed drawings and a detailed model photographed from a variety of viewpoints. The model served to communicate the complexities of the spatial organization. Additionally, according to Alejandro Lapunzina, "the photographs were altered in the atelier using drafting, montage, and transfer-paper techniques to further emphasize particular aspects of the project."[7] The use of collage in the communication of design concepts to the client rather than in the internalized design process demonstrates another value of this method. Dr. Curutchet responded to the design of his home and office with great enthusiasm, saying:

> The elegance and transparency of the building's organization, the form
> and disposition of bathrooms and bedrooms, the ramps, and the overall

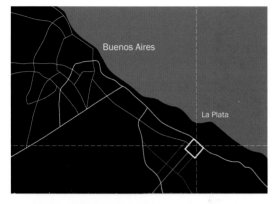

harmonic continuity, particularly between the living room and the terrace-garden were the unexpected great news. However, after that first impression, I look and, in every detail, I find a new interest, a new mirror of clear intellectual beauty.[8]

Reflecting on the embodiment of collage in the realized Casa Curutchet, evidence exists at multiple scales. At the site scale, we must consider the urban context. La Plata at the time was the new capital of the province of Buenos Aires, built from a tabula rasa as a city of pure geometry. It reads as a square inscribed by a wide boulevard, containing a grid of blocks and sliced through from corner to corner by two wide, diagonal boulevards. The more complex geometries applied at the scale of the city block render the site of Casa Curutchet surprisingly irregular, narrow, and deep with a sharp diagonal defining the front of the site. Although bound on three sides by other buildings, the site opens to a panoramic view of the large urban park. Dr. Curutchet emphasized the importance of this adjacency in his initial correspondence with Le Corbusier by including images of the site and its views to the park. The urban qualities of La Plata and the natural elements of the adjacent park intertwine with the spatial construction of Casa Curutchet. Voids within the volumetric organization allow for views out into the park, while the park seeps into the building through the interior courtyard. Vegetation becomes a medium within the composition, while a hanging garden creates a green buffer between the medical office and the residence. The collapse of space indicative

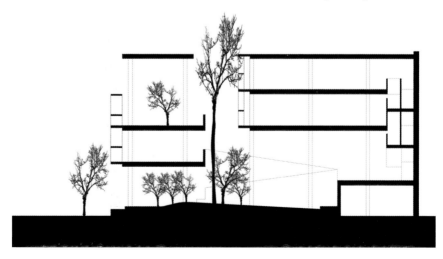

of Cubism reveals itself in the frontal approach to Casa Curutchet from the boule-vard, in which "The brise-soleils, the baldaquin, the concrete-framed entry door, the pilotis and the poplar tree, appear all at once, projected upon the frontal plane and poetically articulated in a carefully balanced composition" according to Alejandro Lapunzina.[9] This strategy reflects an earlier statement by Sigfried Giedion in *Space, Time and Architecture* published in 1941. He states, "the interpenetration of inner and outer spaces in modern architecture corresponds to the simultaneous presenta-tion of the inside and outside of objects in cubism."[10] Colin Rowe and Robert Slutzky subsequently characterized the spatial overlap identified by Giedion as phenomenal transparency.

In Chapter 1.1, we found phenomenal transparency to be a common con-ceptual thread between Cubism, collage, and Modern architecture. A colleague and collaborator of Rowe and Slutzky at the University of Texas at Austin, Bernhard Hoesli wrote the "Commentary" and "Addendum" to their 1968 book *Transparency*. In this, Hoesli describes the role of phenomenal transparency in the work of Le Corbusier: "The dialectic between full corporeality and the illusion of shallow space, the multiple interpretational possibilities of his formal relationships, the classification of form and function in his buildings – these have never been made clearer. And indeed made clear from the object itself, without benefit of 'extra-architectural' association."[11]

Hoesli proposed phenomenal transparency as a tool for interpreting the formal design process and resulting organizational tactic, using Casa Curutchet as an example in his commentary. He describes how: "In a structure characteristic of Le Corbusier, horizontal layers are continuously pierced by deep, vertical cuts." Hoesli points out that the internal two-story space serves to provide visual relief for smaller adjacent spaces while creating ambiguous spatial conditions. Casa Curutchet incor-porates the free plan with the overlapping L-section, with evidence of phenomenal transparency in its spatial configuration. This ambiguity of spatial definition occurs in the overlap of interior spaces as well as in the overlap of interior and exterior spaces, as recognized by Giedion. The frontality of the composition creates a density of spatial

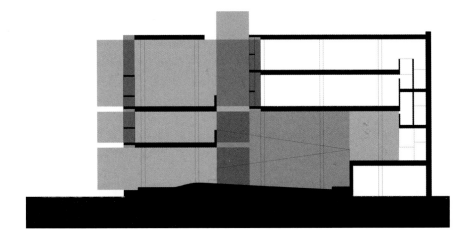

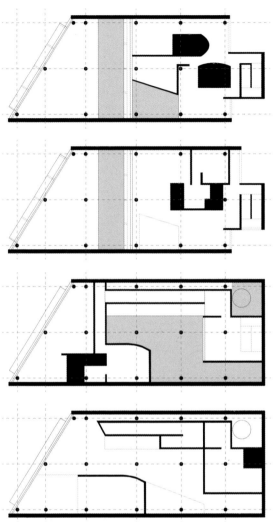

overlap, varying conditions revealed through temporal and spatial progression. Considering Casa Curutchet planimetrically, identifying a geometric order superimposed with organic forms speaks to Le Corbusier's use of the plan as the generator of space. A regular grid establishes a structural metering for the house while sculptural forms, both built and natural, disrupt the grid, creating a dynamic spatial experience.

Lapunzina states: "To enter Maison Curutchet is, in effect, to penetrate the three-dimensional spatiality of a purist canvas."[12] He points to three themes that Le Corbusier draws from Cubist influences and Purist themes into his architecture: layered, vertical planes; juxtaposition of foreground, middle ground, and background; and compositional devices.[13] As described in relation to site, the layers of spatial and physical enclosure offer a compressed reading, while establishing a metering through the depth of the site. These planes mark thresholds between interior, exterior, and transitional space. A ramp moves through the site, weaving through programmatic volumes and voids. This procession both vertically and horizontally offers a variety of viewpoints and spatial experiences, much like the simultaneous viewpoints defining Cubist collage. The switchback ramp offers first a compressed and internalized experience, while after the 180 degree rotation the spatial perception broadens and expands to include vistas of the park beyond.[14] The perceptual experiences are augmented by the foregrounding of backlit elements, provided by light penetrating the exterior voids.[15] Literal and phenomenal transparency within the composition of vertical planes provides a diversity of spatial and material experience along the procession. While the thresholds created by the vertical planes promote movement, they also define moments of pause. They can be understood as layers in a collage, which allude to a collapse of space until the layers are penetrated. Hoesli argues: "Transparency as organization of form produces clarity as well as it allows for ambiguity and ambivalence," promoting an engagement of the occupant in the use and interpretation of the space.[16] Compositional devices developed in Le Corbusier's Purist paintings and collages are demonstrated in Casa Curutchet, including his proportioning system and balance between horizontal and vertical elements. Considering the material execution of these compositional and experiential devices, it is important to note that Amancio Williams was responsible for the detailing of Casa

Curutchet, utilizing the known strategies and recommendations of Le Corbusier. The pervasive smooth white stucco finishes help to maintain the abstract formal properties of the design proposal, clarifying solid/void relationships within the work. It was Le Corbusier's intent that blue, red, and pale grey be used as accent colors to highlight select vertical surfaces and niches, however this color scheme was never implemented.[17]

The regulating lines superimposed with irregular forms become formal accents within the composition and experiential procession. These curvilinear volumes, such as the bathrooms in the residence, read as floating elements within the larger volume of the bedroom. They also provide visual relief to the strongly gridded rectilinear geometry of the project (see p. 215). Alternatively, hierarchy is established in the procession. The culmination of the architectural promenade is the terrace garden above the clinic. At this moment the occupant reengages the frontal plane in the space contained by the brise-soleil, becoming an inhabitant of the façade.[18] Casa Curutchet is one of Le Corbusier's first completed projects to feature a brise-soleil, providing solar shading for a glazed façade. This brise-soleil consists of a grid of concrete planes, framing views of the park. The

© 2012 Artists Rights Society (ARS), New York / ADAGP, Paris / F.L.C.

integration of vegetation with the abstract formal construction of the Casa sets up a more immediate juxtaposition in the vein of collage. In the void separating the clinic volume from the residential volume, Le Corbusier called for a tree to be planted. This poplar tree grew rapidly and became a focal point at the heart of the project, contrasting the pure white geometry with this ever-changing natural element.

Casa Curutchet demonstrates a number of strategies analogous to collage-making. Le Corbusier's overlap and ambiguity of spatial definition through phenomenal transparency, disruption of an established geometric order with irregular forms, and juxtaposition of unrelated elements contribute to an interpretation of Casa Curutchet itself as a collage. A multiplicity of formal and experiential readings is inevitable. In his "Commentary" to *Transparency*, Bernhard Hoesli attempts to abstract the layers of a Le Corbusier Purist painting and Villa Stein through diagrammatic axonometrics, proving the fallacy of this oversimplification. Like Casa Curutchet, the ambiguity of spatial relationships cannot be made static. The success of Casa Curutchet understood through the lens of collage lies in its simultaneous and multiplicitous readings, creating a programmatic clarity while offering diverse spatial and material experiences.

Notes

1 Le Corbusier, *Towards a New Architecture*. (New York: Dover Publications, 1986), 29.

2 As Le Corbusier and his project team were unable to travel to Buenos Aires to supervise construction of Casa Curutchet, he recommended a local architect, Amancio Williams. Acting as construction supervisor, Williams was responsible for the development of the construction documents including small design changes approved by Le Corbusier. Delays and increasing expenses for the project led to a contentious relationship between Dr. Curutchet and Williams, and the project was ultimately completed under the supervision of a different local architect, Simón Ungar. In 1954, Casa Curutchet was finally complete and ready for occupation.

3 Bernhard Hoesli, "Addendum," in *Transparency*, Colin Rowe and Robert Slutzky (Basel: Birkhäuser, 1997), 99.

4 Alejandro Lapunzina, *Le Corbusier's Maison Curutchet* (New York: Princeton Architectural Press, 1997), 21.

5 Lapunzina, *Le Corbusier's Maison Curutchet*, 51–53.

6 Lapunzina, *Le Corbusier's Maison Curutchet*, 53.

7 Lapunzina, *Le Corbusier's Maison Curutchet*, 73.

8 Lapunzina, *Le Corbusier's Maison Curutchet*, 75.

9 Lapunzina, *Le Corbusier's Maison Curutchet*, 171.

10 Sigfried Giedeon, *Space, Time, and Architecture: The Growth of a New Tradition* (Cambridge, MA: Harvard University Press, 1941), 432.

11 Bernhard Hoesli, "Commentary," in *Transparency*, Colin Rowe and Robert Slutzky (Basel: Birkhäuser, 1997), 60.

12 Lapunzina, *Le Corbusier's Maison Curutchet*, 164.

13 Lapunzina, *Le Corbusier's Maison Curutchet*, 164.

14 Lapunzina, *Le Corbusier's Maison Curutchet*, 157.

15 Lapunzina, *Le Corbusier's Maison Curutchet*, 166.

16 Hoesli, "Addendum," 97.

17 Lapunzina, *Le Corbusier's Maison Curutchet*, 103.

18 Lapunzina, *Le Corbusier's Maison Curutchet*, 159.

2.2 LUIS BARRAGÁN's
House and Studio

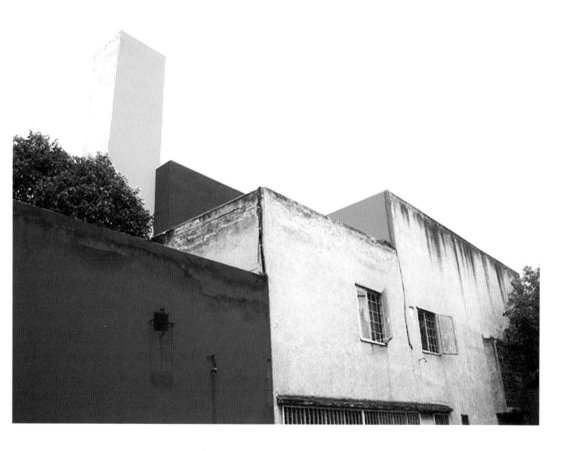

[For architecture] to be highly human it must represent not only the beautiful action of the space, but above all that of time. For this matter the most refined art, the most difficult and dangerous, is that of patina.[1]

Luis Barragán

In 2004, the Mexico City House and Studio of Pritzker Prize winning architect Luis Barragán, built in 1948, was inscribed on the UNESCO World Heritage List on the basis of the following criteria:

> Criterion (i): The House and Studio of Luis Barragán represents a masterpiece of the new developments in the Modern Movement, integrating traditional, philosophical and artistic currents into a new synthesis.
>
> Criterion (ii): The work of Luis Barragán exhibits the integration of modern and traditional influences, which in turn have had an important impact especially on the design of garden and urban landscape design.[2]

Luis Barragán's house and studio reflects a collage mindset in three distinct ways. The synthesis of competing ethos, assimilating traditional Mexican building materials and techniques with elements of Modernism, demonstrates characteristics of collage. Additionally, due to influences of Modernism, the house and studio reveals qualities of collage in the simultaneity resulting from dynamic spatial relationships. Finally, the abstract planar compositions juxtaposed against the rich tactile quality of materials that acquire a patina over time resonates with artistic developments in collage-making beginning with Cubism.

Luis Barragán (1902–88) was born in Guadalajara, Mexico, to a family of landowners who farmed and raised cattle in the isolated rural context of Michoacán in western Mexico. The vernacular architecture, rugged terrain, and mountainous landscape of this region would influence Barragán's interest in integrating architecture and landscape. He explains:

Church in Cuitzeo de Porvenir, Michoacán (sixteenth century)
Photo by Ernesto Perales Soto, 2006

> The interest in architecture that was gradually awakening really came alive when visiting the villages of Mexico and the houses of the people. I think traditional dwellings are incredibly beautiful in Mexico, particularly in the State of Michoacán. This is the state, that in my opinion, has the nicest Traditional architecture . . . for me [those visits] aroused a love of architecture and the desire to apply traditional features to a modern house.[3]

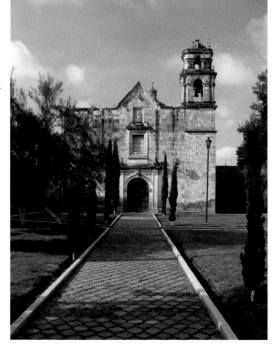

Barragán was drawn to the simple massing and monolithic nature of the vernacular homes of Michoacán. The distinctive colors, textures, materials, and spatial strategies found in traditional houses served as an inspiration for Barragán, cultivating his love and appreciation for the humble beauty and cultural complexity of Mexico's vernacular architecture.

Barragán earned a degree in engineering in 1923 at the Escuela Libre de Ingenieros de Guadalajara (Free School of Engineering). Although his course work was focused on civil engineering, Barragán explains "we studied architecture in a rather primitive way," taking several courses in drawing and art history, and incorporating architecture into their thesis work.[4] In 1924, Barragán embarked on his first trip to Europe, in part to escape the social and political instability of Guadalajara at the time. Barragán describes this trip as stemming from a desire to explore and experience European culture, rather than an intent to study architecture. He does point to two key experiences that would subsequently influence his architecture. In 1925, while living in Paris, Barragán attended the Exposition des Arts Décoratifs; and at this time he was exposed to the work and writing of garden designer Ferdinand Bac.

At the Paris Exposition, Barragán would have visited the pavilion of the Soviet Union, by Constructivist Konstantin Melnikov, and the L'Esprit Nouveau Pavilion by Le Corbusier. The reductive planar compositions and plastic spatial strategies likely influenced Barragán's later work. The writing of Ferdinand Bac (whose work focused on the sacredness of gardens of the Mediterranean and the role of nature in creating place for a dialogue between humans and the gods) fueled Barragán's parallel interest in landscapes and gardens. Barragán describes how "it is his writings that explain what creates the magic of the places."[5] The sacredness and solitude of gardens would become a common theme in the work of Barragán upon his return to Mexico. Although the economy offered little opportunity for architects in Guadalajara, from 1927 to 1929 Barragán designed and built seventeen single-family houses.[6]

Postcard of Konstantin Melnikov's URSS Pavilion at the Paris Exposition des Arts Decoratifs (1925)

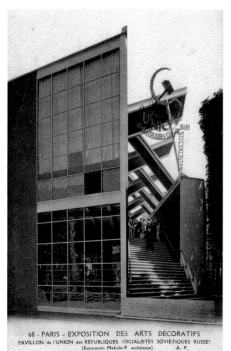

60 - PARIS - EXPOSITION DES ARTS DÉCORATIFS
PAVILLON de l'UNION des RÉPUBLIQUES SOCIALISTES SOVIÉTIQUES RUSSES
(Konstantin Melnikoff, architecte) A. P.

While Barragán's first trip to Europe introduced him briefly to the work of Le Corbusier and Ferdinand Bac, it was not until his second trip in 1931 that he met with both men. Le Corbusier suggested that Barragán visit some of his projects, specifically those most representative of his ideals, including Villa Savoye and Villa Stein in Garches.[7] The sculptural forms, geometric precision, and use of light and shadow greatly impressed Barragán, as did Corbusier's theoretical conception of Modernism. As a counterpoint, Barragán spent time in the south of France visiting some of the gardens designed by Bac. The poetic nature of Bac's writing and garden design stayed with Barragán, and would be drawn upon in the design of his own house and studio years later.

In 1935, with enhanced knowledge of Modernism and its conceptual depth, Barragán moved to Mexico City. The city at this time was undergoing rapid expansion and modernization, embracing the influences of European and American Modernism.[8] The next decade saw Barragán's involvement in the expansion of housing in Mexico City, drawing on the innovations of Le Corbusier in which larger-scale structures called for contemporary spatial and material strategies. A spec-

ulative single-family house and gardens at 10 General Francisco Ramirez, designed by Barragán beginning in 1940 and briefly occupied in 1943, marked a return to the ideology of synthesizing the traditional and the modern, and the natural and the artificial. The culmination of this exploration occurred on the adjacent property after the sale of #10, in what would become Barragán's house and studio, a forty-year experiment.

The house and studio of Luis Barragán at 14 General Francisco Ramírez lies on a small, unassuming street in the Mexico City suburb of Tacubaya. West of the historic center, Tacubaya lies adjacent to Chapultepec Park, the largest city park in Latin America, which offers respite from the scale and density of the city. Simple masonry walls with few apertures demarcate the lot lines and create an urban wall. The exterior of Barragán's house and studio retains a modesty to assimilate itself with the existing urban context. The grey stucco exterior remains unpainted and simple apertures disguise the complexity of the spaces contained within. From a distance however, the top of the structure begins to reveal a playful quality, as a pure white tower and planes of color begin to project above the grey street wall. Barragán used the urban context of the surrounding neighborhood as a canvas for his house and studio in Tacubaya, subtly collaging elements of form and color with the punctuated two-dimensional urban wall. The flat and barren façade contrasts with the colorful and volumetric spaces found inside. Antonio Fernández Alba describes the role of the wall in the architecture of Barragán, saying:

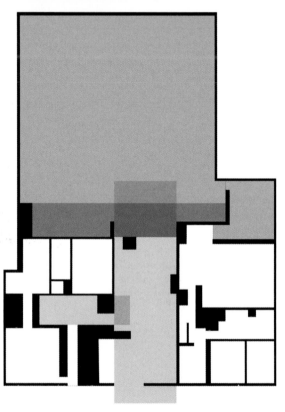

> Here, the wall is a frontier that demarcates living space. His architecture tends to be unified by one material, which is easily manufactured and exists in harmony with its immediate natural surroundings. Limited in scale, the house grows within the outline of its walls, which are laden with evocation and memories, mortared labyrinths of pleasing textures and order, through whose perspectives we discover space.[9]

The three-dimensional implications are only revealed as one undertakes a choreographed procession through the house.

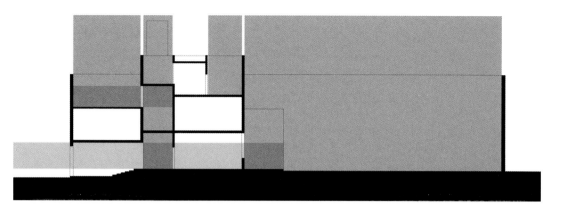

Barragán's architectural style was personal and idiosyncratic, derived from a collection of borrowed ideas, techniques, materials, and forms that he reinvented – a collage of elements that he found relevant and valuable. These elements include Moorish fountains, Hispano-Muslim gardens, volumetric spaces of sixteenth-century Mexican architecture, and Mediterranean terrace gardens (like those of Bac), in addition to the Modernist architecture seen by Barragán in Europe.[10] Like collage, Barragán's spatial and material compositions stand as careful and intentional aggregations and juxtapositions of his memories and experiences. Barragán explains: "I think that everything will keep changing because architecture is a living being, which adjusts itself according to the way its inhabitants change. A house is never finished, it is an organism in constant evolution."[11] The value of process to Barragán demonstrates yet another correlate to collage-making, as the design reveals itself over time, and continues to change as a result of intentional modification and weathering. The interior of the house presents a unique dialogue between traditional materials and techniques and modern spatial strategies. Kenneth Frampton describes how: "The exposed timber rafters on the ceilings of these and similar volumes patently allude to the Mexican vernacular, while the limited spatial interpenetration surely owes something to the legacy of Cubism."[12] Barragán employed a key characteristic of Modernism in both

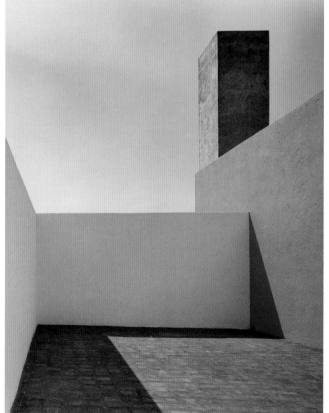

collage and architecture, phenomenal transparency, in the design of his house and studio. This ambiguity is most evident in the definition of exterior spaces contained by walls, occurring both at grade adjacent to the house, with visual interpenetration of interior and exterior, as well as within the footprint of the house manifested as a roof terrace. Modified from the original construction, Barragán heightened the walls enclosing the roof terrace in order to shift focus from the context to the sky. This change also results in a unique experience in which the architecture and landscape are silenced, reading only as abstracted planes and volumes of color. An attention to this fifth façade references one of Le Corbusier's five points of architecture.

Federica Zanco explains that, in the design of the house: "Luis Barragán's primary concern was with iconic fragments, selected and presented with little regard for context, that would summarise and convey the narrative – in this case a domesticity deliberately turned inwards, secluded yet urban, individual yet universal."[13] It is important to note that photomontage was exploited by Barragán in a retrospective analysis of the house and studio for publication, as a means of reconsidering the dialogue between fragments of the composition. Utilizing photographer Armando Salas Portugal's photographs, Barragán "used images generated by his architecture (of which a photographic interpretation by fragments was, paradoxically, truer to the complexity of the actual whole) in the same way, constantly breaking them up and reassembling them in different contexts."[14]

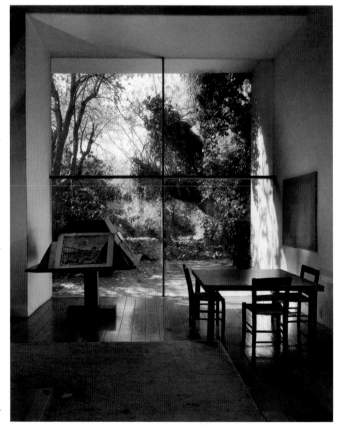

Two moments highlight the juxtaposition of elements in Barragán's house and studio. A large aperture in the living room establishes a dialogue between the interior and the exterior through literal transparency. The articulation of the glazing at this threshold offers an ambiguity, however, in the frameless edges and continuity of surface between interior and exterior. The bisecting mullions identify the artificiality of the perceived fluidity, while collapsing the perspectival view of the wild vegetation beyond. This moment defines Barragán's theme of silence, offering a quiet and reflective space with a surrealist influence that is both engaged with and detached from nature. The UNESCO Nomination suggests: "the house proposes a new relation between interior space and landscape architecture, where house and garden are seen as one indivisible, harmonic unit devoid of any idea of

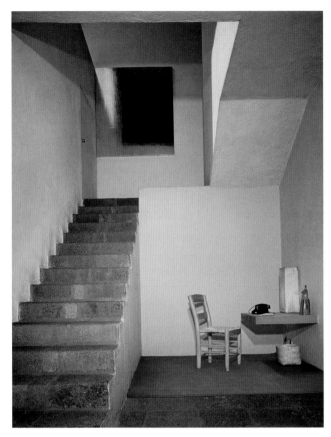

subordination."[15] Barragán highly valued the negative space in his conception of the house, studio, and garden and this links him to the conceptual framework of the Cubists.

The second moment of spatial and material juxtaposition occurs in the hall, the nucleus of the house. The space appears to be carved from a large monolithic volume, the edges exposing a volcanic stone. The use of this stone, typically an exterior material, in the center of the house inverts a sense of interiority or exteriority. The color and weight of the stone begin to create a hierarchy within the space, as the stairs are read against the smooth plastered walls. The light in this space adds another layer of complexity, as it is "composed by a mechanism of reflections: from the outside yellow southern plane, light shines onto the golden surface of an abstract altarpiece, created by Mathias Goeritz, and bathes the intense pink discovered for the first time in this hall."[16] The abstracted forms of the hall foreground the dynamic conditions of light and color as one ascends through the house.

The humble and contextual façade of 14 General Francisco Ramírez belies the spatial and material richness contained within it. Barragán's ability to synthesize disparate architectural traditions and aesthetics is proven here. The ambiguity of solid and void within the composition of the house and studio reflects the mindset of the Cubists in their two-dimensional collage-making and Le Corbusier in his use of phenomenal transparency to create dynamic spatial conditions. Further articulation of these concepts demonstrates an intentional juxtaposition of abstract and tactile elements, defined and rearticulated through four decades in which the house and studio served as a laboratory for Luis Barragán's exploration of these themes.

Notes

1 Antonio Riggen Martinez, *Luis Barragan: Mexico's Modern Master, 1902–1988* (New York: The Monacelli Press, 1996), 133.
2 *Casa Estudio Luis Barragán: Proposal For Inscription on the World Heritage List*, 2004, 1. http://whc.unesco.org/en/list/1136/documents/
3 Daniele Pauly, *Barragan Space and Shadow, Walls and Color* (Basel: Birkhäuser, 2002), 22–23.
4 Riggen Martinez, *Luis Barragan*, 17.
5 Riggen Martinez, *Luis Barragan*, 25.
6 Riggen Martinez, *Luis Barragan*, 33.
7 Pauly, *Barragan*, 102.
8 Marco De Michelis, "The Origins of Modernism: Luis Barragan, the Formative Years," in *Luis Barragan: The Quiet Revolution*, ed. Federica Zanco (Milan: Skira Editore, 2001), 55.
9 Antonio Fernández Alba, "Postscript: Shaded Walls," in *Barragán: The Complete Works,* ed. Raúl Rispa (New York: Princeton Architectural Press, 1996), 39.
10 Marc Treib, "A Setting for Solitude: The Landscape of Luis Barragan," in *Luis Barragan: The Quiet Revolution*, ed. Federica Zanco (Milan: Skira Editore, 2001), 116.
11 *Casa Estudio Luis Barragán: Proposal For Inscription on the World Heritage List*.
12 Kenneth Frampton, "A Propos Barragan: Formation, Critique, and Influence," in *Luis Barragan: The Quiet Revolution*, ed. Federica Zanco (Milan: Skira Editore, 2001), 22.
13 Federica Zanco, "Luis Barragan: The Quiet Revolution," in *Luis Barragan: The Quiet Revolution*, ed. Federica Zanco (Milan: Skira Editore, 2001), 95.
14 Zanco, "Luis Barragan," 97.
15 *Casa Estudio Luis Barragán: Proposal For Inscription on the World Heritage List*.
16 *Casa Estudio Luis Barragán: Proposal For Inscription on the World Heritage List*.

2.3 SIGURD LEWERENTZ's Markuskyrkan

In architectonic terms, then, Nordic space is topology, Nordic form collage, and Nordic gestalt a hybrid that unites contradictions.[1]

Christian Norberg-Schulz

Multivalency, through ambiguities in measurement and discernment of time and space, creates a meaningful, relevant architecture that marks a moment in space and time while transcending both. A multiplicity of readings is constructed through the breaking down of form, both accommodating new relationships between architecture and site and offering a means of synthesis. These themes are fundamental to the collage-making process, and, as a design mentality, are embodied by Sigurd Lewerentz's Markuskyrkan (St. Mark's Church) in Stockholm, Sweden (1956–63). In 1931 Erik Gunnar Asplund, a collaborator of Lewerentz, wrote an essay entitled "Our Architectonic Perception of Space," in which he says that "architectonic space does not therefore attempt to enclose itself as an architecturally determined and independent unit but opens out, more or less firmly, to the sun, the countryside and human life and movement."[2] The respect for and sensitivity to the dynamic natural environment of Scandinavia has been a primary design consideration for Scandinavian architects, and these conditions in flux are viewed as design opportunities. As Lewerentz did not teach or write – there are very few of his own project descriptions – but rather focused on building, an interpretation of Markuskyrkan must occur through an analysis of the physical artifact first and foremost. Lewerentz's design of Markuskyrkan, as an assembly of seemingly disparate parts addressing multiple scales of both site and occupant, reveals itself to be a collage of sensory phenomena in which materials and spaces unfold and slowly divulge themselves to the occupant. The drawings produced by Lewerentz for the design and construction of Markuskyrkan are evidence of this fragmented nature, as they document elements within the composition but not the relationships of parts to the whole. These drawings and the on-site design changes instigated by Lewerentz have resulted in a unified yet dynamic and multivalent church complex.

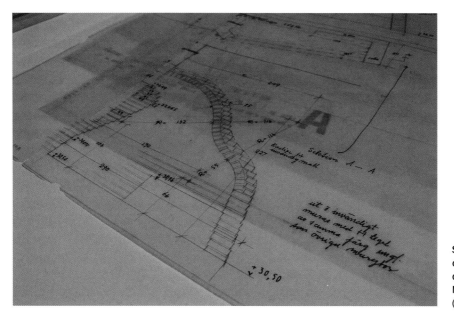

Sigurd Lewerentz, construction drawings for Markuskyrkan (1956–63)

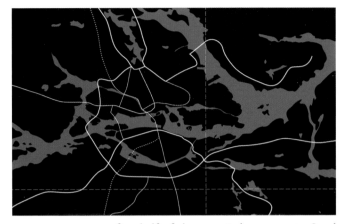

Markuskyrkan was poetically dubbed 'The Church at the Bottom of the Lake' due to its proposed location at the site of Lillsjön ('the small lake'). Lewerentz was granted the commission after an invited competition in 1956, selected from a pool of five architects, in part because he submitted a variety of design alternatives. Markuskyrkan was an anomaly in the era of Swedish Functionalism. As a student and practicing architect in the first half of the twentieth century in Sweden, Lewerentz's design ethos built upon National Romanticism, Nordic Classicism, and Functionalism. In 1910, as students at the Stockholm Art Academy, he, Asplund and others were frustrated with the emphasis on the Beaux Arts curriculum and left to start their own school. They invited teachers in National Romanticism (or 'Material Realism'), a movement that had a substantial presence in Stockholm at this time and would impact Lewerentz's focus on the authenticity of material expression. Another significant event that affected Lewerentz's subsequent design work was his visit to Italy around 1920 – although he made no sketches, he did take a limited number of photographs which were unconventionally composed, rendering the subject unrecognizable and fragmentary.[3] This unique approach is tied to

Erik Gunnar
Asplund and
Sigurd Lewerentz,
Skögskyrkogården,
Stockholm, Sweden
(1915–40)

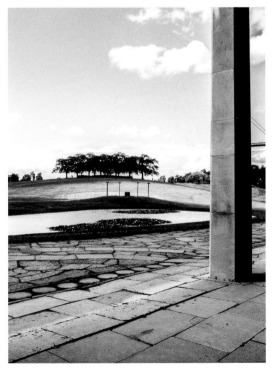

his process in Markuskyrkan, as according to Nicola Flora, "the way he composes [the photographs] is the result of his rejection of 'transcription' in favour of 'representation' of the fragment; they are ranged like the vestiges of a hypothetical map of the memory, a store of experiences that could later be used again in different places and narratives."[4]

Lewerentz first made a name for himself in Swedish architecture after winning an international competition with former classmate Asplund for Skögskyrkogården (The Woodland Cemetery) in 1912 at age 28. The resulting project is a profound expression of the Swedish landscape and the power of subtle architectural intervention. Work continued here for decades, however in the 1930s Lewerentz was excluded from further work at Skögskyrkogården when Asplund was granted the crematorium commission. At this point, Lewerentz left architecture for over a decade, establishing a factory in Eskilstuna to make Idesta stainless steel windows and wall panels, after his own patent. His interest in detail

and material configurations is exhibited throughout
his subsequent works of architecture. Lewerentz's
return to architecture for the Markuskyrkan project
reengaged an artistic approach to Swedish architec-
ture which had suffered as a result of Functionalism
and demands for housing in Sweden in the post-
war period.[5] Markuskyrkan, as a turning point in
this resuscitation, embodies "an intellectual struggle
in which ideas of material assembly are inseparable
from the formation of intensely characterful spaces,"
according to Adam Caruso.[6] An analysis of the com-
pleted Markuskyrkan and Lewerentz's design process
demonstrate thought and intentionality to design
at multiple scales of intervention, considering both
the visitor's haptic experience as well as the dialogue
between building and landscape.

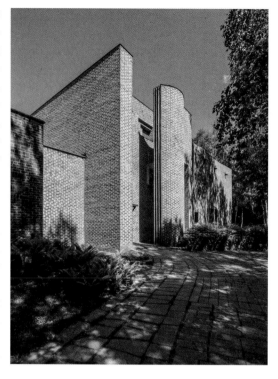

Collage as a metaphor for the multivalent
spatial and material conditions of Markuskyrkan
manifests itself at each scale of design: beginning an
analysis at the scale of the human body, Lewerentz
clearly conceptualized the multi-sensory experience
as the occupant engages the work of architecture. An attention to detail stems from the
time Lewerentz spent at Chalmers Technical Institute in Göteborg, studying mechan-
ics and building construction. Two aspects of material expression contribute to the
rich, haptic experience at Markuskyrkan: the spaces seemingly carved away from a
monolithic brick conglomerate, and the highly refined tectonic elements inserted into
the otherwise stereotomic mass.

The visitor's experience of the church begins by crossing a thickened,
sculpted masonry threshold, entering directly into the darkness of the sanctuary.
Tactility and plastic spatial experience are emphasized over the visual: "When the rich
variety of spatial conditions begin to emerge from this darkness they appeal directly to
our emotions, bypassing an understanding of the building within our personal inven-
tory of experiences."[7] The first visually perceived elements in the sanctuary are the
suspended light fixtures designed by Lewerentz and fabricated from steel and copper –
they appear to float as points in a field. Only as the eyes adjust is the visitor exposed to
the rough, heavy, sculpted surfaces of the brick enclosure. Brick is used to form every
surface, including permanent furniture such as the altar and lectern. "The presence of
brick . . . becomes an enveloping surface on which we walk, which covers us, which
surrounds us."[8] A ruin-like quality to the heavy walls is achieved through a running
bond with wide, variable mortar joints to accommodate Lewerentz's intentions that
no brick would be cut – only whole bricks would be used.[9] Mortar joints were left
unraked to retain evidence of the construction process, giving the brick the appear-
ance of aggregate in a composite material absorbed by the thickness and texture of the

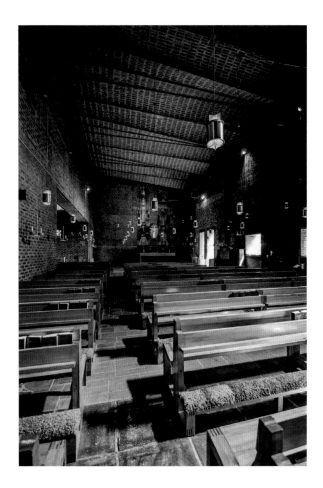

mortar.[10] Brick was a common material choice in turn of the century public buildings in Sweden, as well as historically in industrial buildings. Caruso points out: "To heighten one's awareness of a humble material like brick, is poetic," allowing the form, constructed by the material, to be the dominant reading in suppressing the structure.[11] Lewerentz's desire that the finished work would show evidence of its making is clear in an anecdote in which he recognized the value of chance occurrences in the construction process: while the round stair tower was being erected, a mason leaned against it, creating a curvature in the wall. Lewerentz appreciated this idiosyncrasy and instructed the masons to leave it in place.

Tectonic insertions offer a visual balance and level of refinement to contrast the rough and massive masonry. These insertions, in addition to the light fixtures, include the plywood organ enclosure, wood window frames, and cantilevered gutter extensions. Lewerentz's design process implies the design of individual elements at a variety of scales which are aggregated and synthesized to create a unified whole while revealing its process of creation, analogous to collage-making.

The collage mentality evidenced in Markuskyrkan at the scale of the building and its immediate physical context is a correlate to the work of Le Corbusier.[12] Like

the collages and architectural work of Le Corbusier, Markuskyrkan demonstrates a clear order and proportion manipulated by conditions of site, both physical and perceptual. Lewerentz employed the Golden Section as an organizing device in both plan and section for the parti of Markuskyrkan, revealing an established logic that is strategically disrupted. The Gestalt of the project defines four separate structures: sanctuary, parish building, office building, and porch. The folding/inversion/collage of interior and exterior achieved by Lewerentz seeks to integrate the buildings with their environment. The south wall of the sanctuary is, according to Flora, "the result of the juxtaposition of a series of fragments"[13] sculpted and assembled in response to site context. Tested at Markuskyrkan and used more extensively at St. Petri in Klippan, Lewerentz attached the glazing directly to the exterior surface of the brick, held with minimal metal clips and waterproofed with black sealant. Fragments of the natural context reflected in the glazing disrupt the monolithic mass of the brick surface to create a dynamic composition.[14] The idiosyncratic nature of the irregular forms and sporadic

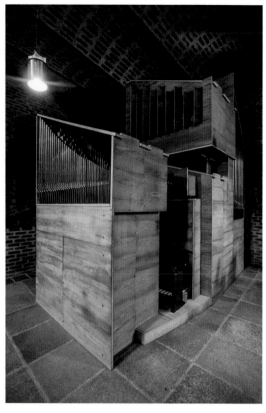

apertures speaks to a responsiveness to conditions of physical context (birch trees) and perceptual experience (light). Norberg-Schulz claims that Lewerentz approached the design "through a highly sensitive, though somewhat heterogeneous, assemblage of memories, wherein the cohesive vehicle is mood rather than formal composition."[15] The walls were sculpted and punctures made where it was necessary to reconnect interior and exterior conditions, engendering a contemplative mood. These irregularities and ambiguities create a project that is experienced through an unfolding of spatial and material events.

While formal decisions were notably responsive to site conditions, there is evidence that Markuskyrkan contains metaphorical references as well, contributing to the layers of meaning embedded in the project. The unique, complex curvature of the ceiling is a reference to Swedish racing boats, as Stockholm's character as a maritime city is a cultural value. Lewerentz's implication of physical, perceptual, and cultural input

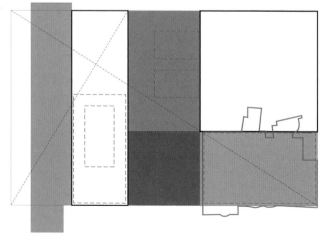

as actors on the fundamentally pure geometry of the project reinforces its collage-like identity.

The ambiguity between architecture and landscape demonstrated by the 'fragile form'[16] of Markuskyrkan provides the opportunity for a simultaneity and diversity of experiences and interpretations. At the scale of the physical and cultural context, we can consider both the immediate site of Lillsjön, upon which Markuskyrkan was

constructed, and the larger influences of Stockholm and Sweden. The character of the site is that of a low-lying area, once a lake, at the edge of a vast nature reserve of birch trees aptly named Björkhagen ('Birch Haven'): this setting provided a multitude of natural features from which to draw inspiration. The fragmented form of the buildings and subtlety of material selection establish a rootedness in and deference to the existing landscape. The reflecting pool in the courtyard was a later addition, which Lewerentz proposed to reference the history of the site and to architectonically mediate between the independent building forms.

The specificity of site conditions addressed by Lewerentz is supplemented by references to the vernacular identity of Swedish folk architecture, in which skeletal, tectonic structures have been replaced by massive, stereotomic volumes.[17] The roof is not a distinct element uniting the walls, rather is it a continuation of the vertical surfaces – in effect, the architecture grows from the earth, retaining an ambiguity of ground/wall/roof.[18]

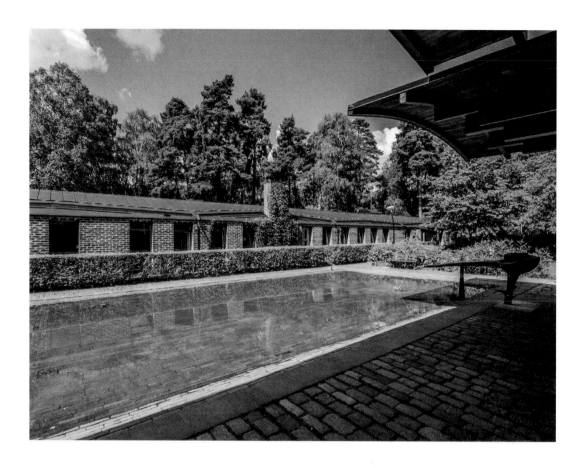

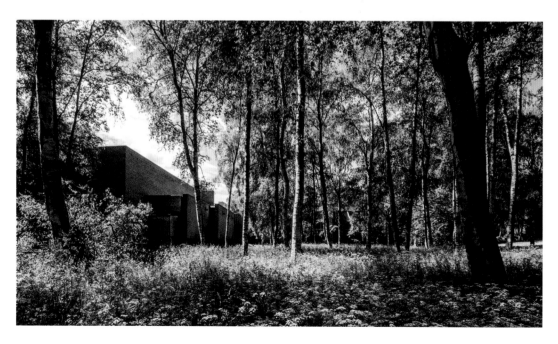

These qualities contribute to the humility of the project, assimilating it into the natural context. Conscious of the nature of the Nordic landscape in general, Lewerentz valued the qualities of Nordic light and the character of the Nordic landscape as a fragmented one, with a weak Gestalt.[19] Stockholm itself is found at the confluence of the Baltic Sea and Lake Mälar, a city of islands. Norberg-Schulz describes how: "Common to [Nordic landscapes] is their incompleteness, thus Nordic understanding becomes the dream of engagement . . . ,"[20] a desire for synthesis. These perceptions align with the Cubist desire to represent shifting perceptual conditions. Where forms are less clearly defined, what matters most is the dialogue that is established between them.

Lewerentz created a richly experiential work of architecture in Markuskyrkan, in which spatial and material layering at multiple scales offer dynamic and diverse opportunities. For Caruso, "In attending to the raw, existential nature of his materials, Lewerentz privileges a subjective and shifting experience of the world."[21] As a structure for a contemplative program, Markuskyrkan facilitates reflection on the fundamental qualities of embodied experience. Swedish architect Peter Celsing, in the 1960s, sought to clarify the modern conception of space in Swedish architecture (drawing on earlier contributions by Gunnar Asplund) describing *"collage-like* encounters between the old and new, in which spatiality was perceived as a 'structure that is built up of objects of varying spatial densities' rather than enclosed or open space."[22] Markuskyrkan is a laboratory for these encounters, a testing ground for spatial and material overlap at every scale of architectural intervention.

Notes

1 Christian Norberg-Schulz, *Nightlands: Nordic Building* (Cambridge, MA: The MIT Press, 1996), 197.
2 Erik Gunnar Asplund, "Our Architectonic Perception of Space," in *Nordic Architects Write: A Documentary Anthology*, ed. Michael Asgaard Andersen (New York: Routledge, 2008), 330.
3 Nicola Flora, ed. *Sigurd Lewerentz* (London: Phaidon Press, 2006), 35.
4 Flora, *Sigurd Lewerentz*, 35.
5 Norberg-Schulz, *Nightlands*, 186.
6 Adam Caruso, "Sigurd Lewerentz and a Material Basis for Form," *OASE* Issue 45/46, (Amsterdam, NL, January, 1997), 88–95.
7 Caruso, "Sigurd Lewerentz," 88–95.
8 Caruso, "Sigurd Lewerentz," 88–95.
9 Lewerentz refers to the archaic character of ancient Persian masonry walls as inspiration.
10 Flora, *Sigurd Lewerentz*, 311.
11 Caruso, "Sigurd Lewerentz," 88–95.
12 Le Corbusier was a contemporary of Lewerentz, although its not known if they ever met. Lewerentz played a pivotal role in the Stockholm Exhibition of 1930, to which Corb was invited though he did not attend.
13 Flora, *Sigurd Lewerentz*, 312.
14 Flora, *Sigurd Lewerentz*, 324.
15 Norberg-Schulz, *Nightlands*, 186.

16 Term coined by Juhani Pallasmaa in "Hapticity and Time."
17 Norberg-Schulz, *Nightlands*, 59.
18 Norberg-Schulz, *Nightlands*, 60.
19 Norberg-Schulz, *Nightlands*, 1.
20 Norberg-Schulz, *Nightlands*, 47.
21 Caruso, "Sigurd Lewerentz," 88–95.
22 Johan Mårtelius, "Swedish Introduction: With Functionalism as the Hub," in *Nordic Architects Write: A Documentary Anthology*, ed. Michael Asgaard Andersen (New York: Routledge, 2008), 303.

2.4 SVERRE FEHN's
Hamar Bispegaard Museum

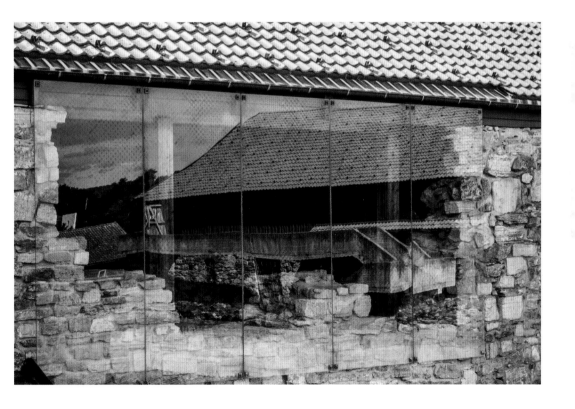

If you chase after the past, you will never catch up with it. Only by manifesting the present can you make the past speak.[1]

Sverre Fehn, on the Hamar Bispegaard Museum

In Sverre Fehn's Hamar Bispegaard Museum in Hamar, Norway, a collage mentality is evident in the careful excavation and layering of new and existing figures and fields. The juxtaposition of time periods through site and building conditions provides a material and formal invitation to explore the intersection of the present with the past. Interventions by Fehn in this archaeological site north of Oslo began in 1967. The simultaneity associated with Cubist collage is evident in this project which concurrently foregrounds his contemporary insertions, conditions of the archeological site, and exhibited artifacts. The building reveals itself as a process: an interpretation of the site, the building, and the detail necessitates time. It is this condition of time that not only creates a multivalent architecture, but also provides a platform for discussing architecture through the lens of collage thinking. Fehn explained: "Time and place must follow one another. Time in itself is a material."[2]

The concepts of fragmentation and aggregation fundamental to Cubist collage can be understood through their manifestations in site. The complex interweaving between building and ground is most apparent in layered sites, built up over time, creating a rich palimpsest of physical and cultural memory. The irregular datum of ground common to sites such as this, according to Robin Dripps, "reveals its multiple ground planes intersecting, reinforcing, or else contradicting one another to produce a new set of volumes, linking these fragments of the past to condition the present."[3] Ground, as both the foundation for architectural constructs and Cubist collages, is subtle and non-hierarchical. As Georges Braque implied, potential exists at these moments of disconnect and overlap where the relationship between figure and

Accumulation of time in folio 280 recto with text of the Codex Carolinus (Romans 15:3–8) and palimpsest text of the Codex Guelferbytanus (sixth century / thirteenth century)

field is ambiguous and in flux. A 'fragile form,' or weak architectural image, focusing on material and experiential qualities reveals processes of time.[4] Fehn's Hamar Bispegaard Museum captures the complexities of the temporal palimpsest of site and inhabitation that are furthered by the ambiguities of spatial definition. The resultant artifacts exist as palimpsests of human inhabitation, inscribed, erased, and reinscribed over time.

Pritzker Prize-winning Norwegian architect Sverre Fehn, although widely traveled, focused his architectural intent on building in his home landscape and culture. In some cases, he was given the opportunity to convey the qualities of light and materiality unique to Scandinavia in projects abroad such as the famed Nordic Pavilion at the Venice Biennale (1962). He worked briefly in Paris in the 1950s where he interacted with Le Corbusier, and it is perhaps here that Cubist concepts began to take form in Fehn's own design work. His design principles and practices were rooted in and have come to influence Nordic building culture in his reverence for the dynamic landscape. An empathetic, almost painterly, consideration of materials was not limited to the scale of the detail or building, but extended to the scale of the site and culture. Fehn articulated his approach to materiality, saying: "[I] believe that the use of material should never happen by choice or calculation, but through intuition and desire."[5] Early in his career, he primarily used wood – a traditional Norwegian building material – though his palette eventually expanded to concrete and steel. Fehn's attentiveness to context was not only manifest in materiality, but also in his practice of intensive site investigations. In many cases, Fehn spent several weeks researching and analyzing photographs and maps of a site before visiting it. He believed that building is a violent act, and attempted to build in order to foreground the beauty of the surrounding landscape. He explained:

> architecture itself changes with the shift of perspective; there is a new and different way of experiencing the earth, the sky and life. With this kind of approach, you can take a similar stance to the past. It is a living structure, always appearing new and different as you move from one philosophical point to another. Finding the past, reaching its different sides and nuances is creative activity.[6]

This recognition of a site and culture in flux defines his approach to the interventions for the Hamar Bispegaard Museum, which Fehn was commissioned to design in 1967.

One of Norway's only inland towns, Hamar once flourished as a medieval market town adjacent to Norway's largest inland lake, Mjosa. This is the location of the ruins of the medieval bishop's palace ('Hamar Bispegaard'), an eighteenth-century barn built atop the ruins of the palace, and the adjacent thirteenth-century

Hamar Cathedral. Hamar Bispegaard Museum is part of a complex of sites known as Hedmarksmuseet: museums, archeological digs, and preservation areas that exist as a palimpsest of 400 years of history. The museum director approached Fehn to design a building that would preserve the remaining ruins of the medieval bishop's palace while allowing for continued archeological excavation of the site.[7] Fehn summarized the goal of the project, saying:

> The objective was to create a museum form to preserve and exhibit what remains of Hamar Bispegaard and to enable the excavations to become as important a feature as the objects on display. The answer was a "suspended museum" which would allow the public to experience history, not a book-learning, but as being brought to life by archeology.[8]

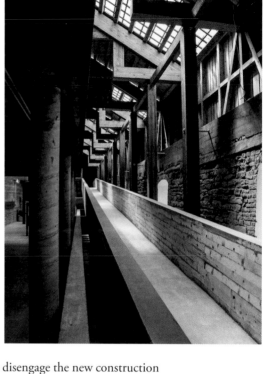

The execution of a 'suspended museum' would necessitate the most minimal of construction. It was in fact the director of the museum who urged Fehn to disengage the new construction from the existing ruins.

It is important to note the solution to the preservation of the adjacent Hamar Cathedral, in contrast to the collage-like approach taken by Fehn in the design of the museum. Unlike Fehn's architectural approach of layering and suspension for the ruins of the bishop's palace, the ruins of the cathedral are sealed in a new steel and glass structure (1998). This structure operates as a foil to Fehn's museum that reveals how collage thinking may function in architecture. While the cathedral ruins are hermetically contained, preventing further change or discovery, the ruins of Hamar Bispegaard are cradled in the u-shaped parti in plan and through the suspension of new structure in section. Rather than arresting time, Fehn makes a porous addition that allows for further interpretation and change. The fourth dimension in this project, as in collage, emphasizes a process over a final product.

The Hamar Bispegaard Museum is comprised of a u-shaped plan, guided by the ruins of the barn and palace with carefully inserted planes of glass and concrete ramps to guide visitors through

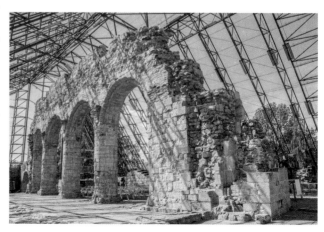

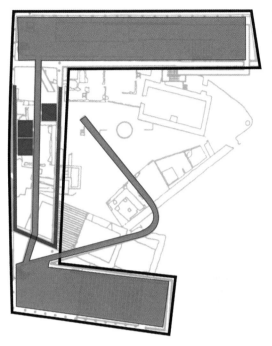

the excavation sites. The interior spaces house an ethnographic museum, medieval exhibits, an auditorium, and offices. A concrete ramp extends to the exterior to occupy the courtyard defined by the plan, criss-crossing the excavation site in order to promote ongoing research as a central part of the museum.[9] In considering the various scales of intervention, Fehn's intent was to create fluidity between site and building. Throughout the project, Fehn demonstrates a collage mentality in his architecture through the physical layering of spaces and materials and consequently the circulation that then unifies the spaces. The site of the ruins and the new museum designed by Fehn are inextricably connected. Literally superimposed, the museum depends on the existing site conditions while the site is highlighted and revealed by the building. A collage may become a palimpsest through the layering of paper fragments as they reveal layers beneath. In this way, Fehn's design creates a three-dimensional, physical palimpsest, a physical index of the time transpired. Per Olaf Fjeld describes how: "Each time layer is not detached from the next, but rather floats across its neighbor. The manifestation of their presence is an effort to inhabit a mystery."[10]

The horizon, a common theme in Fehn's work, plays a critical role in the interpretation of Hamar Bispegaard. Fehn frequently refers to it as a site with a broken horizon. Without a continuous ground plane, the site contains many horizons simultaneously. This allows for the creation of a horizon, one that does not necessarily remain constant throughout the site but sets up conditions where spaces overlap, not only in plan, but also in section. The horizon exists as the moment of contact between the sky and the ground, or between the new and existing artifacts. A subtle but important design decision that articulates a new horizon is the eave of the inserted roof, set just above the highest point of the ruined wall. The datum of the new roof establishes a dialogue with the jagged profile of the ruin wall, resulting in the modulation of the new column lengths based on the ruin wall height.[11] The dialogue between existing and new elements occurs both visually and physically. The visual dialogue occurs between the jagged and crisp edges of existing and new elements, and the physical dialogue occurs as the column lengths of the canopy structure modulate to meet the existing walls.

Acknowledging these seams is vital to an understanding of Fehn's design intent as an analogue to collage-making. Decisions made by the collage-maker in the placement of fragments include juxtaposition, overlap, excision, dissection, synthesis, and so on. Thus, the delicate point where the structure and the earth meet can be considered the seam between two elements of the collage. In the museum, the occupant

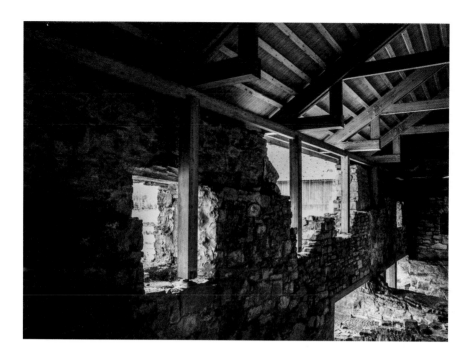

becomes yet another element in the collage. Fehn's focus in designing the museum was to simultaneously preserve what remains of the ruins of Hamar Bispegaard and to emphasize and encourage a constant exchange between the occupant and the excavations below. This idea of simultaneity often presents itself in the method of collage, whether through phenomenal transparency in *papier collé* or the juxtaposition of images in photomontage. Hamar Bispegaard exhibits this characteristic of collage in that Fehn intentionally designs for the delicate preservation and reverence of the remaining ruins, yet at the same time boldly interacting and interlacing the occupants with the ruins.

This juxtaposition and interaction also occurs at the scale of the detail. Fehn described this project as a nested composition: "It's like Chinese boxes, because you have the Bishop's walls, and then the barn construction, and then you have a museum in the museum itself. You make a small museum in the big building and you make a shadow box for the little thing. So, there's a room-in-a-room-in-a-room-in-a-room."[12] Fehn had been given specific instruction from the museum director to "not touch the walls"[13] of the ruin. The project objective was to create a system of exhibition and circulation spaces that minimally impact the physical characteristics of the site while creating movement throughout the ruin. The specified disposition towards the site in conjunction with the design objective to circulate and occupy the ruin created a distinct set of tectonic relationships between the existing ruin walls and the inserted structure of the museum.

One of the primary design objectives for Fehn was to juxtapose the existing remnants found within the site against the added suspended museum. The detailing

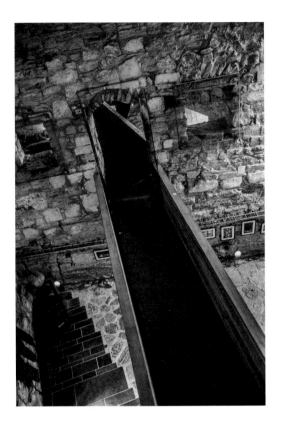 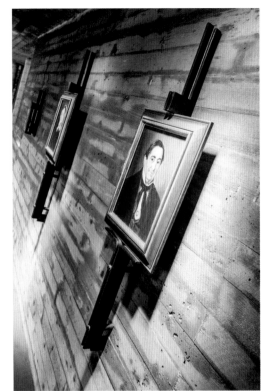

of the moments of interaction between existing and new elements serves to heighten the experience of this juxtaposition. Display cases were designed to showcase found artifacts and excavated building fragments within the newly inserted exhibition spaces. Two specific expressions of this juxtaposition between old and new elements can be read: in the detailing of the connection moment between the existing walls and the columns of the added roof, and the apertures in both the new and existing walls.

The timber structure supporting the roof canopy is carefully inserted into the footprint of the existing barn. Instead of bearing on the ruins below, the wood column never touches them but instead meets an anchor bolt embedded into the existing wall. The visual effect of such a detail is to hide the moment of connection, giving the appearance of the inserted structure floating along the surface of the ruins. The high degree of articulation and negotiation occurring at the detailing of the column joint is comparable to the process of stitching dissimilar fragments of paper during the collage-making process.

A similar moment occurs at the existing barn apertures. Enclosure was necessary in order to keep water and wind from entering the interior excavation and exhibition spaces of the museum. Instead of framing the existing openings and infilling with glass, frameless glass is pinned lightly to the exterior side of the ruin walls. Christian Norberg-Schulz describes the laminated condition employed at the apertures: "The light that filters through the roof blends with the light that enters through

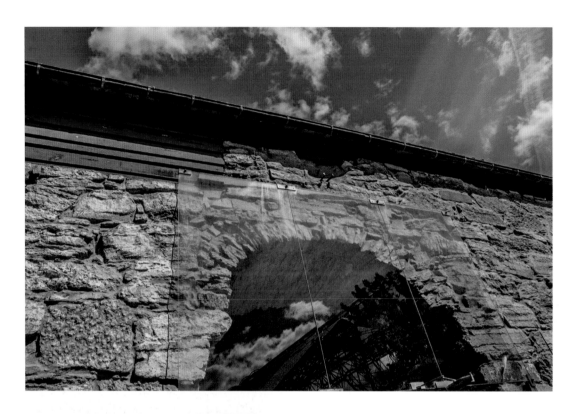

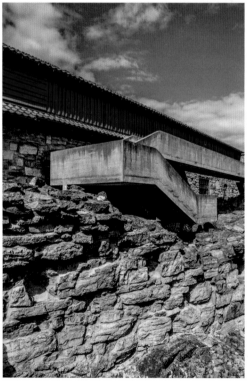

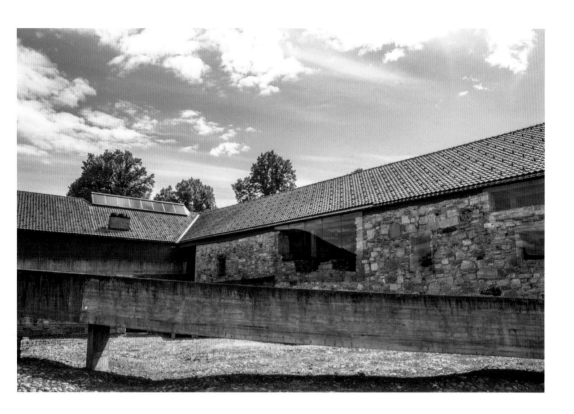

the openings in the old wall, which were not filled, just covered with unframed glass during the restoration."[14] From the interior, the presence of the laminated glass is negligible, allowing the occupant to understand the undisturbed deteriorating state of the walls. On the exterior, the surface-mounted frameless glass is read as laminated onto the surface of the existing wall, creating a transparent layer that simultaneously protects the ruin while showcasing the rough surface beneath.

In Sverre Fehn's Hamar Bispegaard Museum, the literal layering of built artifacts demonstrates a cursory view of collage thinking in architecture. But the interdependence of the building with the site reveals a synthesis of fragments and an ambiguity of figure and field. Unlike the adjacent preservation of the cathedral, which addresses the layers of history with a singular sealed glass structure, the Hamar Bispegaard Museum is a discontinuous aggregation. By celebrating the ruins and intervening in deference to them, Sverre Fehn has not only reacted to an ongoing contextual dialogue, but has taken part in it. The moments where the new and old constructs meet reveal a collage mentality. The careful negotiation of disparate elements that is evidenced at Hamar Bispegaard is an analogue to the process of collage-making. The collagist understands the importance of juxtaposition and layering. Fehn reveals a similar understanding in his design with the delicate preservation and reverence of the remaining ruins, yet at the same time boldly inserting new forms, foregrounding the existing remnants against the tectonic moments of the 'suspended museum.'

Notes

1 Sverre Fehn, *The Poetry of the Straight Line* (Helsinki: Museum of Finnish Architecture, 1992), 17.
2 Sverre Fehn and Per Olaf Fjeld, "Has a Doll Life?," *Perspecta*, Vol. 24 (1988), 44.
3 Robin Dripps, "Groundwork," in *Site Matters,* eds. Carol J. Burns and Andrea Kahn (New York: Routledge, 2005), 68.
4 Juhani Pallasmaa, "Hapticity and Time: Notes on Fragile Architecture," *The Architectural Review* (May, 2000), 81.
5 Per Olaf Fjeld, *Sverre Fehn: The Thought of Construction* (New York: Rizzoli, 1983), 46.
6 Fehn, *Poetry of the Straight Line*, 48.
7 Sverre Fehn, *The Skin, The Cut, and The Bandage* (The Pietro Belluschi lectures) (Cambridge, MA: School of Architecture and Planning, Massachusetts Institute of Technology, 1997), 11.
8 Sverre Fehn, "Three Museums," *AA files*, Vol. 9 (1984), 10.
9 Fehn, *The Poetry of the Straight Line*, 18.
10 Fjeld, *Sverre Fehn*.
11 Ranald Lawrence, "Sverre Fehn: the architect who built on the horizon," *Architectural Research Quarterly*, Vol. 13 (2009), 11–15.
12 Fehn*, The Skin, The Cut, and The Bandage*, 12.
13 Fehn, *The Skin, The Cut, and The Bandage*, 15.
14 Christian Norberg-Schulz and Gennaro Postiglione, *Sverre Fehn: Works, Projects, Writings, 1949–1996* (New York: The Monacelli Press, 1997), 129.

2.5 WEISS/MANFREDI's Olympic Sculpture Park

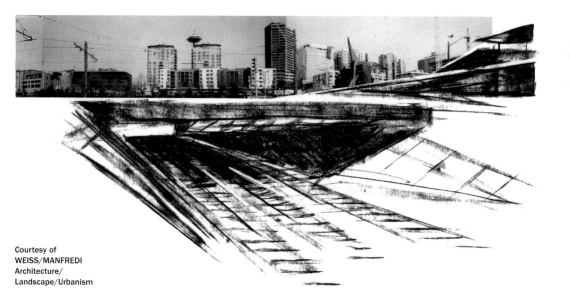

Courtesy of
WEISS/MANFREDI
Architecture/
Landscape/Urbanism

We regard the existing site as an architectural condition already rich in possibilities. Superimposing new programs on a site can bring into focus that which is unseen, creating opportunities for invention, transformation and use.[1]

Marion Weiss and Michael Manfredi

The Olympic Sculpture Park, designed by New York-based WEISS/MANFREDI Architecture/Landscape/Urbanism, is an 8.5-acre collage of landscape, art, and architecture. The park, completed in 2007, lies on top of a former brownfield site along the shore of Elliot Bay in downtown Seattle. Alaskan Way and the active rail lines of the waterfront trisect the site. Upon this is superimposed a Z-shaped gesture that integrates the diverse conditions of the site while embracing each

unique character. Marion Weiss describes the layers of experience in the park, saying: "The design creates connections where separation has existed, illuminating the immeasurable power of an invented setting that brings art, city and sound together – implicitly questioning where the art begins and where the art ends."[2] The evidence of collage-based design strategies is clearly developed in this project, from the competition-winning photo-collage to the manner in which the topography is delicately manipulated. The Olympic Sculpture Park serves as a clear example of how a collage methodology can generate not only architectural form, but an entire urban landscape. The five distinct sections of the park have their own identities, yet share a formal language that creates a dialogue with the existing infrastructure.

Collage exists at multiple scales from site to building to detail. The park allows for the simultaneous reading of art, landscape, and city, linking it to the aggregative nature of the collage-making process. This strategy reflects WEISS/MANFREDI's intent to address the concept of boundaries, both within the design as well as in the overall site context.

Marion Weiss and Michael Manfredi are founding partners in WEISS/MANFREDI, a New York-based architecture, landscape, and urbanism design firm, and have taught at numerous institutions in the Northeast US. Their work takes a stance on architecture that spans the fields of architecture, landscape, and infrastructure. Through multiple methodological processes in multiple disciplines, WEISS/MANFREDI is able to fully express the cultural and formal

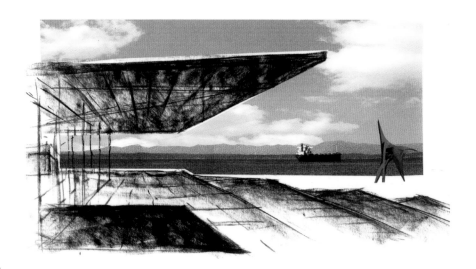

identities of each project. Clifford A. Pearson, in an article about the project in *Architectural Record*, describes how: "While some architects have tried to blur the lines between these disciplines, WEISS/MANFREDI has knitted them together here, so you can see the seams and the stitches."[3] The legibility of the individual components and their contribution to the reading of a cohesive whole demonstrates an interpretation of the park as a collage, revealing evidence of its conceptual and physical construction.

Park development was initiated by a desire to increase the accessibility of fine art through the decentralization and dispersion outside New York and Los Angeles, and integration with the city, encouraging and facilitating interaction. In 1999, the Seattle Art Museum, with help of the Trust for Public Land, bought a site on the waterfront of downtown Seattle. As their art collection had become larger and more diverse, the collection of sculptures was without a permanent location. The museum began looking for a large site to create a garden where their sculptures could be part of a permanent exhibition. The site purchased was a post-industrial lot with an area of 8.5 acres, making it one of the largest unused lots in downtown Seattle. It was not only chosen for the potential to repurpose a brownfield site, but to synthesize disconnected fragments of the city. It was previously a fuel storage facility founded in 1910 by the Union Oil Company of California. The industrial waterfront thrived due to its close proximity to the railroad tracks, as well as shipping routes, although the site was eventually abandoned in 1990. This turn of events set in motion a decade-long remediation. Before construction could begin, 120,000 tons of contaminated soil and 15,000 liters of petroleum had to be removed. The site was then capped with 200,000 cubic yards of fill. In 2001, a competition jury selected the design proposal of WEISS/MANFREDI as the winning entry. Construction began in 2005. The proposal bridged the site, trisected by highway and rail line, by means of a zigzag pathway. This design approach would encourage pedestrians, visitors, cyclists, vehicular drivers, and adjacent residents to engage the park and the artwork. After the park opened to the

public in 2007 it became the only place in
downtown Seattle to connect the city to
the reclaimed waterfront, with stunning
views across Puget Sound to the Olympic
Mountains beyond.

 The Seattle Olympic Sculpture
Park embodies the notion of collage at
the scale of the site, in its composition of
delicate layers that create a new landscape
from the strata of urban fabric extant in
the site. The park creates a multiplicity
of new boundaries, between art and city,
the city and nature, and organic and inor-

ganic form. Influenced by land art and its potential to enter the space of occupation,
WEISS/MANFREDI sought to intertwine nature and culture.[4] Manfredi describes
their shared interest in the physicality of site and the actions upon it in the naming of
their monograph *Surface/subsurface*. He explains "The idea that surface foregrounds a
two-dimensional, extensive, and visible condition while subsurface alludes to the three-
dimensionality of ground, which is deep, intensive, and lends itself to cutting, filing,
and exposing."[5] This duality suggests a process of additive and subtractive methods to
create and reveal layers and fragments. The design process for WEISS/MANFREDI
began by the simple cutting of paper, which was later modified to result in the final
gesture. These cuts were translated as cuts into the land where the excisions are marked
by concrete panels, highlighting their artificial character. The negative space is defined
by the distinctive landscapes of the Pacific North West: valley, meadow, grove, and
sound. The valley creates places of refuge and quiet contemplation. The three meadows
to the site exist as uninterrupted planes in which to place art. The meadows are not
only areas for viewing large-scale art, but also allow views to the city and Puget Sound.
The grove consists of quaking aspen, with dynamic sounds and colors. The shoreline

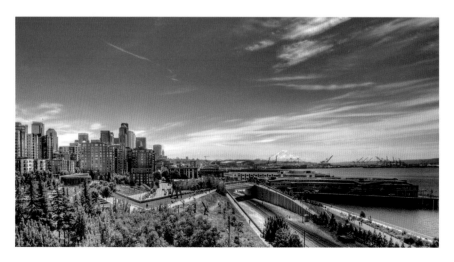

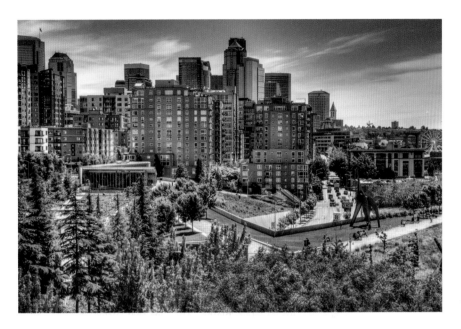

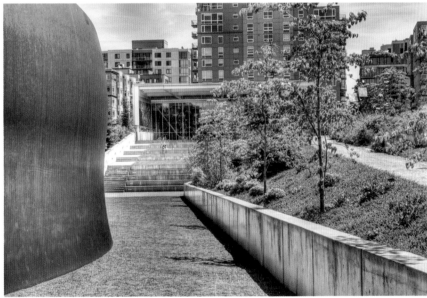

houses a migratory salmon habitat, a pocket beach and a sub-tidal zone to create an environment for kelp, algae, and other marine organisms. The fragments of diverse natural habitats become integral components to the composition of the park while offering distinctive experiences along the procession.

The dialogue between the path and the adjacent context changes as the visitor proceeds through the park. At either end of the Z-shaped path, the city grid is warped into a diagonal axis that highlights the artwork and its setting in the city. This condition is extended and altered within the interior of the park as the path becomes

compressed and shaded by vegetation, which creates a sense of respite from the urban context. As the path moves over roadways and rail lines the contrast grows between the grassy embankments and the traffic below. The edge conditions of the park serve as examples of the thresholds that connect the diverse moments of the park into a cohesive experience.

Layering and planar displacement is also evident at the scale of the entry pavilion. Transparent walls mediate between the manipulated horizontal surfaces and dissolve the thresholds between interior and exterior, and above and below ground. This allows for service circulation to occur without interrupting the flow of pedestrian traffic within the park. From within the pavilion, the heavy horizontals frame panoramic views to the sound and the mountains, collapsing space into a simultaneous image. The pavilion leads to a stepped 'valley' that tapers as the distance from the pavilion increases. This creates a forced perspective by manipulating the perception of the viewer. Within this valley, Richard Serra's series of rusted steel sculptures entitled *Wake* become occupants. The materiality and form of the tectonic elements inserted throughout the park are juxtaposed against the textures of the more natural elements and the artwork to highlight the seams between fragments.

Natural and man-made forces acting on the site reveal qualities of collage at the detail scale. The beach cove allows viewers to experience the tidal fluctuations of the sound. The rising and falling of the water leaves traces of its occupation. Driftwood collects on the shore and marks the water level. On the shoreline, these are transparent layers that constantly leave an index of the high and low tides. The temporal condition highlighted in moments such as this relate to the fourth dimension in collage-making, revealing process and change over time.

Transitioning to the artifice of infrastructure, a series of vertical planes consisting of precast concrete panels marks the threshold between highway or railway and park. The wall responds to both the vehicular scale and the scale of an individual,

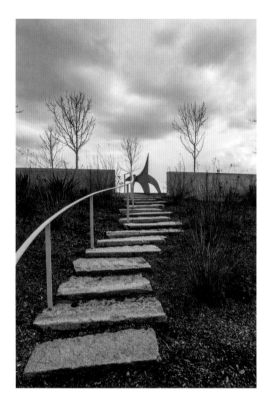

acting as both highway edge and guardrail. The wall is segmented into unique panels that fit together to make a large continuous shape. The fragmented panels allow for controlled movement in the case of seismic activity, and create a rhythm through the site. In the words of the architects: "Light, climate, sound, and movement produce a constant and invisible rhythm."[6] The wall can also take on color from the pedestrian bridge that passes over the railroad tracks. In fall, the low sun shines through the colored glass panels found on the bridge and projects them onto the concrete wall. Experienced from the bridge, the translucent images provide a unique lens through which to view the active rail line and the dense city core beyond. From an oblique view, the images screen quaking aspen trees that change colors in autumn and begin to have a shared character with the static colored glass projection.

Finally, the art itself offers a layer of complexity and contradiction in the experience of the park. When art is placed outside of its expected context, the museum, it creates a level of disturbance and engagement for the viewer. The curator has the opportunity to establish a narrative. The curator's narrative begins to take the role of the viewer from passive to active by creating juxtapositions that must be interpreted. WEISS/MANFREDI have created a richly layered urban intervention in which the park becomes a collage. A multiplicity of readings is possible in an attempt to synthesize landscape, infrastructure, art, and architecture.

Notes

1 www.weissmanfredi.com/architects-statement.
2 Charles Anderson, "Olympic Sculpture Park: a Northwest Collage," *Seattle Daily Journal of Commerce*, April 10, 2003.
3 Clifford A. Pearson, "Weiss-Manfredi weaves the Olympic Sculpture Park and its mix of art and design into the urban fabric of Seattle," *Architectural Record*, Vol. 195, No. 7 (2007), 110.
4 Michael A. Manfredi and Marion Weiss, *Weiss/Manfredi: Surface/subsurface* (New York: Princeton Architectural Press, 2007), 78.
5 Manfredi and Weiss, *Surface/subsurface*, 78.
6 Manfredi and Weiss, *Surface/subsurface*, 178.

2.6 ROBERTO ERCILLA ARQUITECTURA's Fundación Sancho el Sabio

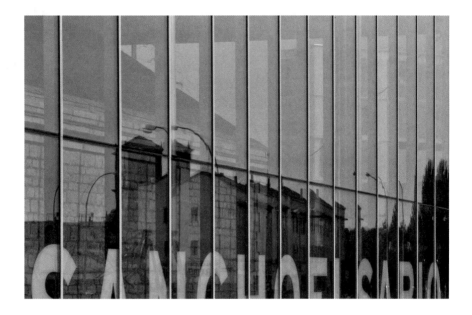

De este modo se produce una doble lectura: durante el día, el dominio corresponde al edifi-cio acristalado, que se refleja en el paisaje, insinuando levemente la presencia de otro cuerpo en su interior. Por la noche y gracias a la iluminación artificial el protagonista pasa a ser el antiguo edificio claramente manifiesto dentro de la urna de cristal.[1]

<div align="right">Roberto Ercilla and Miguel Ángel Campo</div>

In this way a dual lesson is taught: during the day, the area corresponds to the win-dowed building, which is reflected in the landscape, lightly insinuating the presence of another structure within. At night, thanks to artificial lighting, the old building, clearly visible within the windowed casing, becomes the protagonist.

Fundación Sancho el Sabio exists as a three-dimensional palimpsest of Basque culture in the Basque capital, Vitoria-Gasteiz, Spain. The Foundation, completed in 2008, serves as the Basque national archive. This archive catalogues and preserves documents, artwork, and maps related to Basque culture and language dating back to the fifteenth century. Designed by Spanish firm Roberto Ercilla Arquitectura (based in Vitoria-Gasteiz), Sancho el Sabio Foundation can be understood as an embodiment of collage principles at every scale. The Foundation is a building reflective of collage due to the physical layering and aggregation of spaces and materials, a revelation of temporal conditions through subtractive and additive processes, and the potential for multiple readings.

Roberto Ercilla's Spanish ethnicity and Basque heritage is evident in the execution of many of his cultural and administrative works. Like Sverre Fehn, Ercilla has focused his architectural practice on his native culture and region, exemplifying the distinctive qualities of the physical and cultural context. Examples of this unique dialogue are found in the electric ramps at the historic city center and the Krea Arts Centre, adjacent to the Sancho el Sabio Foundation. These projects attempt to synthesize physical fragments of Vitoria-Gasteiz's history with new program. The figural quality of these interventions begins to dissolve due to the ambiguous relationship between the figures and the complex field condition into which they are inserted. The Basque culture seems to have inspired Roberto Ercilla to engage the physicality of the existing ground condition and develop design sensibilities based on the richness of the context underlying the site.

Roberto Ercilla Arquitectura, Electric Ramps, Vitoria-Gasteiz, Spain (2006)

The Foundation was named for King Sancho VI the Wise who founded the city of Vitoria as a hilltop fortification at the site of a primitive village, Gasteiz. When looking at the entirety of Vitoria-Gasteiz in Northern Spain, a dichotomy exists between the contemporary city and the medieval city. This clear distinction is most likely a result of the Basque people's strong cultural heritage and concurrent progressive economy. However, while the Basque people's rich history is at the forefront of their sensibility, they do not look down upon modernity and seem to foster development. Despite the distinction between the new city and the historic center, contemporary works of architecture have been subtly laminated and integrated into the old city. An attitude of respect for the physical and cultural history while valuing modernity seems to be pervasive in Vitoria-Gasteiz.

Sancho el Sabio Foundation lies on a primary route into the original fortified city, a spine now linking the hilltop fourteenth century cathedral with the

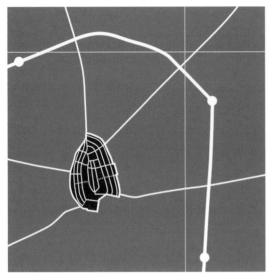

1905 Carmelite convent and cemetery, the site of the Foundation and the Krea Arts Centre. At the cathedral under renovation, visitors have a unique opportunity to pass through layers of Basque history more than a millennium old. From the remnants of the original village of Gasteiz to the striations of foundations from Romanesque and Gothic eras, this cathedral is a palimpsest of the Basque culture. An elevated catwalk weaves through the excavation, establishing a new yet artificial ground superimposed over the richly layered ground condition of the historic site. Qualities of the cathedral experience are manifested in Ercilla's Sancho el Sabio Foundation.

Sancho el Sabio Foundation and the adjacent Krea Arts Centre are conceived of as icons, with a clear formal strategy. The intent of architects Roberto Ercilla and Miguel Ángel Campo was "to establish a contemporary dialogue between both existing structures, without sacrificing their identities."[2] The Basque National Archives hold such importance to the Basque culture that the architecture they are housed in is designed to reflect their significance. The Basque people are known for fiercely defending their history, language, and customs. This is because it is believed to be one of the oldest cultures in Western Europe and their language, *Euskara*, precedes the development of other European languages. A desire to preserve

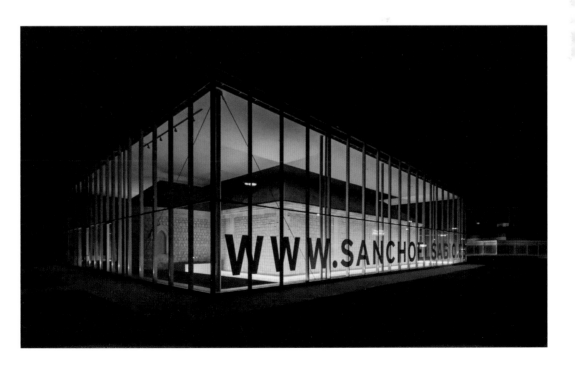

and communicate the richness of their culture motivated the lamination of the con-
temporary with the historic in an iconic structure.

 Like much of Ercilla's work, the Sancho el Sabio Foundation has a dynamic
relationship with the site. The appropriation of the convent cemetery carried with it
significant physical and symbolic complexities in contending with the ground. The
design strategy for the archive is provocative in the substantial excavation that occurred
below grade. In contrast with the United States or Great Britain, it is extremely rare
for the Spanish to bury the deceased in the ground. Instead, columbarium walls are
the most common form of interment. Thus the existing subterranean landscape was
relatively untouched, and provided the opportunity to house the substantial space
required for the archive. The pure geometric formal properties perceived from the
exterior belie a complex and dynamic spatial strategy negotiating the existing structure
and ground plane. The process by which the cemetery site was intervened in through
a subtractive process is an aspect of the collage quality inherent in this project. Slow,
cautious, and deliberate construction methods allowed the ground to be substantially
excavated below the cemetery structure. The most challenging part of the process was
the excavation itself.[3] The use of foundation trenches helped to prevent the collapse
of the cemetery from above. Concrete walls were added to stabilize the cemetery
foundation. While the walls were being constructed, the perimeter trench was con-
structed to allow light to permeate to the lower level. Once the foundation walls were
established, a lightweight steel structure was placed on the concrete base to protect
the existing structure without physically engaging it. The courtyard of the once open
cloister was covered with a roof punctuated with skylights. The perimeter of the base-
ment was then infilled through the addition of other programmatic elements housed
in wooden boxes. Finally, the new steel structure was enclosed by a glass façade. The
spatial overlap facilitated by these additive and subtractive processes creates moments
of phenomenal transparency – spaces of ambiguity that allow for simultaneous read-
ings. Collage qualities in the Foundation extend from abstract spatial conceptions
to material execution. The excavation around the perimeter of the original cemetery
structure becomes a space of dialogue between the materiality of the existing and the
new, and between the subterranean and the superterranean.

 The entrance to the Foundation illustrates a unique threshold condition.
At this moment, the visitor, in quick succession, passes through the thin glazed surface

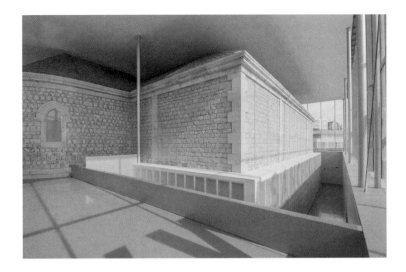

of the protective enclosure and then through the heavy, thick masonry wall of the original cemetery entrance into a compressed foyer space. Zones of compression and expansion, of heaviness and ethereality, are in constant flux as the relationship between the existing and the new is modulated. These conditions are created in plan as well as through sectional thresholds, as the visitor proceeds to the archive below. The revelation of a temporal palimpsest is typically manifested as an aggregation of layers that are, with time, eroded. The Foundation creates an inversion of this perception by suspending the past. The reoccupation of the site in each dimension surrounding the cemetery structure subverts this preconception, creating new insertions under and around the object of preservation. It reveals itself to be an index of the past that is held in the present. The valued artifacts of the archive are isolated and protected beneath the earth, wrapping the subterranean extrusion of the cemetery.

The significance at the detail scale is experienced through qualities of transparency within building materials, qualities of light and shadow, and moments of transition between material systems. These qualities are predominantly experienced by the eye and the hand. The eye interprets the separation of the cemetery from its glass shell while the hand makes contact with the materials to sense the passage of time. Transparency in the Foundation serves multiple roles in highlighting the building's relationship to the site. During the day the glass façade serves to bring significance to the site by the way it reflects the existing surroundings upon its taut skin. The cemetery's presence is only insinuated through a delicate tracing that can be seen through the almost opaque surface of glass during the day. At night, the glass dissolves to illu-

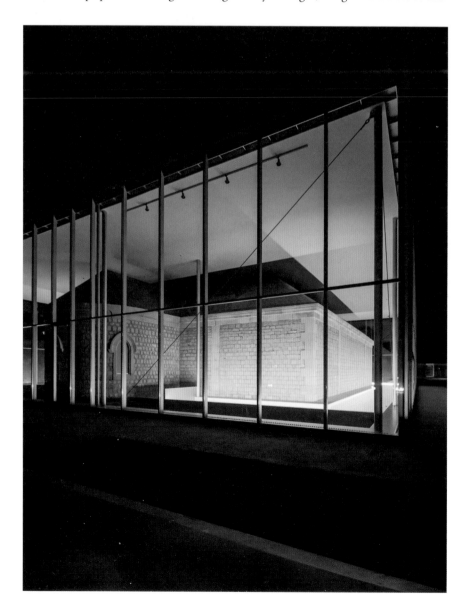

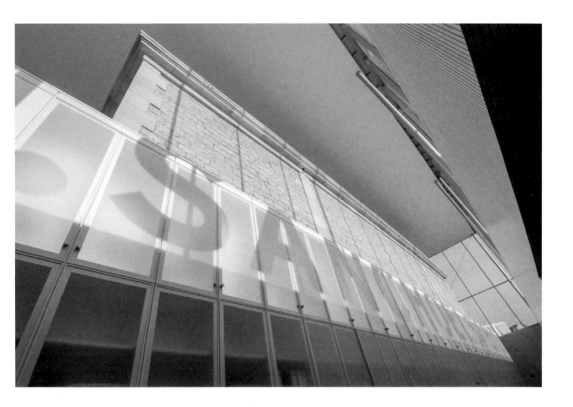

minate the cemetery as a single figural object within the background of the opaque blackness of night.

A reading of the building in response to the passing of time throughout the day can be experienced by the sepulchral shadows that penetrate the lower level through the perimeter void. Morning light is drawn down into the lower level, washing the rough walls of the existing structure and the smooth surfaces of the enclosure below. As the day continues, the shadows slowly occupy the walls until the low angle of the sun no longer permits daylight to reach these spaces. The architects explain that this void "allows the building to breath, and unifies it into one whole."[4] Shadows within this breathing space recall the enigmatic and unsettled nature of the Basque culture and contain the secrets and mysteries that are preserved within the archives.

It is important to consider the more static material conditions, where the existing building interacts with the new steel and glass enclosure. These tectonic moments reflect both the tension and reluctance of the two systems to co-exist within the same space. As a result, the cemetery and the steel frame are purposely articulated as two separate systems that maintain their own identities despite the overlapping of space created by their dialogue. This co-existence is experienced in moments such as the interior of the old cloister space of the cemetery. Though the existing walls of the cloister remain untouched, there is a clear sense that the new system is a cloak over the former courtyard. Subtle indicators mark this intrusion, including the steel columns that reach into the ground of the cloister without touching the cemetery

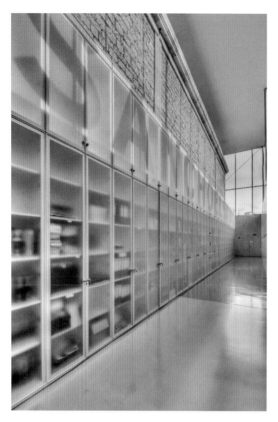

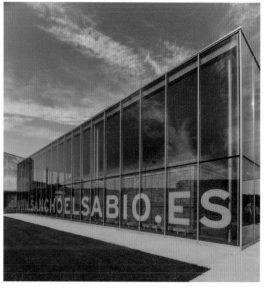

walls. The axis of the original entry passes through the cloister and terminates in the primary vertical circulation, a new stair occupying the original apse. The stair serves as the transition point between above and below ground, as a means of synthesizing the existing and the new. Collage-like juxtapositions include the use of lightweight materials like wood, glass, and metal below ground and under the existing masonry structure, and the suspension of the original masonry entry over a void below. Though there are scripted moments where the detail is emphasized in the building, the most profound revelations occur in the spatial and material juxtapositions of the new against the patina and wear of the cemetery walls revealing traces of history and time.

Sancho el Sabio Foundation is representative of a collage mentality in its nature as an index of Basque history: layers that have been revealed, superimposed, and synthesized to capture the richness of their culture. Collage as a method for creating juxtapositions and simultaneous readings has a clear correlate in the Foundation. A combination of additive and subtractive methods constructs and reveals a temporal process in the microcosm of the appropriated convent cemetery, while the nature and value of the archive itself superimposes an additional layer of meaning onto the site. The Foundation's character as a palimpsest demonstrates its role as an aggregation of Basque cultural artifacts.

Notes

1 Roberto Ercilla and Miguel Ángel Campo, "Nueva Sede Para La Fundación Sancho El Sabio En Betoño, Vitoria-Gasteiz," *Sancho El Sabio*, in-house publication, 121. Available at www.slideshare.net/FUNDACION2009/edificio-transparente-fondos-documentales-de-la-fundacin-sancho-el-sabio?utm_source=slideshow03&utm_medium=ssemail&utm_campaign=share_slideshow_loggedout.
2 Ercilla and Campo, "Fundación Sancho El Sabio," 121.
3 Ercilla and Campo, "Fundación Sancho El Sabio," 123.
4 Ercilla and Campo, "Fundación Sancho El Sabio," 122.

Selected Bibliography

Bachelard, Gaston. *The Poetics of Space*. Boston: Beacon Press, 1969.

Benjamin, Walter. *The Work of Art in the Age of Mechanical Reproduction*, 1936. Source: UCLA School of Theater, Film and Television; Transcribed: Andy Blunden 1998; proofed and corrected February, 2005.

Besset, Maurice. *Le Corbusier: To Live with the Light*. New York: Rizzoli, 1987.

Betanzos Pint, Christina. *Bernhard Hoesli: Collages*. Knoxville: University of Tennessee, 2001.

Blau, Eve and Nancy J. Troy. *Architecture and Cubism*. Cambridge, MA: The MIT Press, 2002.

Boddington, Anne and Teddy Cruz, eds. *Architectural Design: Architecture of the Borderlands*. Oxford: John Wiley & Sons, 1999.

Burgess, Gelett. "The Wild Men of Paris." *The Architectural Record* (May, 1910), 405.

Caragonne, Alexander. *The Texas Rangers: Notes from the Architectural Underground*. Cambridge, MA: The MIT Press, 1995.

Cook, Peter, ed. *Archigram*. New York: Princeton Architectural Press, 1999.

Cooper, Douglas. *The Cubist Epoch*. London: Phaidon Press, 1971.

Corner, James, ed. *Recovering Landscape: Essays in Contemporary Landscape Architecture*. New York: Princeton Architectural Press, 1999.

Curtis, William. "Le Corbusier: Nature and Tradition." In *Le Corbusier, Architect of the Century*. London: Arts Council of Great Britain, 1987.

Dripps, Robin. "Groundwork." In Burns, Carol J. and Andrea Kahn, eds. *Site Matters*. New York: Routledge, 2005.

Fehn, Sverre. *The Poetry of the Straight Line*. Helsinki: Museum of Finnish Architecture, 1992.

Fehn, Sverre. *The Skin, the Cut, and the Bandage* (The Pietro Belluschi lectures). Cambridge, MA: School of Architecture and Planning, MIT, 1997.

Fischer, Volker. *Richard Meier: The Architect as Designer and Artist*. New York: Rizzoli, 2003.

Flora, Nicola, ed. *Sigurd Lewerentz*. London: Phaidon Press, 2006.

Giedeon, Sigfried. *Space, Time, and Architecture: The Growth of a New Tradition.* Cambridge, MA: Harvard University Press, 1941.

Green, Cristopher. "The architect as artist." In *Le Corbusier, Architect of the Century.* London: Arts Council of Great Britain, 1987.

Haussman, Raoul, and John Cullars. "Photomontage." *Design Issues*, Vol. 14, No. 3 (Autumn, 1998), 67–68.

Heidegger, Martin. "Building Dwelling Thinking." *Poetry, Language, Thought.* Translated by Albert Hofstadter. New York: Harper Colophon Books, 1971.

Hejduk, John. *Education of an Architect: The Cooper Union School of Art and Architecture, 1964–1971.* New York: Cooper Union, 1971.

Henry Art Gallery, Richard Adams, and Milena Kalinovska, eds. *Art Into Life: Russian Constructivism 1914–1932.* New York: Rizzoli, 1990.

Hoesli, Bernhard. "Commentary." In Rowe, Colin and Robert Slutzky. *Transparency.* Basel: Birkhäuser, 1964.

Holl, Steven. *Anchoring.* New York: Princeton Architectural Press, 1989.

Holl, Steven. *Intertwining.* New York: Princeton Architectural Press, 1996.

Hopkins, David. *Dada and Surrealism: A Very Short Introduction.* New York: Oxford University Press, 2004.

Kipnis, Jeffrey. *Perfect Acts of Architecture.* New York: Harry N. Abrams, 2001.

Krauss, Rosalind. "Sculpture in the Expanded Field." *October*, Vol. 8 (Spring, 1979), 38.

Lang, Peter and William Menking. *Superstudio: Life Without Objects.* Milano: Skira Editore, 2003.

Lapunzina, Alejandro. *Le Corbusier's Maison Curutchet.* New York: Princeton Architectural Press, 1997.

Lund, Nils-Ole. *Collage Architecture.* Berlin: Wilhelm Ernst & Sohn Verlag für Architektur und technische Wissenschaften, 1990.

McQuaid, Matilda, ed. *Envisioning Architecture: Drawings from The Museum of Modern Art.* New York: The Museum of Modern Art, 2002.

Manfredi, Michael A. and Marion Weiss, *Weiss/Manfredi: Surface/subsurface.* New York: Princeton Architectural Press, 2007.

Mathur, Anuradha and Dilip da Cunha. *Mississippi Floods: Designing a Shifting Landscape.* New Haven: Yale University Press, 2001.

Mathur, Anuradha and Dilip da Cunha. *Deccan Traverses: The Making of Bangalore's Terrain.* New Delhi: Rupa & Co., 2006.

Meier, Richard. "Essay." *Perspecta*, Vol. 24 (1988), 104–105.

Mertins, Detlef, ed. *The Presence of Mies.* New York: Princeton Architectural Press, 1994.

Miralles, Enric. *Enric Miralles Works and Projects: 1975–1995.* New York: The Monacelli Press, 1996.

Miralles, Enric and Bendetta Tagliabue, *Enric Miralles: Mixed Talks.* New York: Academy Editions, 1995.

Miss, Mary. *Mary Miss.* New York: Princeton Architectural Press, 2004.

Moure, Gloria. *Gordon Matta-Clark: Works and Collected Writings.* Barcelona: Ediciones Poligrafa, 2006.

The Museum of Modern Art, *The Changing of the Avant-Garde: Visionary Architectural Drawings from the Howard Gilman Collection.* New York: The Museum of Modern Art, 2002.

Nesbitt, Lois. *Richard Meier Collages.* London: St. Martin's Press, 1990.

Nicholson, Ben. *Appliance House.* Cambridge, MA: The MIT Press, 1990.

Norberg-Schulz, Christian. *Nightlands: Nordic Building.* Cambridge, MA: The MIT Press, 1996.

Norberg-Schulz, Christian and Gennaro Postiglione. *Sverre Fehn: Works, Projects, Writings, 1949–1996.* New York: The Monacelli Press, 1997.

Pallasmaa, Juhani. "Hapticity and Time: Notes on Fragile Architecture." *The Architectural Review* (May, 2000), 78–84.

Pauly, Daniele. *Barragan Space and Shadow, Walls and Color.* Basel: Birkhäuser, 2002.

Perez-Gomez, Alberto and Louise Pelletier, "Architectural Representation Beyond Perspectivism." *Perspecta*, Vol. 27 (1992), 34.

"The Playboy Interview: Marshall McLuhan." *Playboy Magazine* (March, 1969).

Poggi, Christine. *In Defiance of Painting: Cubism, Futurism, and the Invention of Collage.* New Haven: Yale University Press, 1992.

Riggen Martinez, Antonio. *Luis Barragan: Mexico's Modern Master, 1902–1988.* New York: The Monacelli Press, 1996.

Rowe, Colin. "The Provocative Façade: Frontality and Contrapposto." In *Le Corbusier, Architect of the Century.* London: Arts Council of Great Britain, 1987.

Rowe, Colin and Robert Slutzky, "Transparency: Literal and Phenomenal." *Perspecta*, Vol. 8 (1963), 45–54.

Selz, Peter Howard. *Chillida.* New York: Harry N. Abrams, 1986.

Shapiro, David. *Richard Meier: Collages.* New York: Gagosian Gallery, 2005.

Tagliabue, Benedetta, et al. "EMBT Enric Miralles / Benedetta Tagliabue 2000–2009." *Croquis*, No. 144 (2009). Available at www.elcroquis.es/Shop/Issue/Details/35?ptID=1.

Vesely, Dalibor. *Architecture in the Age of Divided Representation: The Question of Creativity in the Shadow of Production.* Cambridge, MA: The MIT Press, 2004.

Waldman, Diane. *Collage, Assemblage, and the Found Object.* New York: Harry N. Abrams, 1992.

Walker, Stephen. "Gordon Matta-Clark: Drawing on Architecture." *Grey Room*, No. 18 (Winter, 2004), 108–131.

Wild, David. *Fragments of Utopia: Collage Reflections of Heroic Modernism.* London: Hyphen Press, 1998.

Zanco, Federica, ed. *Luis Barragan: The Quiet Revolution*, Milan: Skira Editore, 2001.

Image Credits

Every effort has been made to contact and acknowledge copyright owners, but the author and publisher would be pleased to have any errors or omissions brought to their attention so that corrections may be published at a later printing.

Part 1

[p.3] Courtesy of Regina Hoesli-Rooney
[p.6] Digital Image © The Museum of Modern Art / Licensed by SCALA / Art Resource, NY. The Museum of Modern Art, New York, NY, U.S.A.
[p.9] Courtesy of Richard Meier
[p.10] Courtesy of Brian Ambroziak and Andrew McLellan, time[scape]lab
[p.11] Courtesy of Estudio Teddy Cruz: Border Postcards, LA/LA – Latin America Los Angeles Workshops, SCI-Arc, Teddy Cruz 1994–2000
[p.12] Courtesy of FELD studio
[p.13] Photo by Bryan Shields, 2010
[p.14] Photo by Bryan Shields, 2011
[p.21] Digital Image © The Museum of Modern Art / Licensed by SCALA / Art Resource, NY The Museum of Modern Art, New York, NY, U.S.A.
[p.25] Digital Image © The Museum of Modern Art / Licensed by SCALA / Art Resource, NY. The Museum of Modern Art, New York, NY, U.S.A.
[p.29] © 2012 Artists Rights Society (ARS), New York / ADAGP, Paris / F.L.C.
[p.31] © 2012 Artists Rights Society (ARS), New York / ADAGP, Paris / F.L.C.
[p.33] Photo by Patrick Gaither, 2011
[pp.35–41] Courtesy of Regina Hoesli-Rooney
[pp.43–45] © 2012 Artists Rights Society (ARS), New York / VEGAP, Madrid
[pp.46–47] Photos by Bryan Shields, 2011
[pp.47–48] © 2012 Artists Rights Society (ARS), New York / VEGAP, Madrid

[p.185] © Chris Jordan

[pp.187–91] Courtesy of Point Supreme

[pp.193–98] Courtesy of Mathur/da Cunha

[pp.201–205] Courtesy of FELD studio © FELD | studio for digital crafts [www. feld.is]

Source material by Klaus Frahm. All rights reserved. [www.klaus-frahm.de]

Part 2

[pp.216–17] © 2012 Artists Rights Society (ARS), New York / ADAGP, Paris / F.L.C.

Photos by Luis Calatayud

[p.220] Photo by Ernesto Perales Soto, 2006

[pp.223–25] © 2012 Artists Rights Society (ARS), New York / ProLitteris, Zürich

Photos by Armando Salas Portugal

[pp.227–34] Photos by Bryan Shields, 2010

[pp.237, 240, 242–45] Photos by Bryan Shields, 2010

[pp.247–49] Courtesy of WEISS/MANFREDI Architecture/Landscape/Urbanism

[pp.250–53] Photos by Bryan Shields, 2013

[pp.255–62] Photos by Bryan Shields, 2011

Index